W9-DHF-470

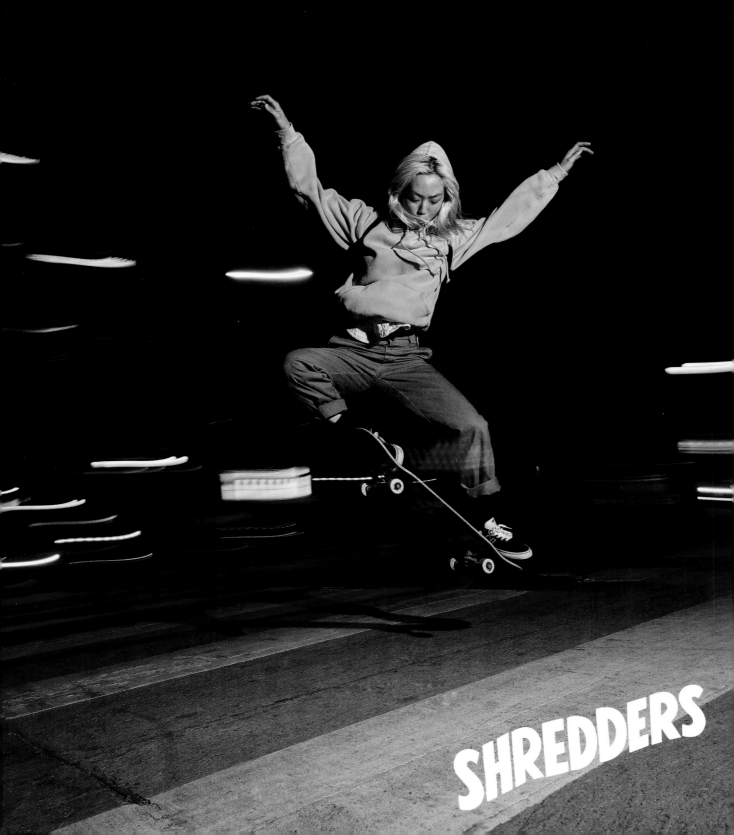

SHREDDERS

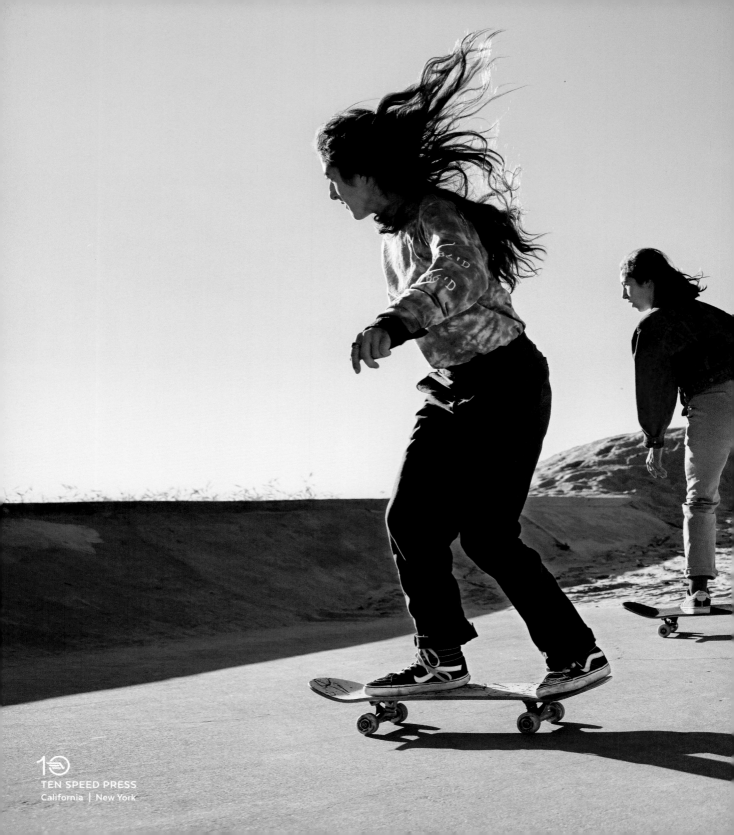

TEN SPEED PRESS
California | New York

SHREDDERS

Girls Who Skate

SIERRA PRESCOTT

ILLUSTRATIONS BY KATE PRIOR

Contents

INTRODUCTION
INTRODUCTION
INTRODUCTION
INTRODUCTION
INTRODUCTION

INTRODUCTION

Skateboarding is not just a sport. It's a feeling. It's a lifestyle. It's a frame of mind, an addiction, a bond. It's an endlessly varying combination of creativity, failure, and mastery. Skateboarding is communication, connection, a universal language shared with other skaters. It is countless hours of love and dedication. But the most magical thing about skateboarding is not what it *is*, but what it *does*.

Skateboarding takes over your body and mind, allowing self-expression through shapes, sounds, and rhythms. It repeatedly challenges your creativity and offers an ever-changing mix of feeling and movement. When you're on your board, you're dancing with the world beneath your feet.

Skateboarding is personal. If you stand on a skateboard, you will inevitably have your own unique experience, style, and individual goals. If you skate, no matter your level of skill, *you are a skateboarder*, and every skateboarder is instinctively a shredder. There are so many ways to enjoy skating, and so many variables that affect a skater's experience. But at the end of the day, skateboarding is all about freedom: How you skate, how often you do it, how hard you go, what kind of board you ride, what terrain you skate—the combination of choices is endless and the choices are yours.

Whether I'm watching, thinking about, or actually skating, I feel happy, focused, and I'm living in the moment. When I first stepped on a skateboard at the age of ten, I could never have imagined how much impact it would have on my life going forward. What began as an afterschool activity turned into a passion explored in my free time, and that turned into a multifaceted career. I never stopped skating, and I truly can't imagine my life without it now. Skateboarding has permeated my being, giving me purpose and a channel to spread the stoke. My favorite part of it is every part.

From its roots in the 1960s, the sport has evolved into a world of complex maneuvers and new possibilities with varying terrains and an untapped platform for growth. It's morphed from something skaters do just for fun, to a potential way to make a living. Its doors have opened to women and children alike, becoming an increasingly equal playing field as time goes on. Although innovation in skateboarding has slowed down, the sport's infiltration into mainstream culture has advanced exponentially. It's not just an "extreme" sport anymore—it's whatever you want it to be.

I hope that this book will inspire girls and women of all ages to follow their passions, try new things, and never feel that something is off limits because it's "a boy thing." Skateboarding is *not* just a boy thing. Girl shredders are out there tearing it up and having a great time, and this book features some of them. There are countless more ladies out there doing standout things on their boards and bringing the sport to new heights. We have only just begun.

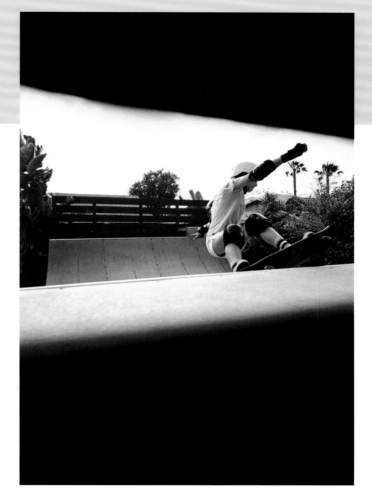

TYPES OF SKATERS: OG, PRO & SOUL

There are so many different ways to approach skateboarding in terms of style, preferences, and purpose. Understanding how long people have been skating, why they skate, and how they skate can tell you a lot about them and can help you develop a deeper appreciation for the sport and the rad girls and women who shred. The skaters profiled in this book are categorized one of three ways: OG, PRO, or SOUL.

The women categorized as OG are pioneers of skateboarding who started skating in the sport's early days: the 1960s and 1970s. They were professionals at some point. They are the originals, the mavericks, the old-school shredders and tastemakers who paved the way for the rest of us.

PRO skaters are those who have been sponsored and/or are currently competing in the skateboarding circuit, at any level or within any skating style, such as Lizzie Armanto (see page 166) and Kanya Sesser (see page 18). These skaters are, or were, sponsored by various brands and companies, which are noted in their profiles.

SOUL skaters are neither OG nor do they compete. They skate purely for the joy it brings them, whether it has been a part of their lives for a long time or is a new thing. All shredders are SOUL skaters at heart, for there's no better reason to get on your board than the pure love of skating.

One of the coolest things about skateboarding is that all you need is a skateboard and an eagerness to shred. But the way you skate and the places where you choose to skate are personal; being familiar with the options out there will help you focus in on what makes skateboarding most fun for you. Give them all a try and see which ones give you the most stoke.

STYLES

There are many different styles of skateboarding. Here is a brief overview.

Flatground Skateboarding: Also known as technical or tech skateboarding, flatground involves performing tricks without the use of ramps or obstacles, and without using slides or grinds.

Freestyle Skateboarding: A type of flatground skating also known as flatland skating, freestyle is one of the first styles of skateboarding, which began in the 1960s. Female pioneers like Patti McGee and Ellen Berryman established the style, which is all about the finesse and fluid creativity that can be carried out on a skateboard. When skateboarding took a turn for the gnarly in the late 1970s, the style quietly got more technical and was practiced by boys and girls alike. Simply stated, freestyle skateboarding consists of finding unique ways to flip or stall one's board on a flat, smooth surface. Tricks are often linked together through hand and footwork. Today's freestyle boards are made to accommodate style innovations. They tend to be smaller and have little to no concave or flex, offset wheels (meaning axles are covered by wheels), and mellow noses and tails that are essentially the exact same shape end to end. This allows for better predictability and consistent board reaction. Grip tape or a tail skid plate are sometimes added to the underside of the tail to help with caspers. Additionally, freestyle skateboarders are known to wear shin guards and finger tape.

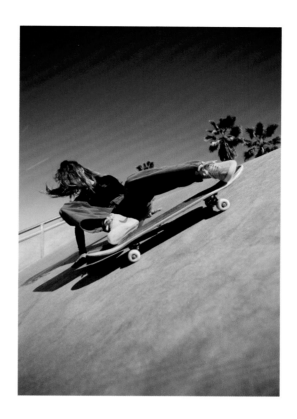

Longboarding: Despite their name, longboards aren't necessarily much longer than other skateboards. The difference lies in the style of board and style of riding. Although typically longer than 30 inches, a longboard can be used for a variety of different experiences or styles, including, but not limited to, downhill racing, cruising or commuting, freeriding, flatground freestyle, and the newest style, long distance pushing. Longboards typically have larger wheels with wider and more flexible boards, allowing for better control and comfort at high speeds.

Slalom Skateboarding: Also beginning in the 1960s, slalom is another early style of skateboarding. Slalom is essentially downhill racing while weaving in and out of deliberately placed cones, trying to avoid knocking them over while racing

to the finish line. Skaters practice slalom on wide, smooth surfaces with a decline, often seeking out newly poured streets and leaving chalk marks on them for a perfect cone setup every time. Typically, the skateboards used for slalom have a fixed back truck for stability at high speeds (leaving the front truck with solo turn capability) and a footstop affixed to the front truck on the grip side of the board to hold the front foot in place when making forceful and quick maneuvers.

Street Skateboarding: After the decline of skate parks in the early 1980s, skaters set out to find new places to go, giving rise to street skating (along with backyard pool skating). Usually called just "street," it is exactly what it sounds like: skateboarding in an urban environment that includes ledges, stairs, rails, and so on. Low and mid trucks with smaller wheels are typically used for street skating since they allow for easier flip tricks. To make the boards even lighter, hollow trucks may be used as well.

Park Skateboarding: Usually simply called "park," this refers to skating in a skate park, which offers a safe place for practicing on different obstacles. A well-rounded park is sure to have a street section with good flow, a snake run, a bowl, mini ramp, and some DIY bits. Skate parks tend to be separated into dedicated sections and are beneficial for consistent and uninterrupted practice. Skate parks that do not have sections of transition are referred to as "skate plazas," and are geared to street and freestyle skaters.

Vert Skateboarding: Another style of early skateboarding, riding vert refers to skating a vertical ramp that is open on both sides (similar to a big fat U) where at least 1 foot of transition is vertical before reaching the coping, an attachment at the top edges of the ramps. Vert skaters typically have higher trucks, which can support bigger wheels for more speed. When the walls of a vert ramp go past vertical to curve inward, this is called "o-vert."

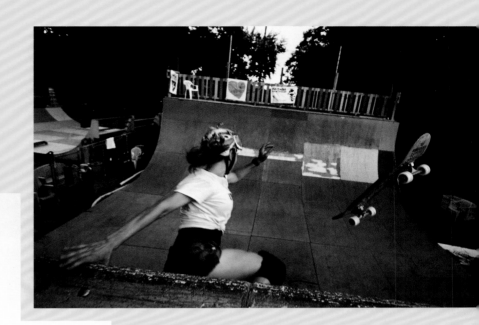
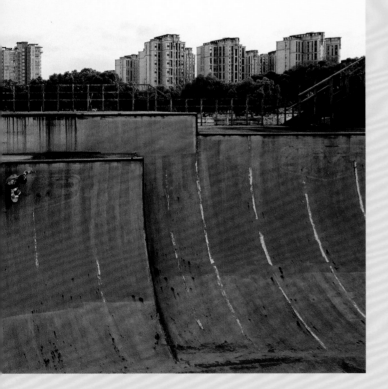
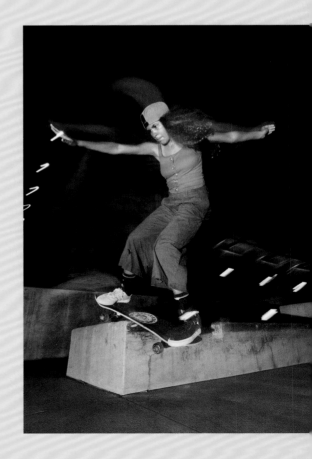

PLAYGROUNDS

There are so many places one can skateboard—these are a few classic skate playgrounds.

Bowls: Originating from backyard pools, a bowl is an enclosed area of transition found in many skate parks. They come in all kinds of shapes, such as eggs, circles, clovers, and kidneys, and they are typically made of smooth concrete or wood (most commonly found at indoor parks). More often than not, bowls will have added flair that nods to old-school pool skating, like labels for the varying depths ("shallow end" and "deep end"), as well as real pool elements like "pool lights" or "death-boxes," which are used as obstacles to trick over. Plus, bowls can be found with various styles of coping, from steel to tile to concrete that are shaped in a multitude of ways, the most common being the "bullnose."

Mega Ramp: This is an extremely big ramp that usually measures 360 feet long, with the highest point of the ramp reaching a daunting 75 feet. A few select skate parks have mega ramps, but they are mostly seen in competitions. In mega ramp competitions, brave skaters proceed down a 180-foot roll in to a launch ramp with a 70-foot gap with nothing but netting to catch them if they fall short. Landing on a sloped section, the skater proceeds to a 30-foot quarter-pipe, launching up an additional 20 feet above the coping to be roughly 50 feet in the air. The mega ramp is now a key part of the X Games and other large-scale skate exhibitions.

Pump Track: A pump track is a mellow, wavelike continuous run, designed with smooth bumps, humps, and turns on a single closed track. Typically made up of rolling concrete or black pavement, pump tracks allow skaters to get a rhythm down by pumping the declines and floating up the inclines, never having to take a foot off the board to push.

Snake Run: With the birth of skate parks came snake runs, which are an exhilarating and fun way to catch speed and carve. Typically made of solid, polished concrete, snake runs mimic a flow of waves of transition with no coping—all curved, all smooth. A nicely designed snake run will empty out into a bowl, allowing the skater to ride out their speed, or to circle around to pick up more speed, sending the skater back to the start.

Transition: Typically found in skate parks, a transition is a skating surface with a gradual buildup of height, often from horizontal to vertical. Transition ramps consist of obstacles such as quarter-pipes, mini ramps, half-pipes, spines, verts, bowls, and so on.

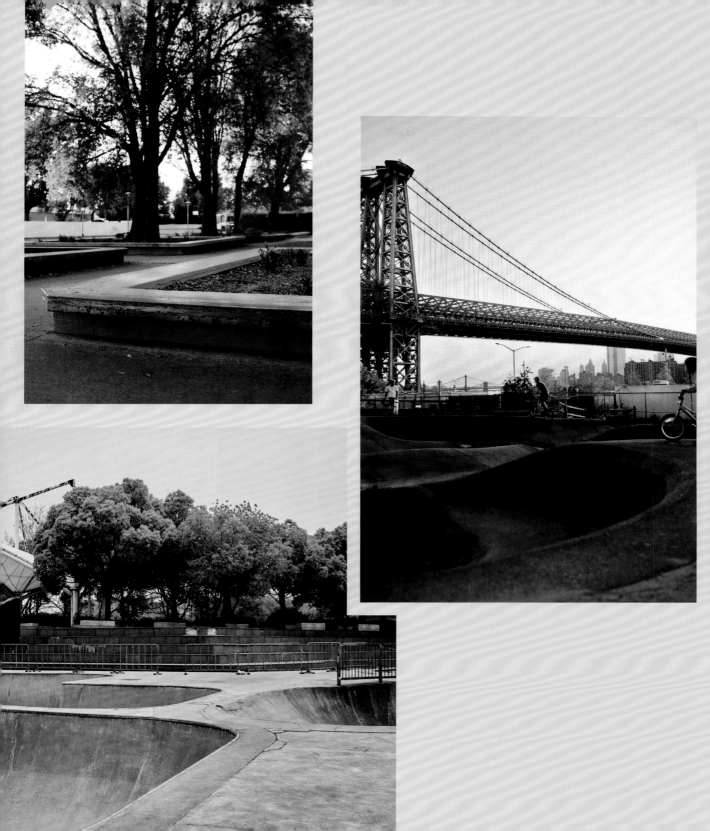

STELLA SERAFIN
STELLA SERAFIN
STELLA SERAFIN

STELLA SERAFIN

SOUL

BORN
Brooklyn, New York

CURRENT HOME
Upstate New York

STARTED SKATING
3 years old

FIRST BOARD
Penny board

BOARD PREFERENCES
Wide board with big, soft wheels

STANCE
Goofy

FAVORITE TRICK
Frontside 50-50

TRICK IN THE WORKS
Dropping in

SKATE DAY FOOD OF CHOICE
Pirate's Booty

FAVORITE TIME TO SKATE
Morning

FUN FACT
Her favorite music to skate to is Sharon Jones & the Dap-Kings

The night before our early morning shoot in Brooklyn, Stella told her family that she "gets nervous in front of important people." She's naturally shy, but when we met, she was smiling and holding her Street Plant brand signature model skateboard, all ready to go. The founder of Street Plant, Mike Vallely, is a childhood friend of Stella's dad, Rob. A lifelong skater himself, Rob got Stella on a skateboard when she was only three years old, and she's loved it ever since.

A curious learner and hard worker, Stella loves school and brings skateboarding into her classwork regularly. For one assignment, she was asked to create a drawing of how to do something. Instinctively, she chose to draw "how to build a skateboard." Her dad was impressed and shared the drawing with Mike, who now includes a printout of Stella's class assignment with all Street Plant skateboard shipments.

Stella is a dreamer and looks up to strong women like astronaut Sally Ride (the first American woman in space), prima ballerina Misty Copeland, and pro skater Lizzie Armanto (see page 166), among others. She's always excited to learn more about the topics that interest her and to grow in numerous aspects of her life. "Everything I do brings me one step closer to my goals," she said when I asked about her future.

To Stella, skateboarding is pure joy. When she's not skateboarding, studying, or reading, you'll find her dancing or making art.

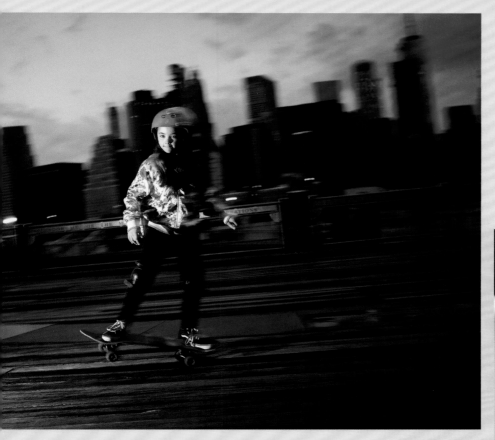

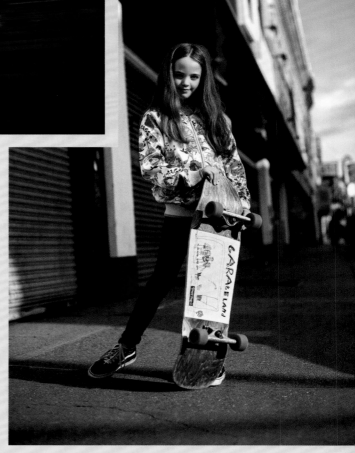

"Some boys think
that skateboards
aren't for girls. . . . But
skateboarding isn't a
boy thing and it's not
a girl thing. That stuff
doesn't matter. All
that matters is if you
like to skateboard."

ARI BESSA

SOUL

BORN
Huntington Beach, California

CURRENT HOME
Everywhere

STARTED SKATING
16 years old

FIRST BOARD
Black Label board with Bones wheels
and Independent trucks

BOARD PREFERENCES
Loose trucks, hard wheels

STANCE
Regular

FAVORITE TRICK
Backside Disaster

TRICK IN THE WORKS
Backside Boneless

SKATE DAY FOOD OF CHOICE
Street tacos

FAVORITE TIME TO SKATE
Any time, any day

FUN FACT
She's a badass who still sleeps with her
childhood blankie

You can tell Ari is gutsy by the way she rides her board. How does she ride it? Any way she possibly can. Will you find her at the skate park? Yup. On the streets? For sure. Flying by you through rush hour traffic? Most likely. And if she's not on her board, she is thinking about the next time she will be, while watching VX skate videos of Mark Gonzales (The Gonz). Ari's part of a solid and supportive crew of friends who skate and whom she looks up to. "All of my friends actually rip," she said when talking about them.

Growing up near the beach, Ari started surfing when she was just five years old, but it wasn't until she turned sixteen that she got her first skateboard and fell in love with concrete. Since then she has dedicated her life to skateboarding, living out of her car and traveling from skate spot to skate spot.

Skateboarding is Ari's world, and her world is a whole lot of fun.

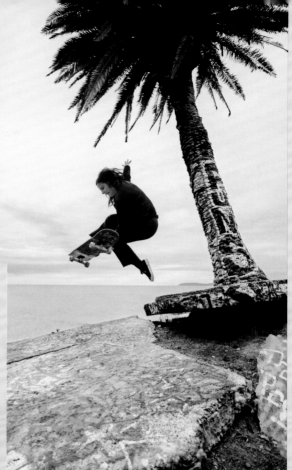

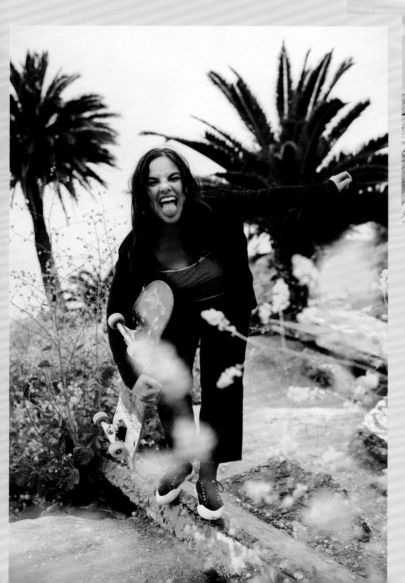

"[Skateboarding is] an insane addiction and life would look rather frightening without it."

KANYA SESSER
KANYA SESSER

KANYA SESSER

PRO

BORN
Thailand

CURRENT HOME
Rancho Palos Verdes, California

STARTED SKATING
9 years old

FIRST BOARD
Element size 8.0"

BOARD PREFERENCES
Small and hard wheels with Thunder trucks

STANCE
Regular

FAVORITE TRICKS
50-50 and 5-0 Grind

TRICKS IN THE WORKS
Ollie Hand Flip, and Ollie 5 Stairs

SKATE DAY FOOD OF CHOICE
Chicken tacos or sushi

FAVORITE TIME TO SKATE
Anytime

FUN FACT
She played a zombie on TV as a series regular on *The Walking Dead*

SPONSORS
RUNA, Sheckler Foundation, Carver

Kanya was born without legs, but from the moment she opened her eyes, she has been on a mission to let nothing stop her from following her dreams.

Born in Thailand, she spent the first five years of her life in foster care before being adopted by a wonderful family in the United States. She grew up in Tualatin, Oregon, where she played with her new brother in a welcoming neighborhood chock-full of active kids. Neighbors turned into friends, and one day Kanya found some of her buddies messing around on a skateboard. She asked to give it a whirl and immediately fell in love. Naturally confident, she ventured off on her own at age eighteen, moving around here and there. By the time she was twenty-three, she had made it to California, which she now calls home.

When I met Kanya, I was speechless. I reflexively kept offering to help her, which is something she's had to deal with her whole life. But she is more than capable of taking care of herself, politely saying, "No, thank you," when I offered assistance. So I just stood back with my camera and let my mind be blown by Kanya's athleticism, passion, and skill on her board. Never have I seen someone have to work so hard to gain speed, pumping solely with her arms. I watched as she maneuvered around without the use of legs, admiring the normally somewhat simple feat of getting back out of transition once the momentum has stopped. Every single thing she does is more difficult and tiring, but

continued →

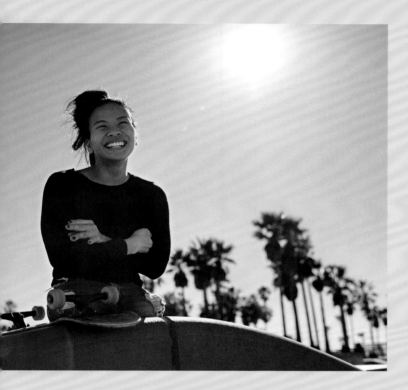

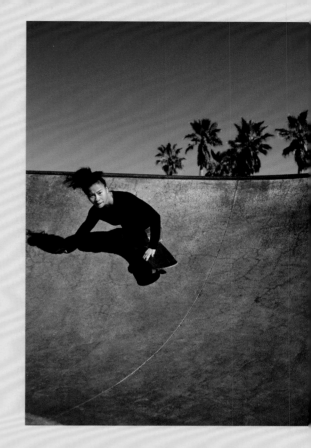

"No legs, no limits."

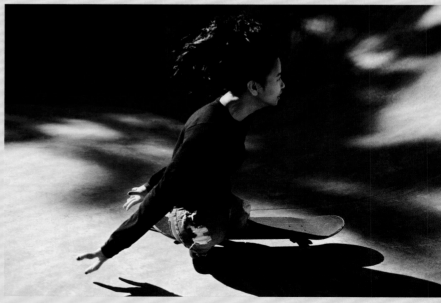

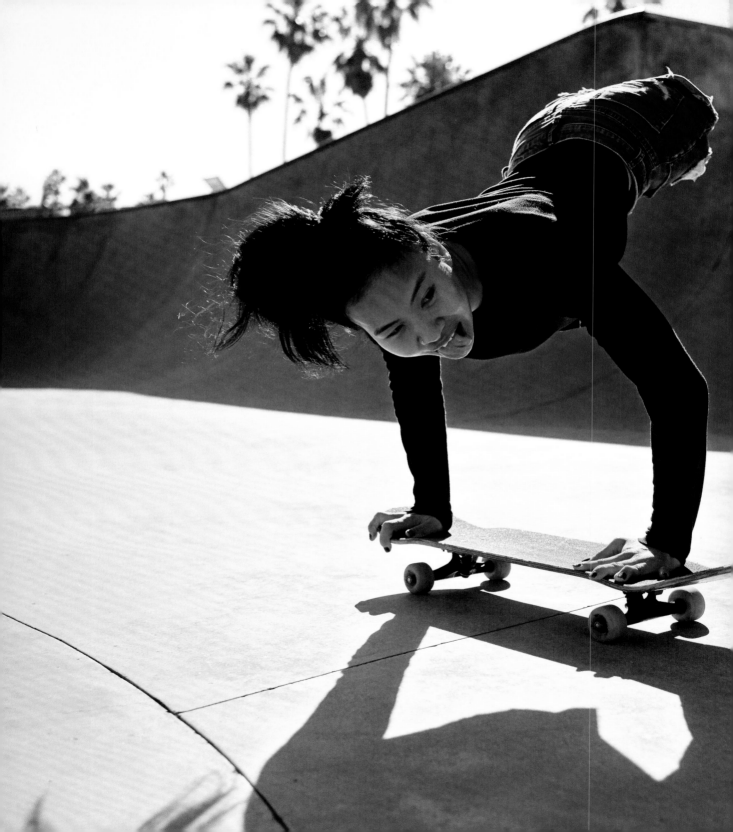

the thing that stood out most while watching Kanya skate was that she *loved* to do it. Skateboarding represents her freedom: "No matter who you are, how good you are, or what tricks you do, you are living life on the edge without limits," she says.

Having no legs has not stopped Kanya from living her dreams and accomplishing her goals. In 2016, she joined the Sheckler Foundation as both an athlete and ambassador. The Sheckler Foundation is a nonprofit founded by former pro skater Ryan Sheckler that aims to "be the change" for children and disabled or injured action sports athletes. "Shining light on adaptive skateboarders and athletes has been something I hold close to my heart—watching guys and girls work hard and defy the odds on the daily is not only a blessing to see but truly motivating," Sheckler has said about his foundation. Kanya has since been a part of a supportive community of athletes where she is not the only adaptive skateboarder on the team. Through her work with the foundation, she has helped to create and participate in an equal playing field for athletes like herself, showing that there really are no limits when it comes to what our bodies can accomplish. Inspiring other adaptive athletes has been something she has dreamed about, and it's now her reality.

Kanya is also a Paralympian and continues to compete in adaptive park events. She has been recognized and supported by major brands such as Billabong (her first sponsor) and Nike throughout her professional career. In 2019, Kanya became the first (and only) woman without legs to compete in the X Games—and on the first adaptive skate park in the X Games—continuing to push boundaries and show the world that life is truly limitless.

Needless to say, Kanya is always busy. When she's not skating, she's giving motivational speeches around the world, modeling, acting, and performing stunt work for the TV and movie industry.

ADRIANNE SLOBOH
ADRIANNE SLOBOH
ADRIANNE SLOBOH

ADRIANNE SLOBOH

PRO

BORN
Van Nuys, California

CURRENT HOME
Simi Valley, California

STARTED SKATING
13 years old

FIRST BOARD
Plastic board from Target

BOARD PREFERENCES
Loose trucks, small wheels

STANCE
Goofy

FAVORITE TRICK
360 Flip

TRICK IN THE WORKS
Backside Lipslide

SKATE DAY FOOD OF CHOICE
Pizza

FAVORITE TIME TO SKATE
Morning

FUN FACT
She loves to breakdance

SPONSORS
Adidas Skateboarding, CHOMP clothing, Reality GRIP, and Bones Bearings

Adrianne surprised me. I was expecting her to have a more aggressive vibe because of her extensive bag of technical and powerful tricks combined with her impressive list of sponsors, but instead I found her to be worry-free and chill. On the day of our shoot, she was happy, excited, and ready to give it her all. Since she's a pro skateboarder, I knew she'd be skating hard and consistently, but I didn't anticipate how graceful she would be on her board. As I watched her repeatedly lock into Back Smith Grinds, I couldn't keep a smile off my face. She was having a blast, and although the skateboarding world takes her seriously—she's widely recognized within the pro circuit—she takes the serious out of it and skates from her heart. "Skateboarding to me means peace and serenity," she explains. "[When] you're skating, your biggest worry is how well you can land a Kickflip, which is amazing the older you get." Her approach to skating is relaxed, encouraging newbies not to be scared to get on a board: "We were all beginners once."

When Adrianne is skating, the rest of the world fades away; it's an experience all her own. Adrianne's laid-back attitude is refreshing to see in a pro skater, and it shows in her loose, rhythmic style. She floats around the skate park, hitting ledge after ledge in one continuous flow, flipping in and out of manual combinations and making it look all too easy.

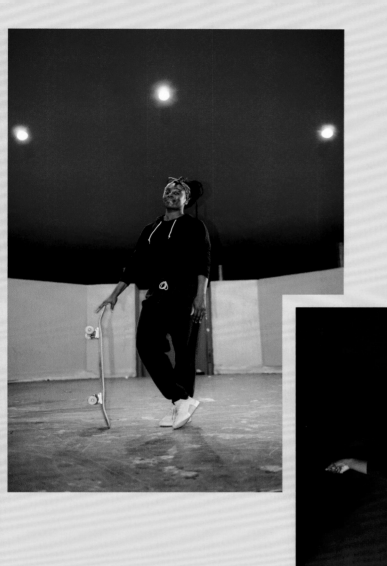

"Calm down, you're fine."

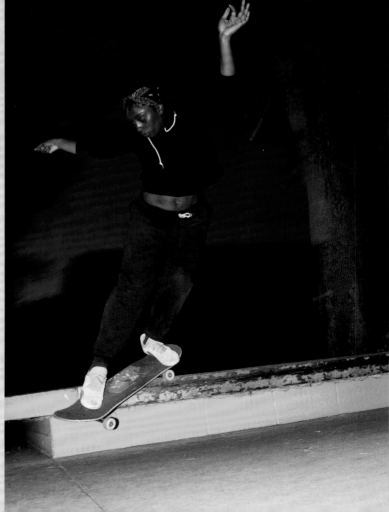

JULIE DANIELS, AMY BRADSHAW
& JULIE GOFORTH

JULIE DANIELS, AMY BRADSHAW & JULIE GOFORTH

JULIE DANIELS
SOUL

BORN
San Diego, California

CURRENT HOME
Los Angeles, California

STARTED SKATING
5 years old

FIRST BOARD
Red Roller Derby board with steel wheels

BOARD PREFERENCES
Loose trucks, hard wheels

STANCE
Goofy

FAVORITE TRICK
Carving

TRICK IN THE WORKS
Getting comfortable on coping

SKATE DAY FOOD OF CHOICE
Coffee

FAVORITE TIME TO SKATE
Night

FUN FACT
Specializing in creative portraiture and children's fashion, Julie is a passionate, full-time photographer

"Don't be afraid of the thirteenth floor."

One of the awesome things about skateboarding is that it can be practiced just about anywhere there's smooth, hard ground, and that it can be enjoyed alone or with a group. The relationship between skaters and their rides is personal, but there is nothing more thrilling than skating with friends. Many people first learn to skate through their friends, and it's often our skater friends who inspire us to skate more, to try new tricks, and to keep at it when we're feeling stuck. Friends offer community and reassurance, and they can encourage us to come back to skating, even if it's been awhile. It can be daunting to learn to skate or to pick it back up—especially as an adult—but with a good crew on your side, what could be a scary thing becomes a fun one. That's certainly true for these three rad skate mates.

continued →

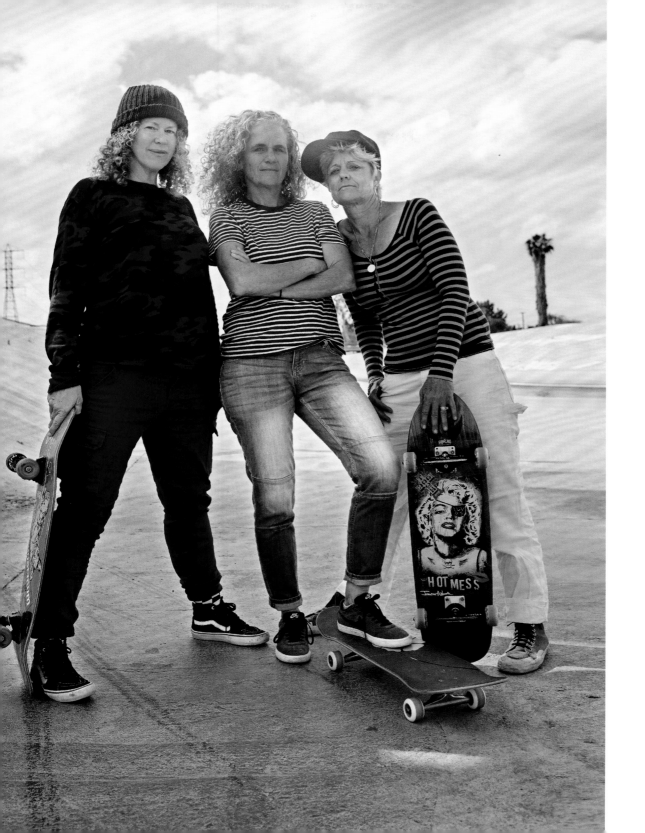

AMY BRADSHAW
SOUL

BORN
Los Angeles, California

CURRENT HOME
Los Angeles, California

STARTED SKATING
10 years old

FIRST BOARD
No-name board with steel wheels

BOARD PREFERENCE
Loose trucks to the max

STANCE
Regular

FAVORITE TRICK
Anything she can roll away from

TRICK IN THE WORKS
Being consistent

SKATE DAY FOOD OF CHOICE
Burgers

FAVORITE TIME TO SKATE
Morning

FUN FACT
She's a wife, mother, and grandma but still regularly skates two times a week

"I do what I want."

The three ladies met up at Bellflower Skate Park, and took turns carving transition and motivating each other to be fearless and commit. The camaraderie they found in one another was infectious, and a strong bond was formed. Though they live radically different lives, they speak the universal language of skateboarding. Beaming with pride over her crew, Julie Daniels reflected that "it felt so good to be with girls who were my age, who are skating hard and have more style than most of the kids around." And the feeling is mutual. Amy added: "They're always down to skate. They don't let other people's ideas decide their reality." When this gang of ladies shred together, everything else falls by the wayside.

continued →

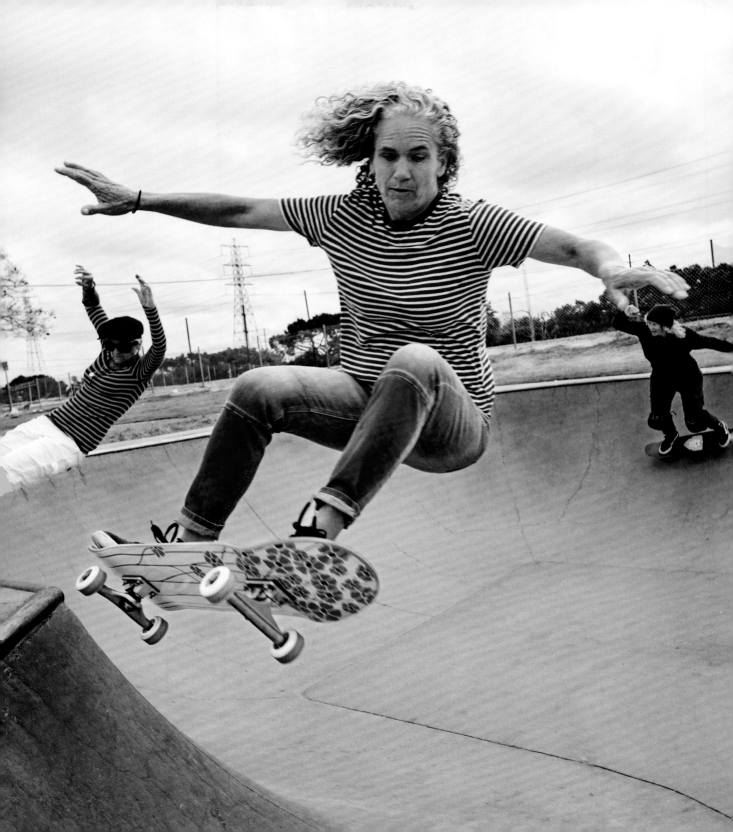

JULIE GOFORTH
SOUL

BORN
Long Beach, California

CURRENT HOME
Long Beach, California

STARTED SKATING
8 years old

FIRST BOARD
Black Knight board with clay wheels

BOARD PREFERENCES
Loose trucks, extra-hard wheels

STANCE
Regular

FAVORITE TRICKS
Carve Grinds and Bertslides

TRICK IN THE WORKS
Frontside 50-50 Grind

SKATE DAY FOOD OF CHOICE
Tacos

FAVORITE TIME TO SKATE
Morning

FUN FACT
In addition to working as a first grade teacher, she's in a band called Stingray Barbie

"Don't quit before the miracle happens."

Julie Daniels has always loved skateboarding, but once she had a family, finding the time and energy to do it was tough. By age fifty-one, life had mellowed out enough for her to occasionally catch a few runs in Venice Beach with her daughter Quinne (see page 70). While skating with Quinne, Julie heard about a woman with "long, flowing silver hair" who skates Venice and could grind coping and air out of the snake run. It became Julie's mission to find and befriend this silver shredder. A year later, Julie spotted and finally had the opportunity to meet the woman, Amy Bradshaw, at an OG Skate Jam. They became fast pals, and Amy was all kinds of inspiring to Julie, encouraging her to enter the contest and getting her to skate, leaving her oozing adrenaline. Meeting someone her own age who also loved to skate was "a game changer," Julie explained. The two exchanged information and made future plans to skate. Amy, already committed to skating at least twice a week, then invited Julie to a skate session with another friend and fellow skater, Julie Goforth.

Axle Nut: The outside nut that secures the wheels to the trucks on the axle.

Axle: The rod located within and extending past the hanger to which the wheels and bearings are attached.

Ball Bearings: The small metal balls within the crown that allow the casing to rotate around them, giving the bearing its motion. (Not pictured.)

Base Plate: The other most important part of the truck, the base plate is the foundation of the truck; it is made up of the kingpin and pivot cup and is what the hardware latches onto.

Bearing Seat: The part of the wheels that holds the bearings centered in position. There is one bearing on either side of the wheel that is placed inside the bearing seat of the wheel.

Bearing Shield: The outer ring or side of the bearing that helps prevent dirt from getting inside the bearings.

Bearings: The bearings are placed in the bearing seat on either side of the wheel and in between the hanger and axle nut to allow the rolling motion of the wheels.

Bushing: Donut-shaped pieces that are inserted onto the kingpin of a truck (two per truck: a top bushing and a bottom bushing). Tightening or loosening the kingpin nut adjusts the ease of turning and the feel of the truck; hard bushings mean stiffer trucks (and less chance of wheel bite), while soft bushings make for easier turning (but increase the risk of wheel bite).

Casing: The disklike metal or steel body that holds the ball bearings, the Delrin crown, and the bearing shield.

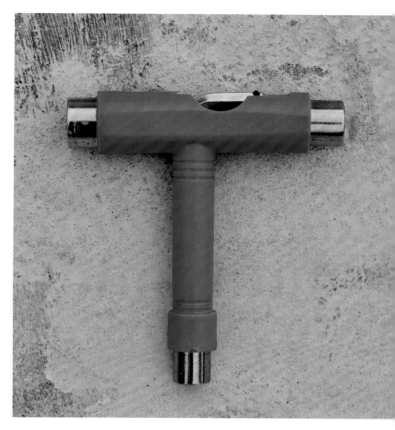

A skate T-Tool

Concave: Describes the curvature of the short side (width) of the deck, arced inward. This gives the rider better control of the board, especially for flip tricks.

Core: The center of the wheels that the bearing will fit into.

Deck (Board): The primary component of a skateboard, which is most commonly made of six to nine (but usually seven) plies of maple wood.

Delrin Crown: The crown is the part that holds and separates the individual ball bearings within the bearing. (Not pictured.)

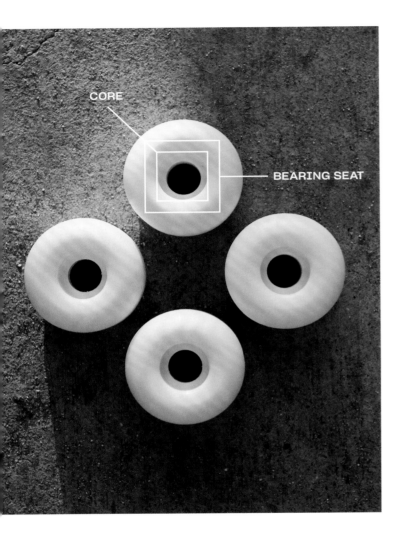

CORE

BEARING SEAT

Grip Tape: A grainy adhesive sheet with a sticky underside that adheres to the top of a deck to provide traction or "grip." (Not pictured.)

Hanger: One of the largest components of the truck, the hanger is the part of the truck that the rider grinds on, resting in the pivot cup and sitting on top of the base plate; it contains the axle, where the wheels are mounted.

Hardware (Nuts and Bolts): The steel rods (eight nuts and eight bolts) that attach the trucks to the deck, holding the board together. There are two types of standard hardware and corresponding tools, regular (also called Phillips) and Allen (also called hex). Regular bolts have indentations on their heads that are the shape of an X, and Allen bolts have indentations in the shape of a hexagon.

Kicktail: Known today as simply the "tail," the kicktail is the angled back-end of a skateboard and it is typically shorter and less steep than the nose and gives the skateboard leverage, allowing for better control and more advanced movements. It was invented by Larry Stevenson in 1968.

Kingpin Nut: The nut on the top of the kingpin that secures and sets the range of motion of the whole truck.

Kingpin: The big bolt in the center of the skateboard truck that holds all the pieces together. When the nut on the kingpin is tightened or loosened, the turning mobility and flex of the truck is affected.

Laminate: The glue used to adhere one ply of a deck to another. (Not pictured.)

Mounting Holes: The two pairs of four holes that bolts are threaded through to secure trucks to a deck. (Not pictured.)

Nose: The raised front end of the deck. On a "popsicle board," the nose typically is slightly longer and steeper than the tail.

Pivot Bushing: The rubber bushing found within the pivot cup.

Pivot Cup: Found within the base plate, the pivot cup is the hole that the hanger sits in.

Ply: A thin sheet of wood used to make a skateboard deck; these come in various weights and degrees of flexibility. Decks are traditionally made of seven pressed plies held together by laminates but can be made of six to nine plies.

Pressure Cracks: These are the small cracks that form on the outermost plies of a deck, originating at the mounting holes as a result of excess and prolonged pressure over the trucks.

Rails: Hard plastic accessories shaped like long skinny rulers that are affixed to the bottom of a board (within the wheel base) toward the outside edges of the deck. They offer better grab and/or a smoother, longer slide. Rails can be applied in a set of two, or with just one rail affixed to one side. (See page 103.)

Risers: The rectangular pieces placed in between the trucks and deck of a skateboard. They can be soft or hard and come in varying depths, allowing for more range of motion with larger wheels, as well as a smoother riding experience on rough ground. The softer rubber will absorb some ground shock. (Not pictured.)

Skate Key (T-Tool): An industry standard for an all-in-one skateboard tool. It consists of a slide-out screwdriver with Allen and Philips heads, as well as three sockets: ⅜" for hardware, ½" for wheels, and 9/16" for trucks.

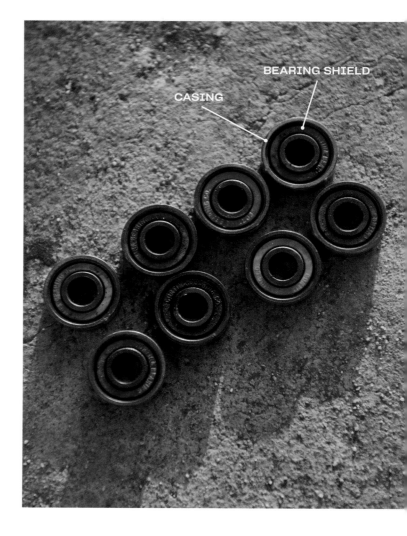

CASING

BEARING SHIELD

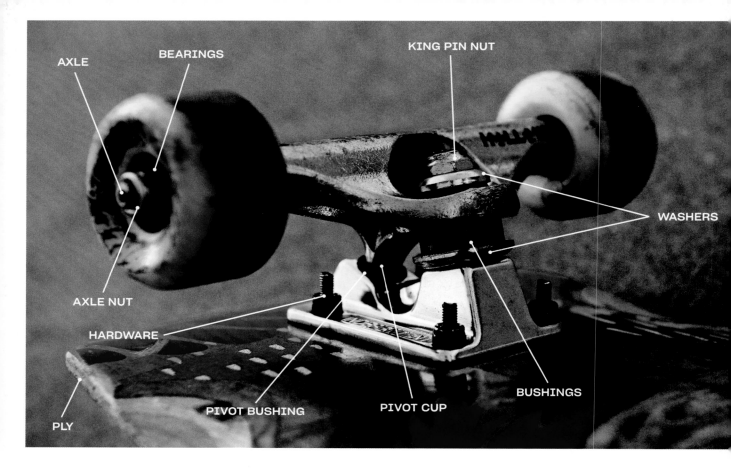

AXLE

BEARINGS

KING PIN NUT

WASHERS

AXLE NUT

HARDWARE

PIVOT BUSHING

PIVOT CUP

BUSHINGS

PLY

Speed Rings: The tiny washers that are placed on the axle in between the bearing and hanger, as well as between the bearing and the axle nut. (Not pictured.)

Trucks: The two metal parts of a skateboard that hold the wheels and bearings. A truck is made up of a base plate, hanger, axle, kingpin, kingpin nut, bushings, axle nuts, pivot cup, and sometimes speed washers.

Washers: The metal disks that sit above the top bushing and below the bottom bushing on the kingpin. They allow for even pressure distribution when the bushings flex with turns and tricks, and they bring the truck back into its neutral position when the pressure is released.

Wheel Base: The distance between the inside mounting holes of the front and back set of trucks.

Wheel Wells: Shaved out sections under the wheels that provide extra turn radius without getting wheel bite. (Not all decks have these).

Wheels: Skateboards have four wheels, which are usually made of polyurethane and come in varying sizes, shapes, and hardness (as specified on the durometer scale, which ranges from 1–100, higher numbers indicating harder wheels).

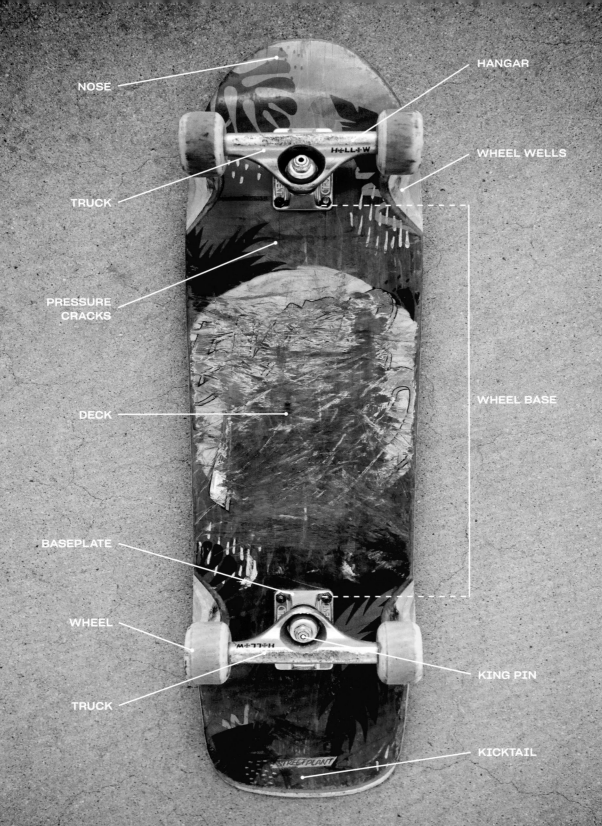

NOSE

HANGAR

WHEEL WELLS

TRUCK

PRESSURE
CRACKS

DECK

WHEEL BASE

BASEPLATE

WHEEL

TRUCK

KING PIN

KICKTAIL

RACHELLE VINBERG

RACHELLE VINBERG

RACHELLE VINBERG

RACHELLE VINBERG

SOUL

BORN
Long Island, New York

CURRENT HOME
Brooklyn, New York

STARTED SKATING
12 years old

FIRST BOARD
Think board

BOARD PREFERENCES
Loose trucks, hard wheels

STANCE
Regular

FAVORITE TRICK
Kickflip

TRICK IN THE WORKS
Impossible

SKATE DAY FOOD OF CHOICE
Oatmeal

FAVORITE TIME TO SKATE
Morning

FUN FACT
When Rachelle was 7 years old, she played football and was the only girl on the team

"Trust the universe."

Rachelle's fascination with skateboarding began when she was an impressionable eleven-going-on-twelve years old, and she would watch her cousin Sebastian push around the local streets. Sebastian loaned her a board and taught her how to Ollie, and Rachelle kicked off into her future as a skater. She studied skate videos on YouTube and joined all the neighborhood skate sessions she could find.

Rachelle didn't see any girls skateboarding, but that was something she was used to, since she grew up playing all types of sports, including football. To her surprise during one of her internet study sessions, she came across some clips of a skater girl, Nina Moran, in New York City. Rachelle reached out to Nina on social media and they began chatting. After realizing how much they had in common, they made a plan to meet up at a House of Vans event. From that point on, Nina and Rachelle were amigos. They would take the train back and forth between Brooklyn and Long Island to meet up and shred, and it wasn't long before they were noticed.

continued →

"Don't skate in a certain way if it doesn't make you feel good; don't go hard to be cool; do what's fun to you . . . skate what you wanna skate, and skate with the people you love."

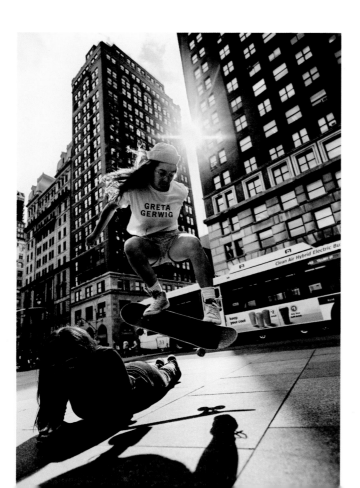

While riding the G train one day, Nina was telling one of her comical stories and happened to be within earshot of filmmaker Crystal Moselle. "Are there more of you?" Crystal asked, stoked by the attitude and style of these female shredders. Although they mainly skated as a duo at that point, Rachelle and Nina knew of other skater girls they could connect with Crystal. Not long after that, Crystal rounded up the girls and produced a short fashion film for Miu Miu entitled *That One Day*, which depicted a day in the life of a skater girl. The film was a hit, inspiring Crystal to expand the concept into her feature-length film *Skate Kitchen*, which was influenced by Rachelle and her crew's relationship with skateboarding, as well as real events from Rachelle's life (including the opening scene where she gets "credit carded"). Rachelle and the other skater girls in the film represent the different styles of skateboarders seen at a skate park, as well as the camaraderie found within the skateboarding community.

Rachelle is a true street skater; she loves to explore the city on her board, but you can still find her practicing lines with friends at skate parks around Brooklyn. And while skateboarding is almost all she thinks about, it's not all she does. In addition to skating and acting, she's exploring her passion for screenwriting.

ZOE HERISHEN

ZOE HERISHEN

ZOE HERISHEN

ZOE HERISHEN

PRO

BORN
Wood-Ridge, New Jersey

CURRENT HOME
Wood-Ridge, New Jersey

STARTED SKATING
5 years old

FIRST BOARD
Leopard print Plan B 8.0" board

BOARD PREFERENCES
Loose trucks, soft wheels

STANCE
Regular

FAVORITE TRICK
Backside Disaster

TRICK IN THE WORKS
Kickflip

SKATE DAY FOOD OF CHOICE
Sushi

FAVORITE TIME TO SKATE
Morning

FUN FACT
Zoe dreams of opening a restaurant on the beach someday

SPONSORS
O'Neill, Heritage Surf & Sport, Sun Bum, Triple 8, Bustin Boards, Rock Star Bearings, Girl is NOT a 4 Letter Word, and Kala Brand Music Co.

When I saw Zoe flying through the pump track in her stylish white overalls, she exuded a positive, infectious energy. It was all big hugs, smiles, and major good vibes when we met.

Zoe looks up to strong women such as her mom Tracey and Michelle Obama, and wants to use her natural leadership skills to build community and get more girls on skateboards. To that end, she founded the all-girls skate jam Chica de Mayo in 2015. It's now an annual event that she hopes to take nationwide. "My goal is to get as many girls as I can into skating and help them learn to love it as much as I do," she said. Zoe stresses that skateboarding is a process that takes time and persistence to master: "Be patient with yourself! Some tricks come easier than others. It may take you a year of trying; but if you quit trying, you will never get it."

Growing up with brothers, Zoe followed their lead. Once they got into skating and surfing, it became her quest to do whatever they were doing—and do it better. Zoe got into longboarding when she was just five years old and starting hitting the skate parks by age eight.

When Zoe isn't skateboarding, she's trying to make the world a better place in any way she can. Every summer, you'll find her on the Jersey Shore, playing ukulele and singing her heart out while collecting donations for the Center for Food Action of New Jersey. She's also a member of her school's student council, serving as an inspiration to her peers.

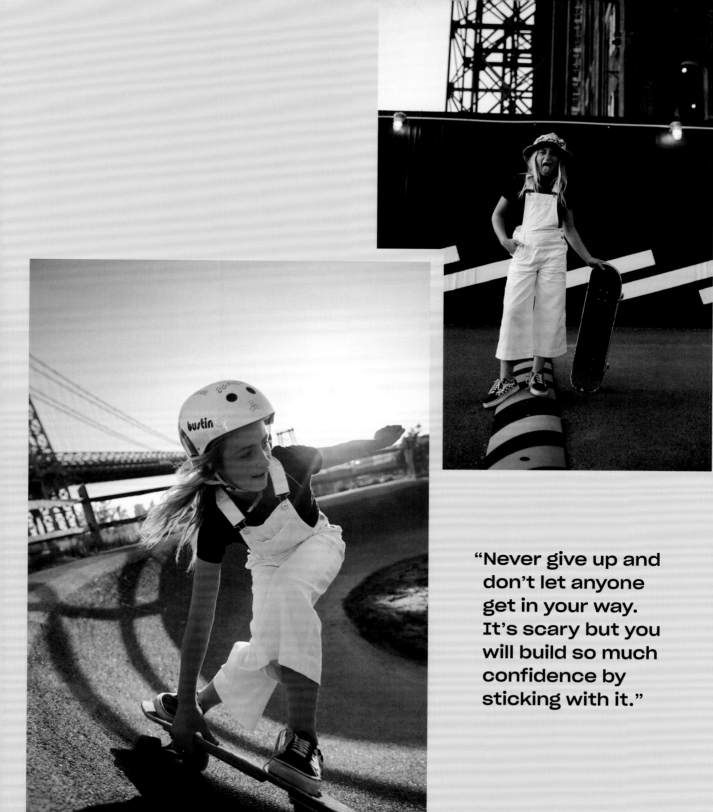

"Never give up and
don't let anyone
get in your way.
It's scary but you
will build so much
confidence by
sticking with it."

FRIEDERIKE VOGL
FRIEDERIKE VOGL
FRIEDERIKE VOGL

FRIEDERIKE VOGL

SOUL

BORN
Rostock, Germany

CURRENT HOME
Rostock, Germany

STARTED SKATING
9 years old

FIRST BOARD
1980s old-school board with rad neon graphics

BOARD PREFERENCES
Independent trucks with soft wheels

STANCE
Goofy

FAVORITE TRICK
Ollie

TRICK IN THE WORKS
180 No Comply

SKATE DAY FOOD OF CHOICE
Bircher muesli

FAVORITE TIME TO SKATE
Morning

FUN FACT
She immediately gets the hiccups after eating raw carrots or fresh bread

In the 1980s, Germany was super different than it is now. The country was still divided, and skateboarding was really only seen in magazines, movies, or on TV. In socialist East Germany, you couldn't just go buy a skateboard, because not only was it not cool, it wasn't actually allowed. Regardless, at nine years old, Freddy fell in love with skateboarding after seeing it in the media. Thankfully, nobody can stop a kid from being creative, and crafty German kids took apart steel roller skates to make their own skateboards, mimicking the boards handmade in the United States in the 1950s and 1960s. Luckily, Freddy had some of these DIY kids on her block, and she would barter with them for time to use their skateboards. She'd relinquish a toy, and in exchange a board was handed over. Then she would spend as much time as the deal allowed cruising the hills, getting a feel for pushing, and teaching herself to Hippie Jump.

When the Berlin Wall came down in 1989 and East and West Germany were reunified, the door opened for new opportunities for people like Freddy. She used her first Deutsche Mark (the currency in West Germany at the time) to order

continued →

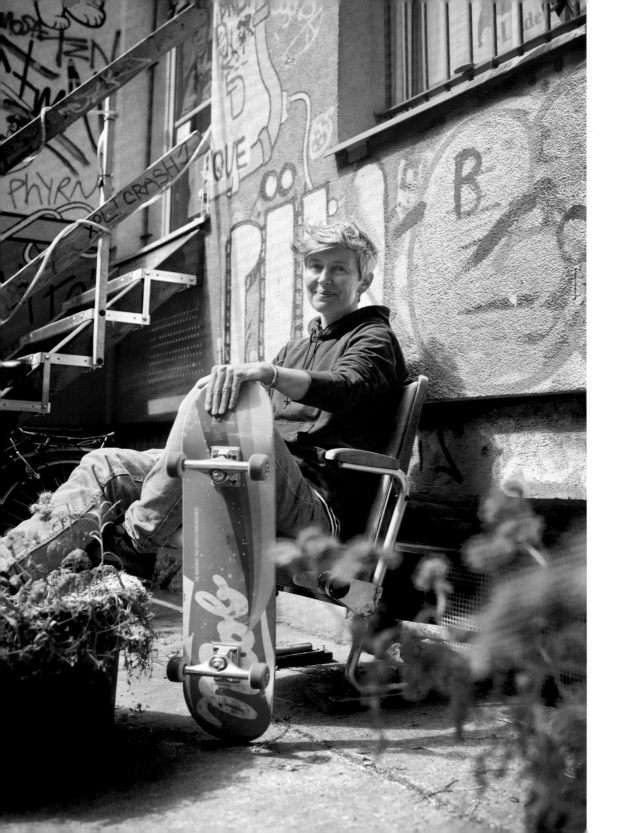

a skateboard from a catalog and waited for what felt like an eternity for it to arrive. The skateboard showed up already assembled, and once the box was open, Freddy hit the streets and headed toward a nearby hill. Without making any adjustments to her board, she went flying down the hill, battling with speed wobbles and eventually slammed into guard poles at the bottom that launched her head over heels. "This is how I learned about the option to adjust your trucks," she admitted. When she made it back home, her clothes destroyed, her Mom wasn't thrilled, but Freddy had officially caught the stoke. She was beaming with excitement.

Many places in Europe are unaccommodating for a skater. The streets are mostly lined with rocks and stone, making it virtually impossible to use skateboarding as a mode of transportation. In Germany, it's often illegal to skate in public places and there are "quiet times," which prevent you from skating in certain neighborhoods during various times of day. But even with all these challenges, Freddy found skateboarding to be her freedom and a constant source of inspiration. In college, she even wrote her thesis on skateboard

"Can't let it get me down."

graphics and has since ventured around the world with her skateboard in tow. Traveling to the United States, she encountered expanses of fresh pavement to skate, further deepening her love of skateboarding.

Skateboarding represents an extension of Freddy's creativity and passion, and she'll often lose herself skating any smooth street she can get her wheels on. A dream of hers is to make it to Hawaii to skate with the island breeze in her silver hair. When she's not making lines on the pavement, she's drawing lines on paper as a graphic designer, often incorporating quirky nods to skateboarding into her work.

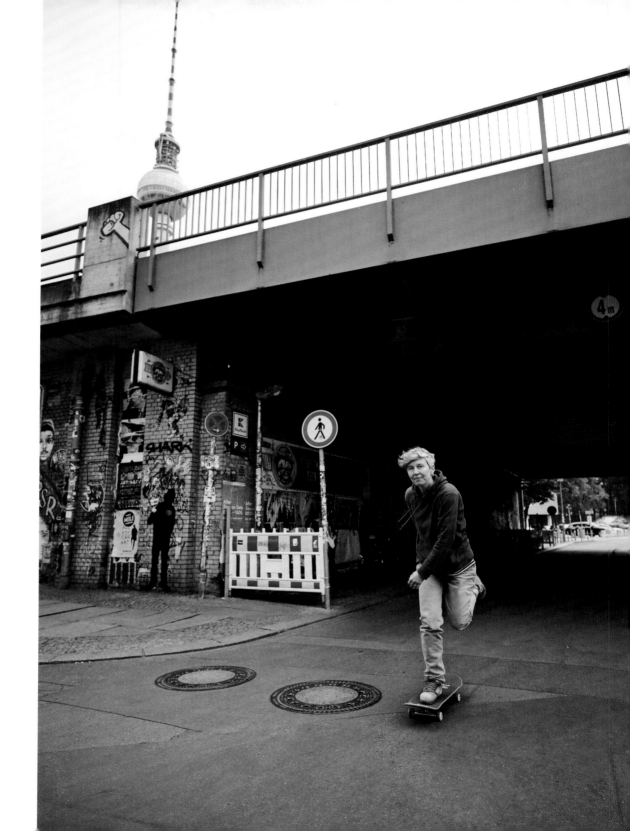

HALSTON VAN ATTA

HALSTON VAN ATTA

HALSTON VAN ATTA

HALSTON VAN ATTA

SOUL

BORN
Los Angeles, California

CURRENT HOME
Beverly Hills, California

STARTED SKATING
9 years old

FIRST BOARD
Haas Brothers XO Barneys New York board

BOARD PREFERENCES
Tight trucks; big, soft wheels

STANCE
Goofy

FAVORITE TRICK
Shove-it

TRICK IN THE WORKS
5-0 Grind

SKATE DAY FOOD OF CHOICE
Anything, because every day is skate day

FAVORITE TIME TO SKATE
Morning

FUN FACT
Halston loves to practice aerial silks

Before Halston discovered skateboarding, her life looked pretty different. She was a competitive dancer, practicing for more than 38 hours a week in addition to schoolwork. Her mom, Melinda, wasn't necessarily thrilled with the lifestyle that came along with being a dancer, but since Halston was interested, she was supportive. One day while out shopping, Melinda randomly picked up a skateboard at a 75-percent-off sale to surprise her daughter. Halston was stoked beyond belief. Soon after, she began taking skateboarding lessons in Venice Beach. It wasn't long before she happily turned away from competitive dance. She now spends her free time skateboarding and taking aerial silk classes.

A notable kismet detail about this turn of events is that Halston's home has an empty indoor pool—a skater's dream! The property has been in her mom's family for generations, and about five years ago, the pool was emptied. Given free reign by her parents, Halston rolls around the concrete wave, working on getting her legs used to the transition of a pool. If she's not skateboarding or working on acrobatics, there is really no telling what she might be up to. Halston is a creative and free spirit with many interests and a laid-back, no-pressure way of living her life. Skateboarding enabled her to roll out of the high-pressure world of competition and just be free.

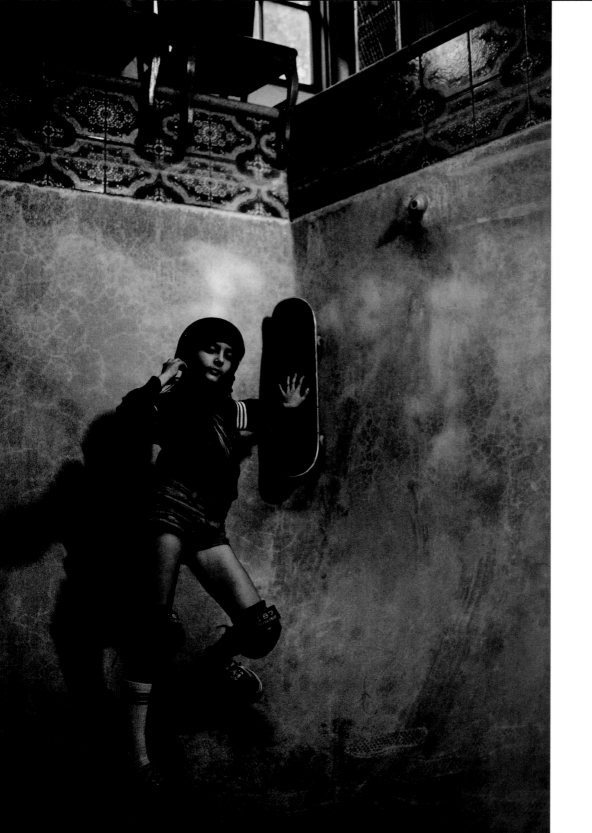

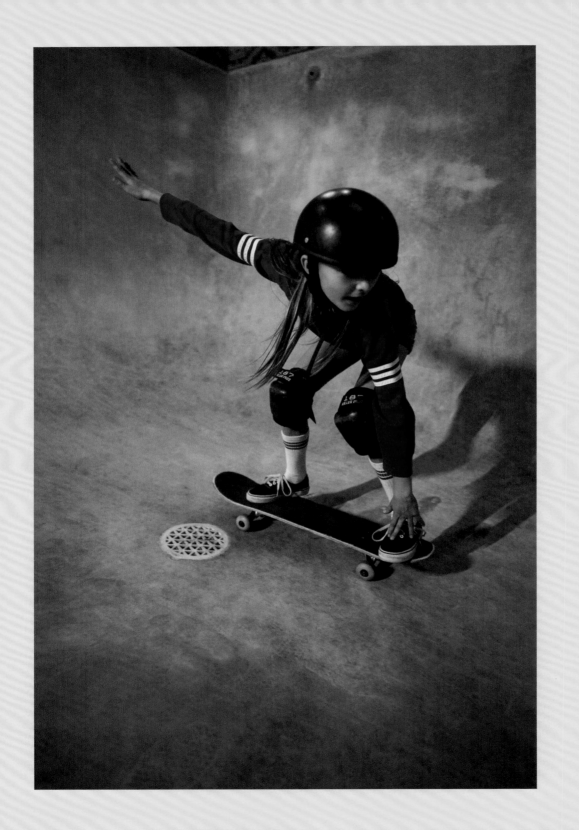

"Just be free. Do what you want.
Your board, your rules."

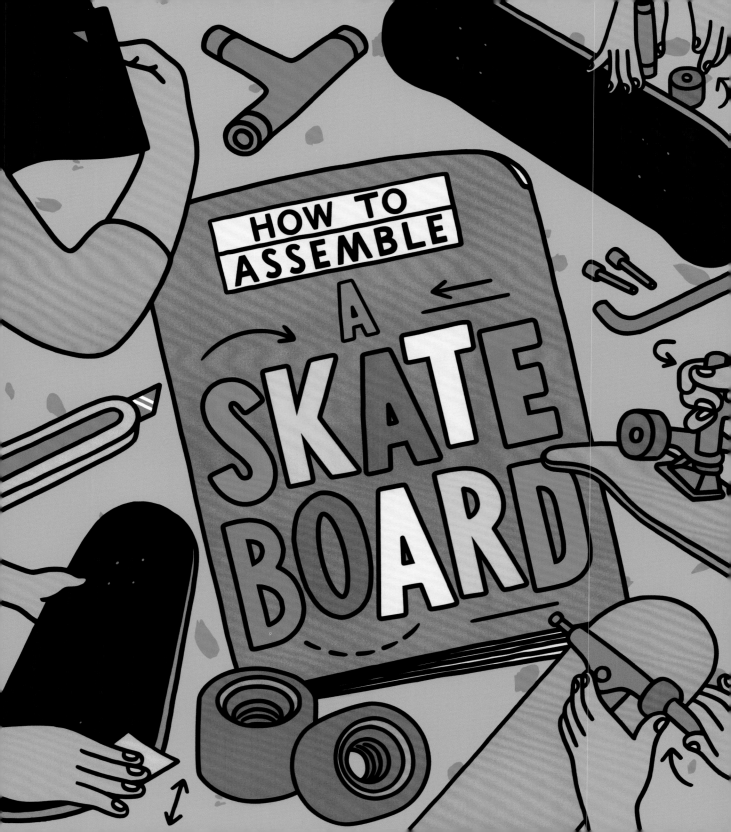

While you can get your board assembled at a skate shop, it's easy and much more satisfying to pick out the parts one by one and do it yourself. Assembling your own board is also a good way to learn more about how a skateboard works. You can adjust it to your preferences and choose specific pieces to reinforce the way you like to ride. If you're just getting started, a good skate shop can show you the different options available and will have all you need to put your new ride together. Then, just be fearless and follow the instructions below, throw in some customization to make it yours, and you'll be set up to shred in no time.

You Will Need

Skateboard deck

Precut sheet of grip tape (typically 9" x 33")

Razor blade

Tool with a blunt end, such as a file or screwdriver

Skate key or T-tool

Hardware: 8 nuts and 8 bolts

Risers (optional)

2 pairs of trucks

Set of 8 bearings

Bearing spacers (optional)

Set of 4 wheels

Speed washers: 2 per wheel, 12 total (optional)

STEP 1: APPLY GRIP TAPE

1 Lay the deck on a flat, stable surface, graphic-side down (nose and tail turning up) and horizontal to your body. Cut the sheet of grip tape into two or more pieces large enough to cover the surface of your deck. It's easier to work with multiple pieces than to put on a full sheet at once (although it is possible).

2 Hover the grip tape above the decking, lining it up for placement; try to leave a little room all the way around the edges of the board (about ½" on an 8.0" size deck). Depending on how big your deck is, you may need to use most of the grip tape, so accurate placement is key.

3 Peel just a little of the tape backing from one end of the tape, then carefully align and stick it to one end of the deck.

4 Once you have that end placed, continue to peel the paper back from the tape while using your other hand to smoothly press it down to the surface of the deck. Make sure to place the tape on straight, and be careful not to create bubbles or creases. Repeat as needed with more grip tape until the deck is covered.

5 Once all your tape is adhered, use a file, a screwdriver, a piece of excess grip tape, or any blunt part of a tool to apply pressure and scrape along the top outside edge of the board. This creates a solid white outline that you will trace with a razor blade to remove the excess tape.

6 Position the deck with the graphic side down and place either the tail or the nose on your lap. Get a solid hold on the board. Then take the razor blade with the sharp end up and poke it through the sticky side of the over-hanging grip tape at the board's edge (face the blade away from yourself whenever possible). Rest the razor against the board and pull it smoothly along the outline you created in step 5. Carefully trace the entire outline with the blade until there is no grip tape hanging over the edges of the board. Use a consistent speed and angle for a seamless cut.

7 Take the file (or excess grip) and use it once again to apply pressure along the outside edge of the grip tape to create the final bond between the grip and the deck.

8 Create the opening for the bolts by taking an Allen wrench or a bolt and gently pushing it through the grip tape covering the bolt holes on the top of the deck with your finger. Use your finger as a cushion on the grip side of the deck for the tool or bolt as you gently wiggle it through, so as not to rip the grip tape or create a bigger hole than necessary.

continued →

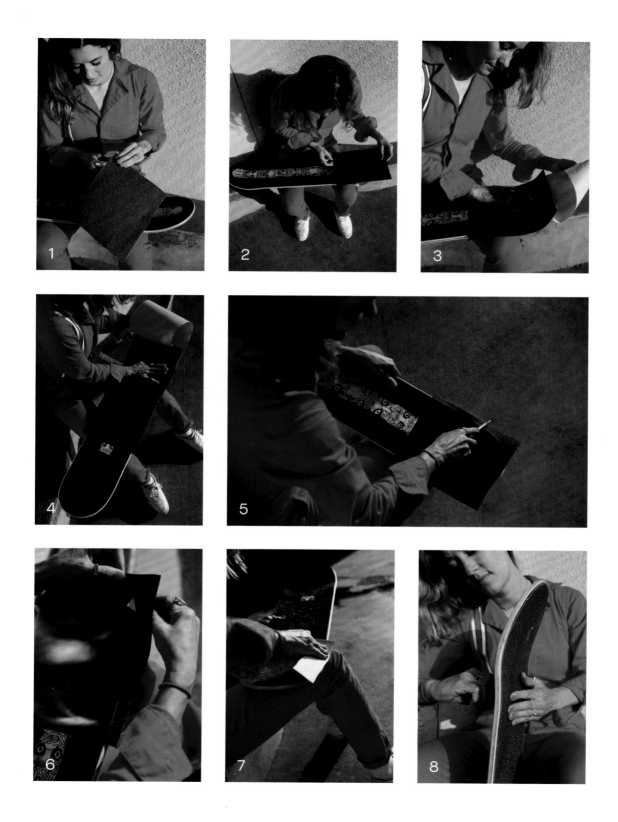

STEP 2: ATTACH THE TRUCKS

9 Hold the board so it is standing upright. Starting at one end of the board, push 4 bolts through the top to the underside of the deck.

10 Place your hand over the bolts on the grip tape–side of the deck to hold them in place, and flip the board over. If using a riser, align it with the bolts now before adding the trucks.

11 With one hand still holding the bolts in place, use your free hand to grab a truck, align its holes with the bolts, and guide the truck into place so it's flush with the board. The smooth end of the truck should be facing the outside edges of the deck and the kingpin should be facing toward the center of the deck.

12 Lightly thread all the nuts to the bolts using your hands.

13 Once attached, use a skate key to secure the truck to the deck. Repeat with the other truck. Hold each bolt in place with the screwdriver or Allen wrench and tighten the nuts using the ⅜-inch socket.

STEP 3: ASSEMBLE BEARINGS AND WHEELS

14 With the board standing upright on its side, place a bearing on the axle or hanger of the truck. If the bearings are exposed on one side, place the covered side down onto the axle; bearing shield should always face outward.

15 Place a wheel on the truck and put your palm over it so it feels level. Press down hard with your body weight. You should feel the bearing snap or slide into place within the bearing seat; it should have no extra room to budge.

16 Remove the wheel and place another bearing covered side down onto the axle of the truck. Add a bearing spacer here, if desired,and press the spacer and bearing into the other bearing seat of the same wheel. Set each wheel aside when done, and repeat with the other three wheels.

continued →

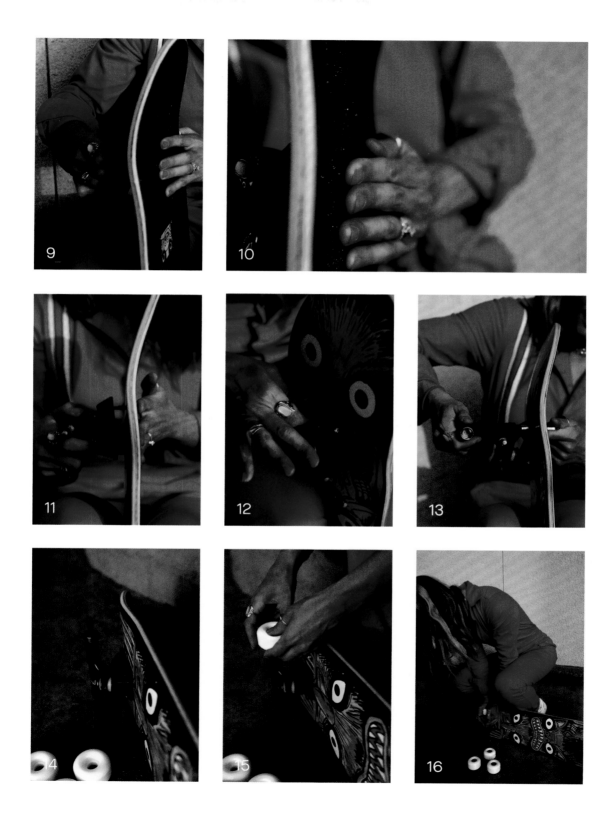

STEP 4: PUT IT ALL TOGETHER AND SET THE RIDE

17　If you have speed washers, grab them now. You will want two per wheel, on the inside and outside of the bearing.

18　Place a speed washer onto the axle, then add a wheel and another speed washer.

19　Finally, add the nut. Use your fingers to attach it and use the ½-inch socket on a skate key to tighten.

20　Using the ⁹⁄₁₆-inch socket on a skate key, adjust your trucks to the feeling you like—loose, tight, or somewhere in between. To further customize your ride, the bushings in your trucks can be switched out for harder or softer ones.

NOTE: If you are using brand new bearings, it's a good idea to "lock them down," which basically means to break them in. To do this, tighten the nut on the axle until it's flush with the bearing (no wiggle room) and take the board for a ride. It won't be as fast, but this will help get the bearings ready. Ride that way for one skate session, then loosen the nuts just enough so they are not flush with the bearing anymore, and you're ready to ride.

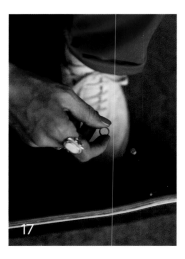

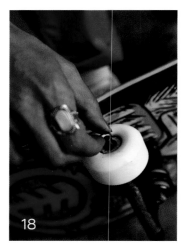

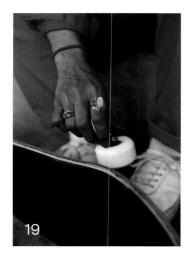

JENNIFER CHARLENE
JENNIFER CHARLENE

JENNIFER CHARLENE

SOUL

BORN
Dallas, Texas

CURRENT HOME
Los Angeles, California

STARTED SKATING
18 years old

FIRST BOARD
Hand-me-down Chocolate board

BOARD PREFERENCES
Hard wheels, hollow trucks

STANCE
Goofy

FAVORITE TRICK
Rock n' Roll

TRICK IN THE WORKS
Nollie 360 Shove-it

SKATE DAY FOOD OF CHOICE
Veggie sandwich with avocado

FAVORITE TIME TO SKATE
Night

FUN FACT
She completed the Royal Academy of Dance curriculum

The first time I saw Jennifer at Bellflower Skatepark, she immediately caught my eye. She was dapper, and she moved definitively but gracefully while Rock n' Rolling with style. Jennifer is a calculated skater—she consistently practices skating in both stances to keep her lines flowing—with an execution that's cool as a cucumber. Even her bails seem choreographed. A classically trained ballet and modern dancer, she is truly light on her feet, balanced, and seems to get better with every skate. But despite her high level of skill, Jennifer doesn't feel pressured to go too hard—she's got a solid bag of tricks and eloquently brings them out when she feels like it.

Fashion is another passion of Jennifer's, and she's all about expressing herself through her clothing, whether she's on or off her skateboard. Her take is that "skateboarding doesn't have a look," and she encourages skaters to feel free to wear what they want. "Skateboarding is so fun, why not make it even more fun and dress up?" She and her friends regularly wrangle together skate-themed editorial photoshoots that feature interesting, deliberately styled outfits. Many of these photos end up in her online magazine, *Apples and Oranges*, which she founded in 2009 as a way to promote skateboarding in a fashionable and artistic way, focusing more on style and passion, rather than tricks and technicalities. She hopes to take it to print someday and share her love of fashion and skateboarding in an effort to empower people of all ages and styles to get out there and enjoy skateboarding.

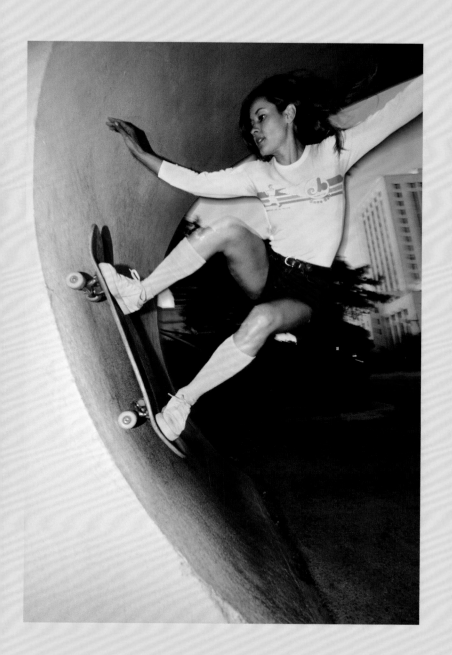

"The best you can do
is good enough."

AMANDA POWELL

AMANDA POWELL

AMANDA POWELL

SOUL

BORN
Boston, Massachusetts

CURRENT HOME
Ventura, California

STARTED SKATING
10 years old

FIRST BOARD
Big brother's hand-me-down board

BOARD PREFERENCES
Loose trucks, soft wheels

STANCE
Goofy

FAVORITE TRICK
Cross-Step Line

TRICK IN THE WORKS
Switch Whirlybirds

SKATE DAY FOOD OF CHOICE
Lavender smoothie

FAVORITE TIME TO SKATE
Night

FUN FACT
Amanda lived out of a van for 1½ years with her husband, Dane, and their Great Dane, Bixby

Amanda is truly mellow, both in life and in skateboarding. You can tell that skating is her form of meditation: she moves in an effortless way, with buttery turns and relaxed posture.

A former professional longboarder, she's been skating for two decades and feels insanely grateful for how she has been able to grow within her practice, and that it's something that's both challenging and relaxing. "In the world of skateboarding, you'll be sure to find your people, belly laughs, and the exact words of encouragement you need. You'll also find your pain tolerance, your breaking point, and strength you didn't know you had."

To Amanda, it was never about landing first place or gaining credibility within the skate community. Skateboarding has always been her creative outlet and how she expresses herself without inhibition or distraction. It's another component of her close relationship with nature and how she connects with the curves of the world.

When she's not skating, Amanda can be found aiming to make the world a better place. She's unmistakably a devoted and upright human. Her heart lies in environmental and social justice, and she's very active within her community. After leaving her professional longboarding career, she went on to follow her other dream of working in digital advocacy for Patagonia, a brand that excels in environmental support. When not working, her spare hours are spent in her garden, living sustainably and growing most of what she consumes herself.

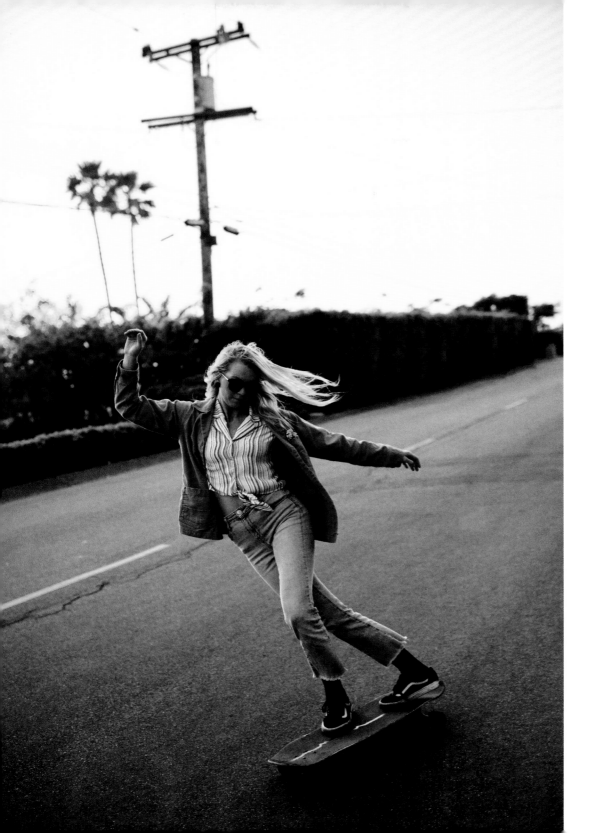

"Gone are the days of skateboarding being a boy's club. It belongs to all of us."

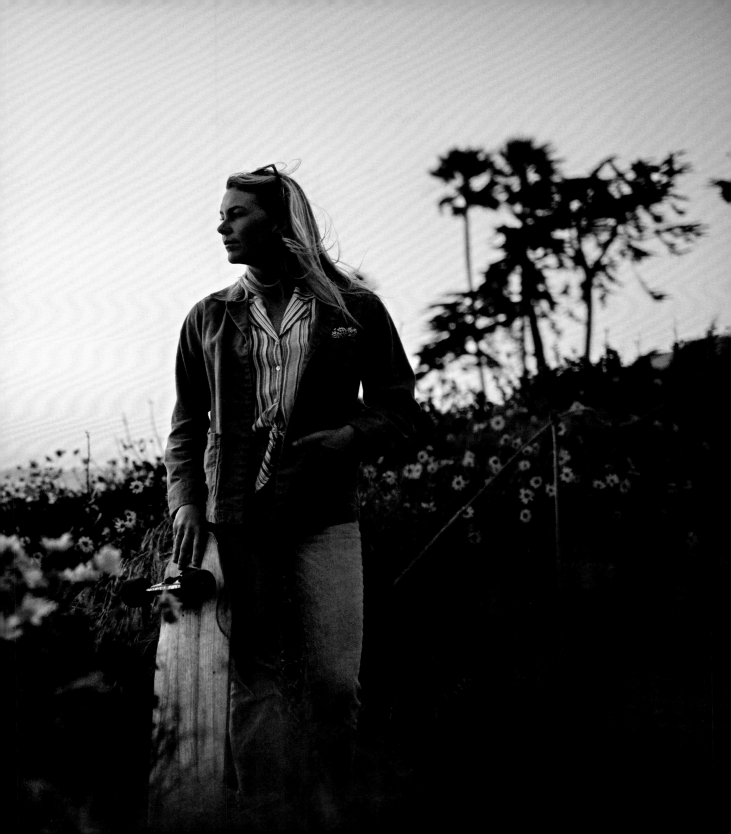

JUDI OYAMA

JUDI OYAMA

JUDI OYAMA

JUDI OYAMA

OG

BORN
Santa Cruz, California

CURRENT HOME
Aptos, California

STARTED SKATING
13 years old

FIRST BOARD
Homemade board her brother made
in woodshop class

BOARD PREFERENCES
Loose trucks, hard wheels

STANCE
Regular

FAVORITE TRICK
Frontside Grind on coping

TRICK IN THE WORKS
Coleman Slide

SKATE DAY FOOD OF CHOICE
Breakfast burrito

FAVORITE TIME TO SKATE
Morning

FUN FACT
As a teen, Judi had horses that she would
sometimes bring into the house without her
parents knowing!

Humble beginnings, legendary standings. Judi started out like many skateboarders: messing around in the driveway on a loaner board. Judi fell in love with skateboarding quickly, but she was living in a boys' world. In the 1970s in Northern California, there were very few girl skateboarders, but this just motivated Judi to prove herself, and so she did. Judi would snake runs and pull off epic lines with a rebel energy that made her notorious among the locals. Within just a few years of consistently flying through her neighborhood, she entered her first slalom competition when she was fifteen. She began with speed wobbles and a crash, but ended the competition with a smile, bloody bandages and all. She placed second, and after the race she was introduced to the owners of Santa Cruz Skateboards, who were super impressed with her guts and skill. Judi rolled away from the race with a sponsorship, and from that point on was a full-fledged pro skater for Santa Cruz Skateboards. She competed in contests up and down California all throughout high school and continuing into college.

Judi enjoyed various styles of skateboarding including vert and street, but she primarily stuck to competing in slalom and downhill. This was mainly because these feats weren't judged subjectively, but with the concrete data of numbers and time. Freestyle, on the other hand, can have a somewhat biased scoring system subject to opinionated judges who may take into consideration things like reputation and wardrobe.

continued →

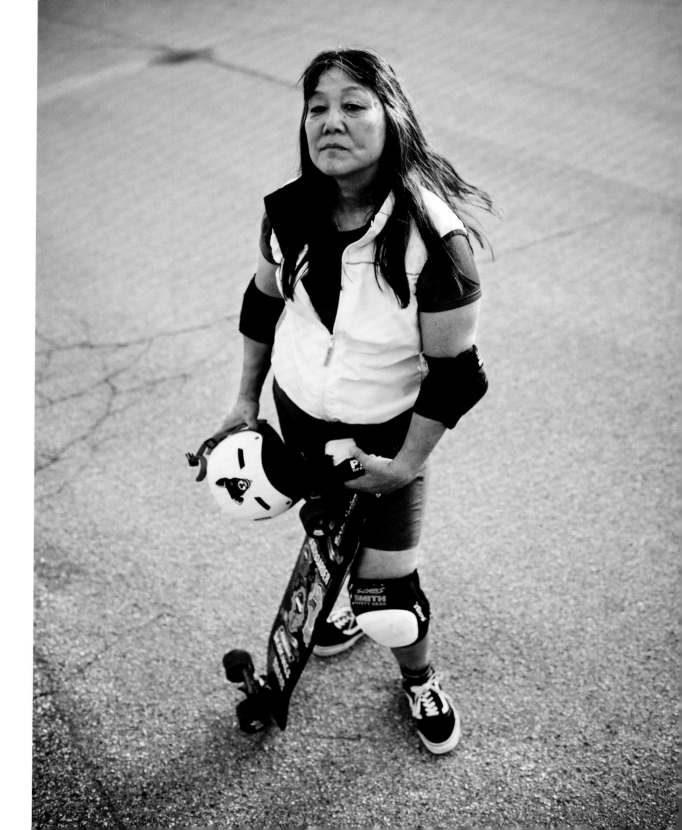

In addition to being an amazing shredder, Judi is also a talented graphic artist. She started off silk screening designs onto Santa Cruz team boards for NHS Inc. After hours, Judi customized board and logo designs for herself, and even created one for Tony Alva. Judi went from skating for Santa Cruz to managing the Santa Cruz surf shop where she created logos for their t-shirts, business cards, stickers, ads, and more. Other business owners including Bob Hurley caught wind of her talents, and before long she was designing ads in *Thrasher* and other magazines. In 1987, Judi launched her own design company, Maximum Impact, which is known for its clean and bold aesthetic. She still operates the business today, designing for all kinds of action sports brands. When she was fifty-three, a local Crossfit gym had her design their new logos, and Judi became a Crossfit fanatic. She's a regular in her local gym today and is constantly pushing herself to get stronger.

Nearly fifty years after she first touched a skateboard, she's still going hard. She won the 2003 Slalom World Championships at the age of forty-three and was ranked second overall at slalom in the United States in 2013. In 2015, Judi also became the first woman to win an N-Men Icon Award, an honor given to Northern California skaters who have made an impact on history. To add to her list of accomplishments, Judi was also inducted into the Skateboarding Hall of Fame in 2018, and a helmet of hers is in the Smithsonian.

Always wanting to give back to the skateboarding community, Judi spends her time as the vice president of Board Rescue, which provides skateboards and safety equipment to organizations that work with underprivileged and at-risk kids. She also runs her own clothing company called BadAss SkateMom, which sponsors skaters. Needless to say, Judi is insanely busy, astronomically talented, and one of the coolest, most down-to-earth people you'll ever meet.

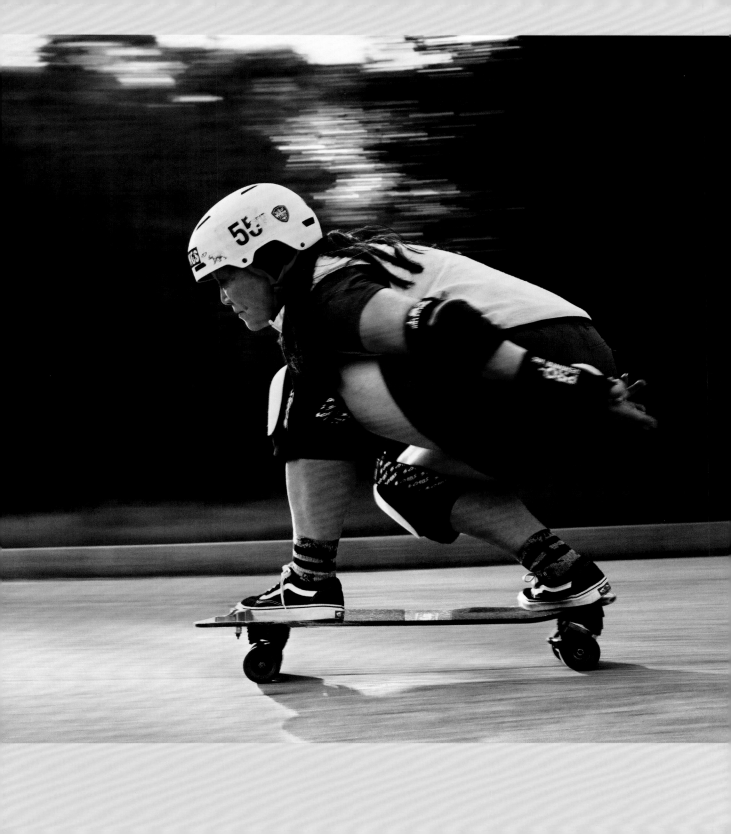

"Just because I'm getting older, doesn't mean I ever have to stop skateboarding."

QUINNE DANIELS

QUINNE DANIELS

QUINNE DANIELS

QUINNE DANIELS

SOUL

BORN
Los Angeles, California

CURRENT HOME
Los Angeles, California

STARTED SKATING
7 years old

FIRST BOARD
Skatedogs board

BOARD PREFERENCES
Loose trucks, hard wheels

STANCE
Goofy

FAVORITE TRICK
Frontside 50-50

TRICK IN THE WORKS
Disaster

SKATE DAY FOOD OF CHOICE
Pizza

FAVORITE TIME TO SKATE
Night

FUN FACT
If granted one wish, she would "pet *all* the dogs"

To this young ripper, skateboarding means getting creative with the world around her and fostering a personal connection to the otherwise mundane. It means making something out of nothing, like a simple curb or a parking block.

Quinne was seven when spring break took her in a totally new direction: Soccer camp was full, so her mom, Julie (see page 27), signed her up for skateboard camp. Within the first day, not only was she comfortably pushing around, but she had learned to drop in. Three hours later, Quinne had her mom film her fearlessly practicing everything she learned. Her progress was uncanny, and from that day forward, she was officially a skateboarder.

When Quinne's not blasting the snake run at her home park in Venice Beach, you'll probably find her roller skating, jumping wall to wall doing parkour, and, more often than not, hanging out with her friends.

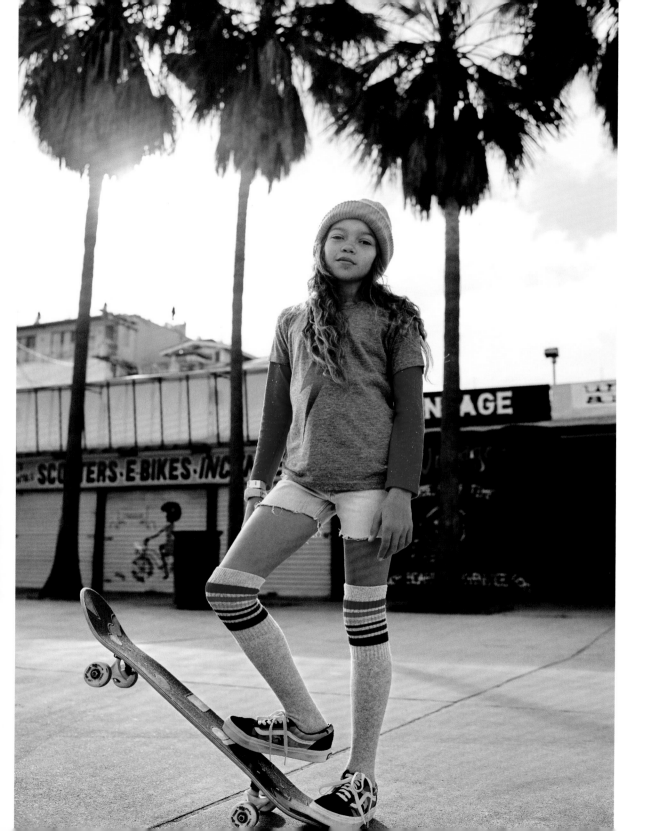

"Skateboarding means meeting friends and becoming one with the Earth."

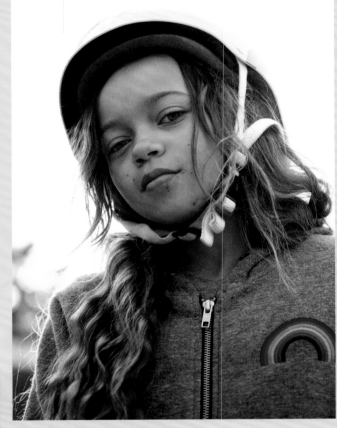

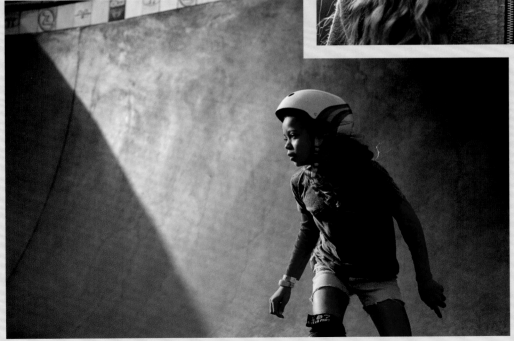

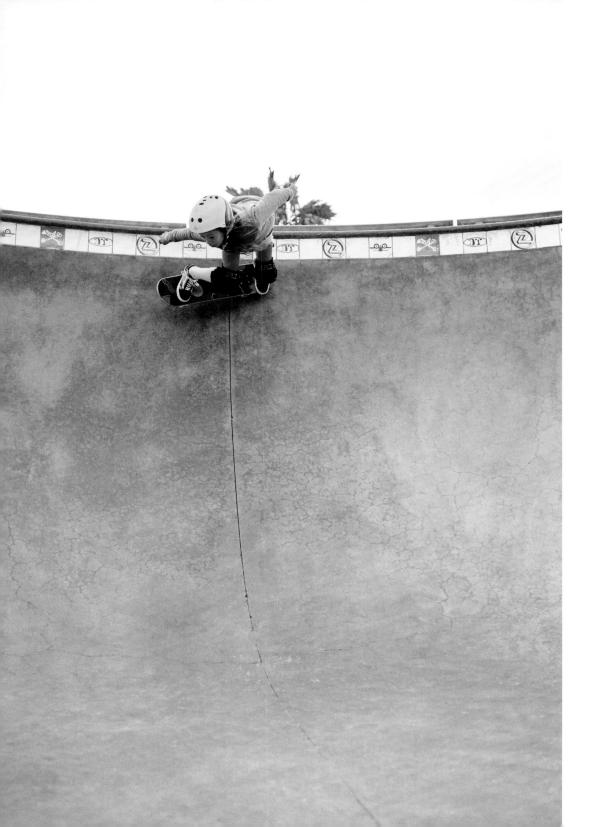

SHELBY FRAME

SHELBY FRAME

SHELBY FRAME

SOUL

BORN
Las Vegas, Nevada

CURRENT HOME
Santa Cruz, California

STARTED SKATING
8 years old

FIRST BOARD
Cheap random board with plastic trucks

BOARD PREFERENCES
Big boards with loose trucks

STANCE
Regular

FAVORITE TRICKS
360 Powerslide and 5-0 Grind in a bowl

TRICK IN THE WORKS
Teaching her daughter, Charlie, to skate

SKATE DAY FOOD OF CHOICE
Burger and a soda

FAVORITE TIME TO SKATE
Anytime

FUN FACT
Before she had met her husband, she saw a photo of him skating her local ditch, and she said to herself, "I will marry that man." And then she did!

When Shelby began skateboarding in the 1990s, skate parks were pretty much nowhere to be found. She grew up in Las Vegas, skating drainage ditches with the boys, stoked on the ruggedness and quiet privacy. She kept skating into adulthood, and after she and her husband, Taylor, moved from Brooklyn to Santa Cruz, surfing became their obsession. For Shelby, skating and surfing have become one and the same, always shredding transition like it's a set of waves.

Now that she has kids, most of her time is spent with the family, which includes teaching her oldest, Charlie, the basics of skateboarding. I had the opportunity to photograph and skate with Shelby when she was eight months pregnant, and then again exactly two months postpartum. Even with a bun in the oven, she was agile on her board. I could see her wanting to push it, but she was understandably careful. The second time we got together, after she'd given birth, she dropped back into a bowl for the first time in years. Her surfy style was immediately evident as she slashed all over as though no time had passed. "Skating is a huge part of my identity," Shelby said. "It raised me and was all I ever wanted to do. It has always been a part of my life, and I am so stoked to be raising my daughter and baby boy to have that same sense of adventure on a skateboard."

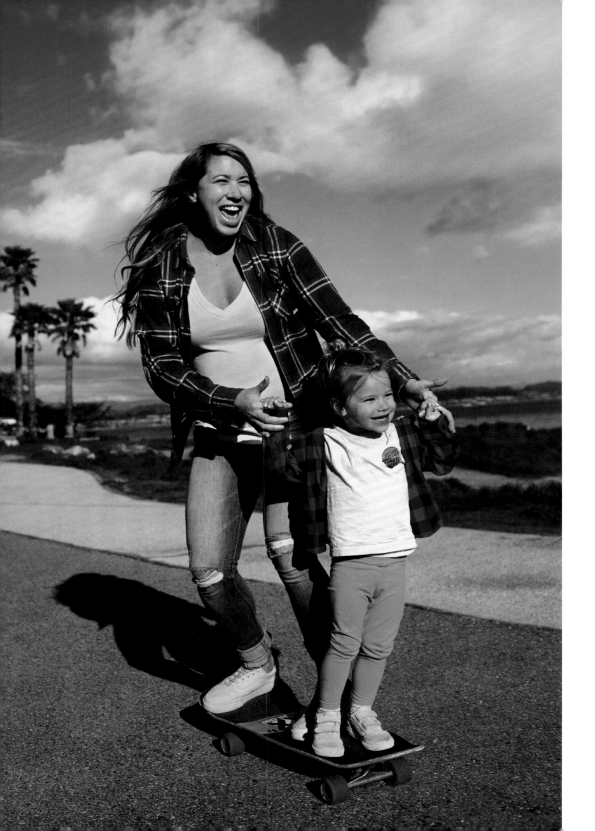

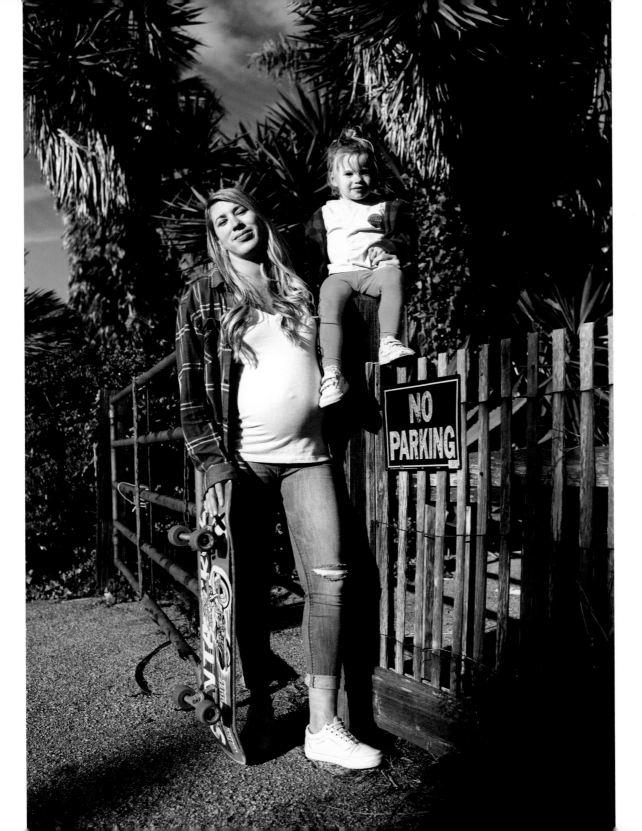

"Go faster."

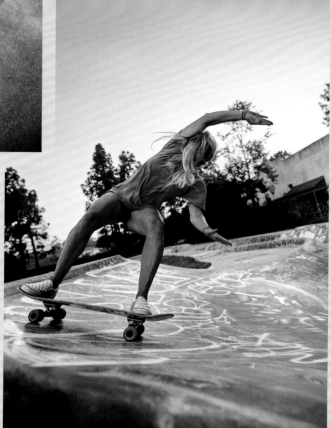

SKATEBOARD
HISTORY

THE
1950s
AND
1960s

Skateboarding was born in Southern California in the 1950s and 1960s, nurtured by the beaches, the weather, and the postwar youth culture. The sport had its origins in the 1888 invention of the roller skate. Kids would take the wheels off their skates and attach them to wooden fruit crates to make scooters. The crate scooters were difficult to turn and steer, so they eventually broke off the tops and handles to make an early version of what we know today as the skateboard. The first generation of skateboarders were just curious kids—teens and young adults—who picked up the sport as something to do when they couldn't surf. Although they were mostly guys, there were some intrepid girls who got in on the action, too. They were pioneers, with no skating role models to look up to, but they enjoyed endless freedom to explore, innovate, and try new things. From its earliest days, skateboarding was hated by parents and other adults, including folks in the media, but that didn't stop it from exploding in popularity to become a bona fide cultural wave. It has held strong ever since, though there have been ups—short-lived bursts of innovation and euphoria—as well as downs. The 1960s, in particular, was a decade of booming popularity and major innovation.

1959

The Roller Derby #10, the world's first commercially produced skateboard, was released. It was a piece of solid wood with metal roller skate wheels attached. It sold for $12.95 (about $80 today) in department stores nationwide, making the skateboard as common as the hula hoop.

Early 1960s

The Roller Derby Deluxe #20 was introduced. It featured clay wheels with internal ball bearings, which became the new standard. Bushings in the trucks made for a smoother ride and better maneuverability.

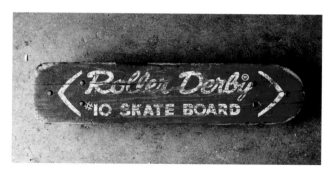

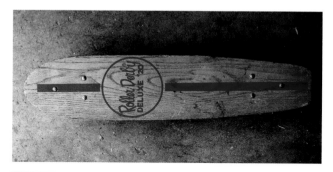

Roller Derby #10

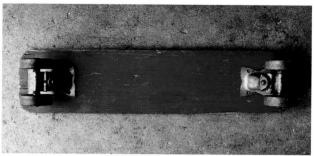

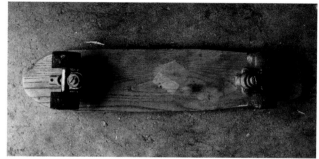

Roller Derby Deluxe #20

79

1962

Val Surf, the world's first skateboard shop, was opened in North Hollywood, California, by surfer and former record producer Bill Richard and his sons, Kurt and Mark. Val Surf remains the oldest board sports shop to this day.

1963

Makaha Skateboards released the first ever pro skateboard, which was made for iconic pro surfer Phil Edwards. By the end of that year, the company was selling ten thousand skateboards a day. These boards sold for $10 to $13, which would be about $80 to $110 today.

1964

The first issue of the *Quarterly Skateboarder* was released. It featured Dave Hilton "jumping the bar" (what was later called the Hippie Jump) on the cover. Shortly after, skateboarding fell into a slump due to bad publicity revolving around injury and safety concerns, and the magazine went on hiatus until 1974.

At Dick Clark's World Teen Fair in Orange County, California, Patti McGee set the record for fastest female skater, with a downhill recorded at 47 miles per hour. Given the limitations of the equipment at the time (clay wheels and ball bearings), this was an incredible feat.

60s era-specific wall of boards, Skateboarding Hall of Fame

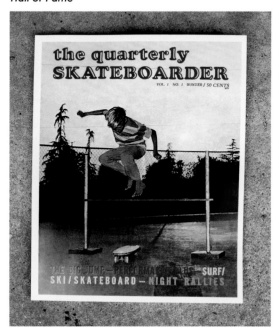

The Quarterly Skateboarder, *Vol. 1 No. 1*

1965

The cover of the May 14 issue of *LIFE* magazine featured Patti McGee doing a handstand on her board and ran the story "The Craze and the Menace of Skateboards." McGee was the first skateboarder to land the cover of a major magazine, which was exciting, but ultimately this issue of *LIFE* helped fuel the public narrative that skating was dangerous. The article concluded that "it's easier to get bloody than to get fancy."

Skateboarding went into its first cultural decline. Skating-related injuries received mainstream media attention, board innovation stalled, many skate parks closed, and skating was banned in many cities. Boards remained largely unchanged for the rest of the decade.

1966

The California-based shoe company Vans was cofounded by brothers Paul and James Van Doren. Vans would go on to be the world's longest-running skateboard brand and an icon of skateboarding fashion.

1969

The kicktail was invented by Larry Stevenson (founder of Makaha), providing a whole new way to skate. The board was designed with an angled back end that added leverage and allowed riders to execute more advanced movements.

Makaha complete with a kicktail

BRIEL WEINGARTNER

BRIEL WEINGARTNER

BRIEL WEINGARTNER

PRO

BORN
Carson, California

CURRENT HOME
Hawthorne, California

STARTED SKATING
4 years old

FIRST BOARD
Darkstar board

BOARD PREFERENCES
Loose trucks, hard wheels

STANCE
Goofy

FAVORITE TRICKS
Kickflips and catching air

TRICK IN THE WORKS
Frontside Smith Grind

SKATE DAY FOOD OF CHOICE
Anything Mexican

FAVORITE TIME TO SKATE
Morning

FUN FACT
She just conquered the Backside Flip

SPONSORS
Grizzly Griptape, Silly Girl Skateboards, Rastaclat, Spyder Board Shop, Girl is NOT a 4 Letter Word

The youngest in a family of boys, Briel is one tough shredder. And though she may come across as soft-spoken and sweet, when she hits the park, she radiates tenacity, always challenging herself to work on new moves and tricks. She charges hard, pumps with power, and launches herself into the air fearlessly. She thrives on speed and fun music, while pushing along with the inner mantra of "I won't give up!" and always making sure to congratulate herself out loud on every make, exclaiming, "I did it!"

To Briel, skateboarding is pure fun. The skate park is where she gets to spend time with her close friends, like Stella Reynolds (see page 86), as well as make new ones. On most days you'll find her at the park working on new tricks. When she's not skating, she spends her time making art, doodling all over a blank canvas and turning it into a colorful world of her own.

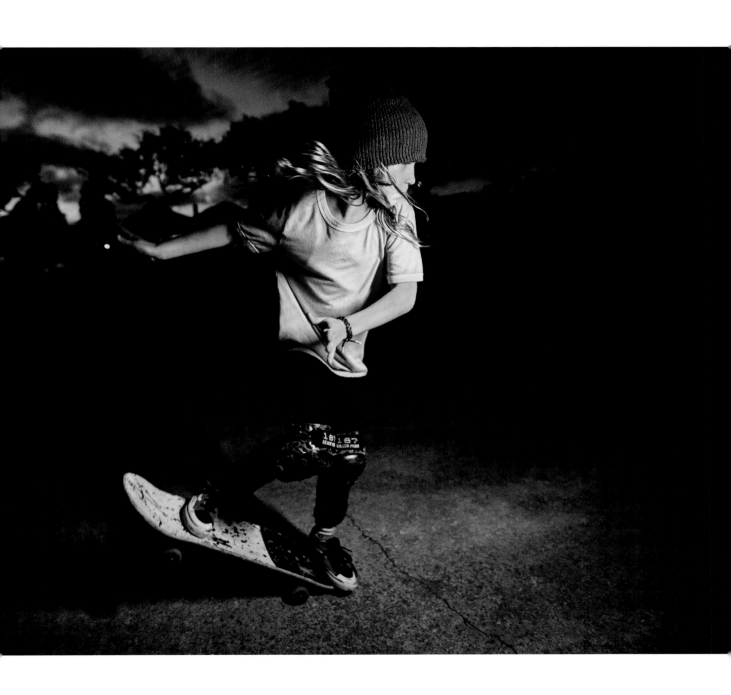

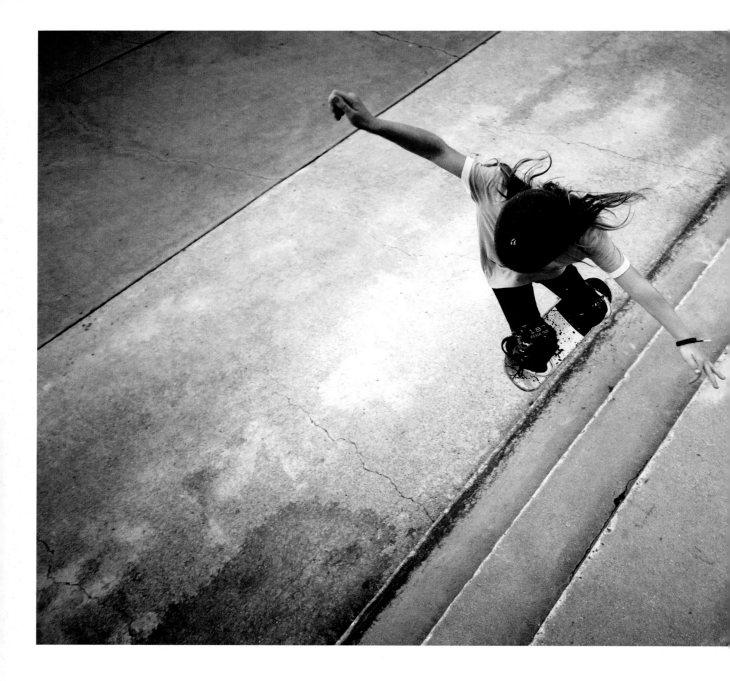

"I won't give up."

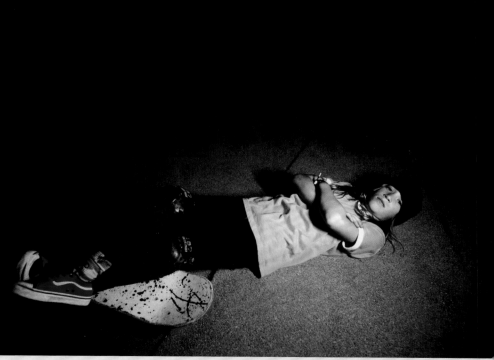

STELLA REYNOLDS
STELLA REYNOLDS

STELLA REYNOLDS

SOUL

BORN
Los Angeles, California

CURRENT HOME
Los Angeles, California

STARTED SKATING
9 years old

FIRST BOARD
Anti Hero Eagle board

BOARD PREFERENCES
Tight trucks, hard wheels

STANCE
Regular

FAVORITE TRICKS
Lipslide or Hurricane

TRICK IN THE WORKS
Kickflip Indy

SKATE DAY FOOD OF CHOICE
Anything Brazilian

FAVORITE TIME TO SKATE
Night

FUN FACT
She paints just about every day

SPONSORS
Spitfire, Volcom, Adidas Skateboarding, Real Skateboards, Val Surf

Stella learned to skateboard from the best—her dad, Andrew Reynolds, is an OG skater known as "The Boss," a household name in the skate community. His influence on his daughter's skate skills is unmistakable when you see her insane pop and powerful flick. Although their physical resemblance is clear, Stella has a skate style all her own. Andrew is a true street skater, where Stella additionally took interest in transition, looking up to legends like Lance Mountain who tear up a bowl. Albeit focused on performance and consistency, Stella exudes pure joy when she's on her board. She skates until she's hungry, breaks to refuel, and then goes right back to skating—a true skateboarder to the core.

Only recently have we seen pro skateboarders raising families, and although Stella is descended from skateboarding royalty, she's never felt any pressure to follow in her father's footsteps. "Stella can already do things I can't do," Andrew says of his daughter, having a blast watching her take her own route within their shared passion. She shreds for the fun of it and because it's what occupies her mind. "I just want to land a Kickflip Indy," she says, homing in on the necessary steps to achieve that goal, asking for tips, and then taking her stab at it. She's living in the present, nothing more. Her advice to anyone learning new tricks is, "Start on something small and work your way up. You're gonna fall no matter what, so just accept it."

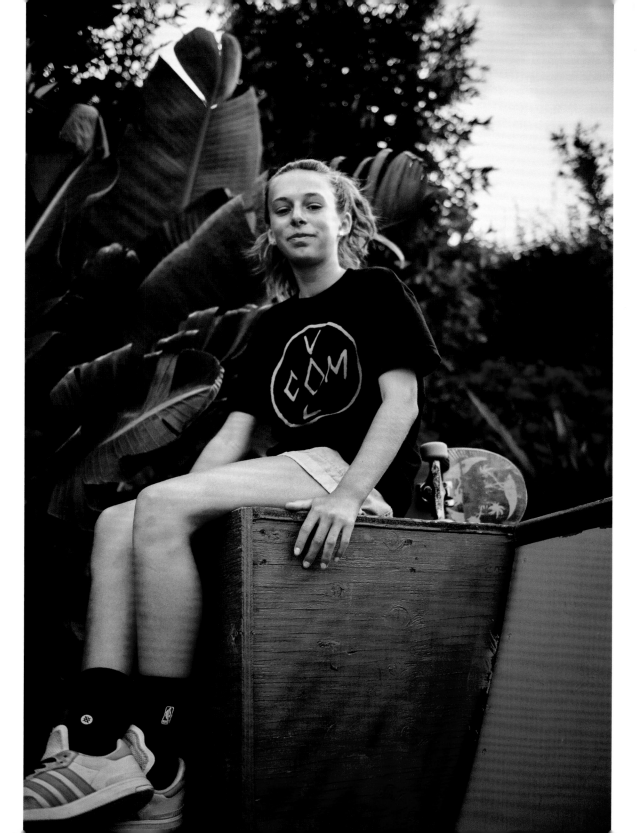

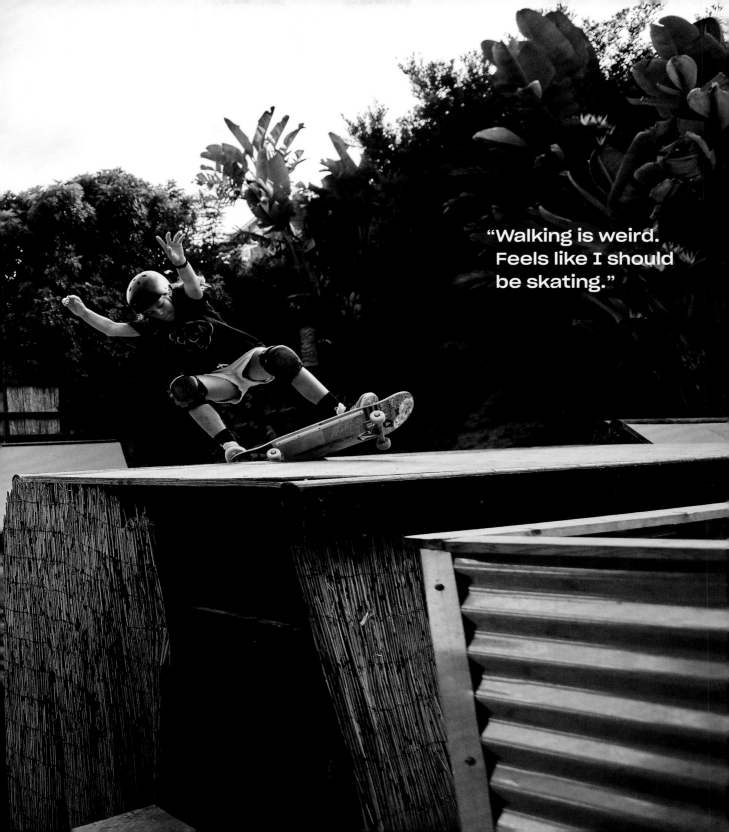

"Walking is weird. Feels like I should be skating."

CALLEIGH LITTLE

CALLEIGH LITTLE

CALLEIGH LITTLE

PRO

BORN
Boston, Massachusetts

CURRENT HOME
Vancouver, Washington

STARTED SKATING
12 years old

FIRST BOARD
Shorty's board

BOARD PREFERENCES
Loose trucks, big and soft wheels

STANCE
Goofy

FAVORITE TRICK
Skate long distances uninterrupted

TRICK IN THE WORKS
Farthest distance traveled in a 24-hour
period via skateboard

SKATE DAY FOOD OF CHOICE
Anything with calories and carbohydrates
to keep her energized

FAVORITE TIME TO SKATE
Morning

FUN FACT
She uses only her dominant push leg
(goofy), while other competitors switch
between legs for prolonged stamina

"Mind your own biscuits and life could be gravy."

Skate pro Calleigh Little used to be all about down-hill skating. But since she retired from the downhill circuit, she uses her ride for a whole new type of shredding: long distance pushing (LDP). A highly athletic (and some would say extreme) type of longboarding, LDP is considered the marathon running of skateboarding, requiring a ton of endurance as well as special gear. Her board is called the "G Bomb." It is set up with a fixed back truck (known as a torsion tail) and an adjustable front truck to apply a preferred turn flex, allowing for a highly customizable ride. Both trucks have built-in shocks, too. Stemming from 1970s slalom board designs, LDP boards are built for speed and consistency, which are exactly what Calleigh needs to dominate as an LDP skater.

continued →

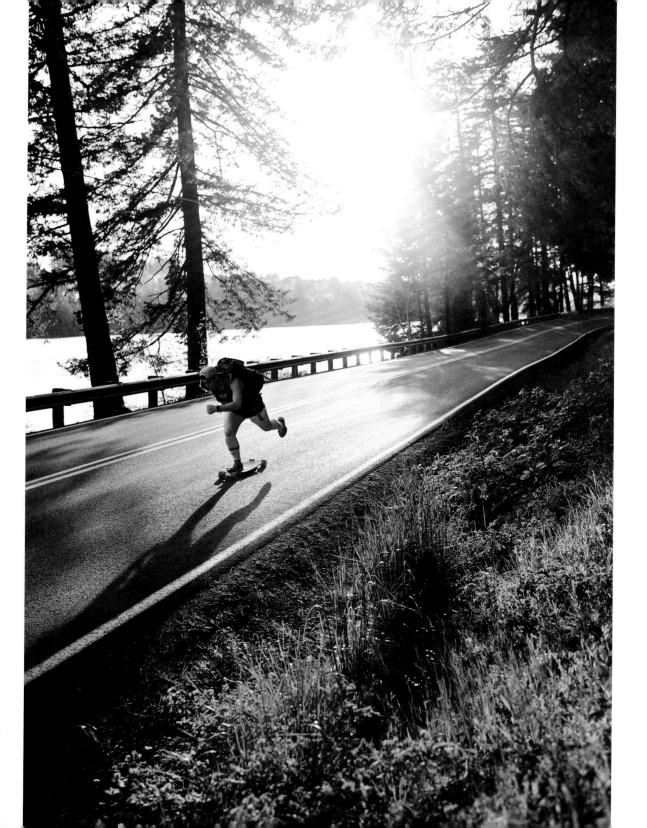

> **"Skateboarding is the vehicle that takes me where I need to be in life, goals, hopes, and dreams. It's the only thing I've really ever given myself to 100 percent."**

Her talent for LDP was discovered by Joe Mazzone, who, not long after meeting Calleigh, sponsored her to enter her first contest, Ultra Skate, in 2019. His hunch turned out to be right, and she took first place. Ultra Skate is a wild feat—a 24-hour uninterrupted long-distance skate. Calleigh really enjoyed LDP, and it was clear that she had a knack for it, so she continued to train and enter as many contests as she could. Winning soon became normal, so her focus changed from simply winning to breaking records—her own records. As of this writing, Calleigh holds the third-place world record for longest distance traveled in 24 hours: 251 miles. She missed second place by just 1 mile, and her goal is to hit 300 miles in 24 hours.

In addition to skateboarding, she's working on conquering one of her biggest fears—water—by training to kayak down the Mississippi River from Minnesota to Mississippi. When she's not pushing herself to accomplish her next big physical challenge, Calleigh keeps busy designing websites and working in graphic design.

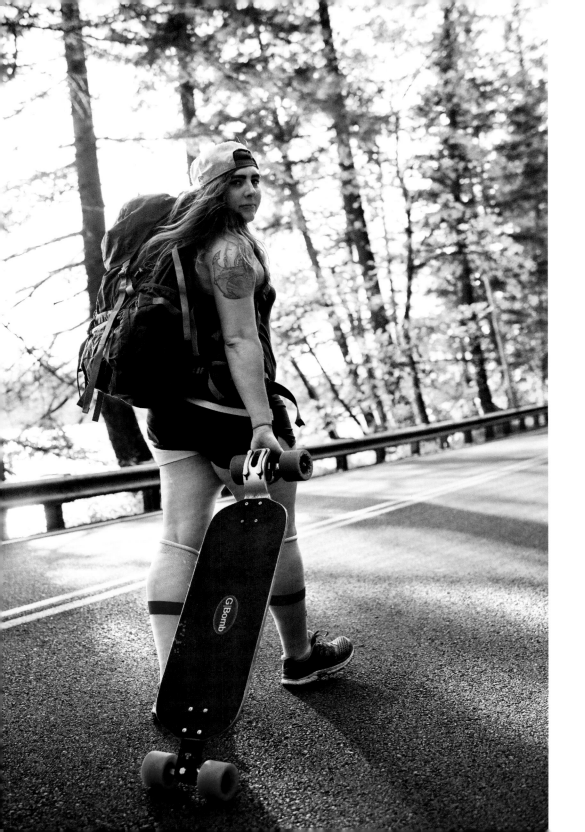

LYDIA & MARISSA MAE MARTINEZ
LYDIA & MARISSA MAE MARTINEZ
LYDIA & MARISSA MAE MARTINEZ

LYDIA & MARISSA MAE MARTINEZ

MARISSA MARTINEZ
SOUL

BORN
Encinitas, California

CURRENT HOME
Los Angeles, California

STARTED SKATING
15 years old

FIRST BOARD
Bam Margera Element

BOARD PREFERENCES
Loose trucks, hard wheels

STANCE
Regular

FAVORITE TRICK
360 Flip

TRICK IN THE WORKS
Bigspin

SKATE DAY FOOD OF CHOICE
Fruit

FAVORITE TIME TO SKATE
Anytime

FUN FACT
Filmed a full-length street part in 2012 for the brand BeerTrash

SPONSORS
Meow Skateboards, New Balance, Transitions Inc. Skate Shop

"Live in the meow."

Watching them skate together is inspiring, and you can totally feel their supportive energy, especially when one of them shouts out, "You got this, Sis!" When the two shred together, it's a skateboard caravan, the pair flowing around one another with a graceful synchronicity. Another cool thing about watching them skate together is that Marissa skates regular and Lydia skates goofy, allowing their movements to mimic each other, like a real-life mirror.

In addition to being sisters and skateboard buddies, Marissa and Lydia are also business partners. Back in 2016, Marissa found herself searching for comfortable pants to shred in and discovered that most skate clothing for women just wasn't doing the trick. So she took matters into her own hands and worked up a design that met her needs. And so Mamaskate was founded. The brand started off with "ready for adventure" pants that are durable and comfortable and have deep pockets. It has since grown to include multiple colors of pants and shorts that can be worn by ladies and dudes alike! The Martinez sisters run Mamaskate full time and

continued →

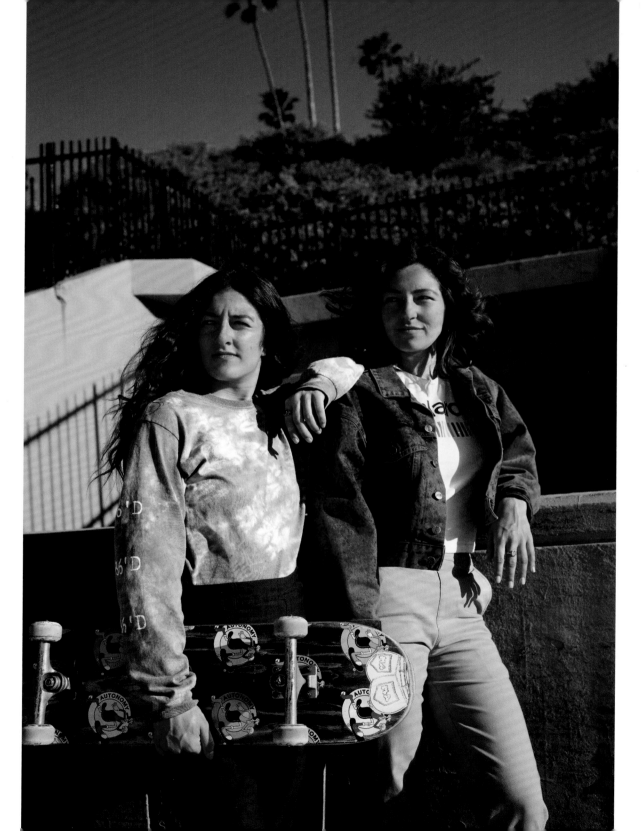

LYDIA MAE MARTINEZ
SOUL

BORN
Claremont, New Hampshire

CURRENT HOME
Long Beach, California

STARTED SKATING
9 years old

FIRST BOARD
Hand-me-down from big sis

BOARD PREFERENCES
Loose trucks, hard wheels

STANCE
Goofy

FAVORITE TRICK
Switch Pop Shove-it

TRICK IN THE WORKS
Heelflip

SKATE DAY FOOD OF CHOICE
Anything vegan

FAVORITE TIME TO SKATE
Anytime

FUN FACT
Lydia bends her knees until she is basically sitting on her board for optimum pop

SPONSORS
Mamaskate, WAS WATCH, Transitions Inc. Skate Shop

also get the opportunity to work together on lots of other jobs, such as commercials and music videos, allowing them to travel the world with each other and their skateboards.

Despite the age difference of seven and a half years, Marissa and Lydia have a close sibling relationship that makes them operate more like best friends. If it weren't for Marissa, along with their cousin Cassie, Lydia might not be skateboarding today, and if it weren't for skateboarding, the duo definitely wouldn't be as close as they are. Big sis supplied the board and know-how, teaching young Lydia the basics and showing her the value of watching skate videos to get a better sense of how to handle herself on a board. Before Lydia had been introduced to skateboarding, she was roller skating, then in-line skating her way around, but Marissa saw a different future for her. Marissa and Cassie, then fifteen and sixteen years old, taught nine-year-old Lydia and the other groms in the family how to mob the streets and make their way around Veterans Sports Complex skate park in Carson, California. The two would skate with their all-female family pack, spending days and nights practicing, often being followed around by local boys who were fascinated by the girl gang. Since then, skateboarding has consistently been their shared passion and a huge part of their close family bond.

"You can go anywhere in the world and have something in common with people who don't speak the same language as you, just because you both skateboard."

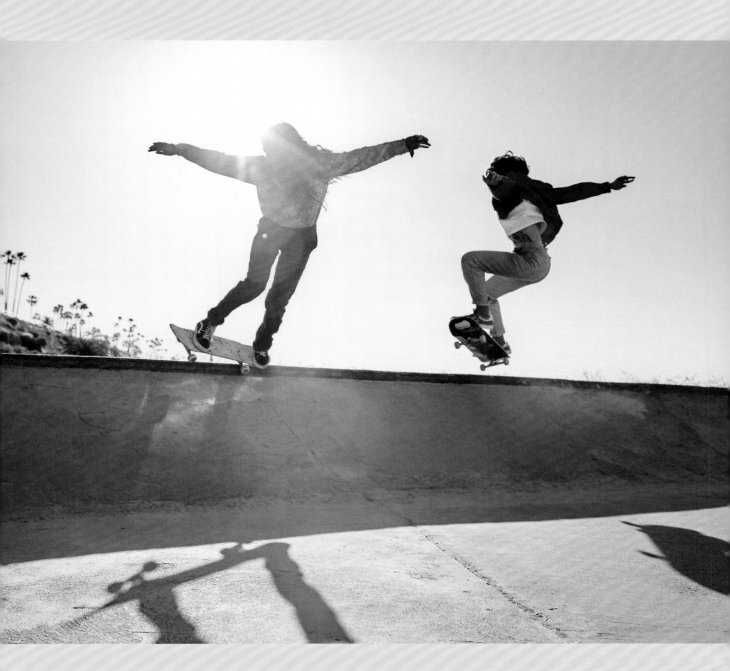

The 1970s marked a significant time in skateboard history that saw exponential progress in innovation and cultural leaps forward. After the media-fueled injury scare of the 1960s, engineers were thirsty for improvement. In 1972, Frank Nasworthy invented the instantly popular urethane wheel, which made skating much more consistent, comfortable, and safe. Mike Rector brought skate-specific safety gear to the market, making helmets and pads standard. With safety gear like knee pads, skaters had more options, such as "bailing" by sliding down ramps on their knees.

Slalom and downhill skating grew in popularity in the 1970s, with skaters adopting techniques from professional skiers who would skateboard to keep in shape and practice moves during the off season. A wide range of new board styles also hit the market in the 1970s—from the super-thin, no-grip fiberglass Bahne pro board to the solid wood Banzai board—which helped boost the popularity of the sport. In the 1970s, board design began to implement the kicktail, which, while rarely given credit, is partially to thank for the skating boom of the era.

Freed up by improved equipment, riders were able to experiment more; before long the primitive "gorilla grip" morphed into the "no hands air" when Alan "Ollie" Gelfund invented the trick we know as the Ollie today. At the time, the Ollie was considered so advanced that people regularly stole Gelfund's shoes, assuming they were Velcro-lined or had some kind of special power.

With skating at the height of its popularity, the first skate parks were born. By the end of the decade, aerials had taken flight, riders were grinding, and handplants were assumed. And slowly but surely, skate parks began to be seen as a positive thing outside the skate community, because they gave kids a place to go, thus keeping them out of trouble and off the streets. The popularity and abundance of skate parks was responsible for more and more girls getting into

the sport, since the parks were safe and welcoming places to learn. The 1970s also gave rise to the legendary and aggressive skate style of the Zephyr Competition Team (Z-Boys), launching skateboarders into stardom, putting them on TV, in films, and on newsstands everywhere, exposing a wider audience to skateboarding.

But, unfortunately, despite its meteoric cultural rise in the 1970s, skateboarding fell back into a slump by the end of the decade due to increased zoning restrictions and liability insurance claims. The skate parks that had briefly boomed were closed, and skateboarding went underground, becoming a more hard-core and angry culture as dejected skaters fled to the empty backyard pools of drought-ridden Southern California. With no skate parks to frequent, many girls stopped skating, and by the end of the decade, skateboarding had become a strongly male subculture.

Early 1970s

Bahne pro board was made up of super thin fiberglass with roller-skate trucks, ball bearings, no grip tape, and a shiny bottom.

———

Solid wood Banzai boards (commonly oak or teak) were made with an additional glued-on kicktail, taking the design from Makaha. The boards had improved trucks with two sets of bushings and ball bearings.

1972

Urethane wheels, called "Cadillac Wheels," were invented by Frank Nasworthy, who designed them specifically for skateboarding in his backyard shop. Although highly advanced at the time, they didn't take off right away, so Frank ended up giving away a ton of them to skate shops for free to get them out there. Soon enough, people caught on to their improved performance, and kids were

coming from all over to Southern California to buy them. Frank hinted at the future of skate parks when he said, "Man was meant to swim in the water, surf in the waves, ski in snow, and skateboard in the streets. And if you don't want them on the street, then build a place where they can go." By 1975, Frank had sold three hundred thousand sets of Cadillac Wheels.

Title IX of the Education Amendments outlawed discrimination based on gender in all educational or recreational programs that receive federal funding, which was a huge turning point for getting more girls into sports.

1974

Cadillac Wheels teamed up with Bahne to be the wheels that came standard on all Bahne pre-assembled skateboards (also called completes) along with Chicago Steel Trucks. This partnership ended up selling what some recall as ten million completes a year during the first couple years.

Peggy Oki joined the Zephyr team (Dogtown and Z-Boys), becoming the first and only girl member of the short-lived skate team phenomenon.

1975

At The Bahne-Cadillac National Championships in Del Mar, California, the Zephyr's Z-Boys blew the skateboarding world away with an aggressive riding style made possible by the capabilities of urethane wheels.

Bahne complete with Cadillac wheels and Chicago trucks

In Orange Country, California, Ron Bennett debuted a new truck style made specifically for skateboarding: the Bennett Pros, which included a kingpin surrounded by a rubber compound, allowing for smoother turns and a reliable pivot.

The second rise of skateboarding began, and most skate teams began welcoming women riders.

The Quarterly Skateboarder magazine from the 60s returned as *SkateBoarder* magazine, a Surfer publication, due to the resurgence of popularity following the introduction of the urethane wheel. The first issue, *SkateBoarder* Vol. 2 No. 1, featured Greg Weaver carving a backyard pool on the cover. Helmed by editor-in-chief Warren Bolster and storyteller Craig R. Stecyk III, the magazine brought skateboard culture back to the cultural forefront with its full-color glossy photos capturing era-defining moments. *SkateBoarder* was the fastest-growing magazine on the newsstand of its time, surpassing *People*. It ran until 2013.

Skateboard-related sales hit an astonishing $250 million annually, with an estimated 2 million skateboarders in California alone and more than 10 million across the United States.

The Road Rider wheel was introduced. Created in Rhode Island by Tony Roderick of MPC (Mearthane Products Corporation) and manufactured by Quality Products, Inc., this was the first wheel with sealed precision bearings, which boasted a 20 percent faster and smoother ride and was also more dirt-resistant than previous models.

Tracker Trucks introduced the skateboard truck as we know it today. Tracker Trucks had a baseplate with the four-hole pattern, a stationary kingpin, and a 4¼-inch wide axle, which was nearly double the width of the roller skate–derived models. This new design, coupled with new wheel technology, made an array of new tricks possible.

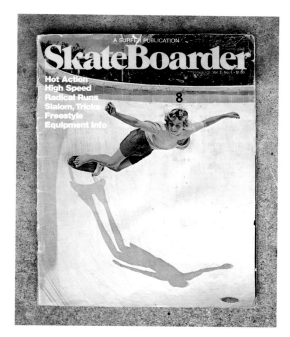

Skateboarder Magazine, *Vol. 2 No 1*

Tracker trucks on a G&S with a tail skid plate

1976

Widespread drought in Southern California left many of the public and private pools empty. The era of backyard pool riding began, and skaters innovated as they mastered skating this new shape, creating aerials, inverts, and grinds. Meanwhile, innovation within freestyle skateboarding on flatland also grew, with spins, handstands, and other gymnast-inspired moves.

As skate parks became increasingly common and popular, cities looked for a way to limit their legal liability and keep riders safe. Helmets and pads—including kneepads, elbow pads, wrist guards, and sometimes even gloves—were made mandatory in most United States skate parks, and photos of skaters could not be published unless they were wearing full gear. As a result, fashion at the parks reached new levels, with skaters color-coordinating their outfits with their protective gear.

The world's first concrete skate park, Skate City, was built in Port Orange, Florida. Soon after (arguably simultaneously) California's first skate park, Carlsbad Skatepark, was built in Carlsbad, and opened by John O'Malley and Jack Graham. Then the Concrete Wave in Anaheim, California, was opened. After that, roughly thirty to fifty parks were built in the coming few years.

1977

The first ever Ollie was invented by fifteen-year-old Alan "Ollie" Gelfand in Fort Lauderdale, Florida. Gelfand referred to this accidental epiphany as a "no hands air," made possible by throwing his board toward his back foot and popping his tail off the lip frontside. He turned this accident into his go-to trick and ended up touring the world with the Bones Brigade.

Kona Skatepark opened in Jacksonville, Florida. After briefly going bankrupt, Kona was reopened in 1979 by the Ramos family and has gone on to be the longest surviving, privately owned skate park in the world.

The G&S Warptail II was released and endorsed by Stacy Peralta. The model featured laminated maple plywood, Tracker trucks, Kryptonic wheels, grip tape, no concave, and a kicktail. Its 2½-inch hole pattern was notably larger than the smaller roller-skate setup.

Tony Alva landed the first-ever documented aerial in a backyard pool.

Skateboard sales hit $400 million annually, with more than 20 million people in the United States participating in the sport.

G&S Warptail II

1978

Paul "the Professor" Schmitt of PS Stix designed wooden rails, which could be affixed to the bottom of a skateboard to assist with grabs.

Mike Rector patented the Rector Kneeguard, a knee pad with a hard plastic shell for skatepark use. These pads made it possible for a skater to more safely dismount (bail) mid-air, fall to their knees, and slide down the smooth concrete. He also patented the first skateboard-specific glove.

Vicki Vickers was one of the only women competing in the men's category, performing handplants and catching air; she became one of the first female athletes to earn equal pay and privileges as men. She was an outspoken female athlete crusading for "equal pay for equal skate."

Kanoa Surf Shops released the first skateboard helmets designed for skaters, not hockey players. The helmet was Jay Adams's signature model called the Flyaway; it featured an aerodynamic design and sleek stripes down the side.

The number of people skateboarding in the United States doubled to forty million, and skateboard sales hit $650 million annually. Consequently, there are 325,000 skateboard-related injuries.

Plastic rails by PS Stix, a step up from wood design

Independent Truck Company released the Stage 1 truck, which represented a more aggressive, punk culture look that countered the clean, progressive look of Tracker Trucks in Southern California. Founded in San Francisco, California, by Richard Novak, Jay Shiurman, Fausto Vitello, and Eric Swenson, Independent first came to prominence in downhill racing and slalom for its unmatched turn ability. It has since come to represent being "built to grind" as the world's top-selling skate hardware brand.

Starring Tony Alva and Leif Garrett, *Skateboard: The Movie* was released by Universal Pictures as the first major motion picture made entirely about skateboarding.

MELISSA SULLIVAN

MELISSA SULLIVAN

MELISSA SULLIVAN

SOUL

BORN
Columbus, Ohio

CURRENT HOME
Santa Cruz, California

STARTED SKATING
17 years old

FIRST BOARD
Santa Cruz's Corey O'Brien Reaper

BOARD PREFERENCES
Loose trucks, bigger wheels

STANCE
Regular

FAVORITE TRICK
Frontside Air

TRICKS IN THE WORKS
Frontside/Backside Disasters

SKATE DAY FOOD OF CHOICE
Burritos

FAVORITE TIME TO SKATE
Morning

FUN FACT
Reggae is Melissa's tune of choice

SPONSORS
Ace Trucks Mfg., Santa Cruz Lady Lurkers,
BadAss SkateMom

Melissa belongs to a radical group of women in Santa Cruz called the Santa Cruz Lady Lurkers. When time allows, she skates with these passionate ladies wherever the road takes them. They aren't a hardcore crew that's about pushing limits; rather, they skateboard for the pure joy of it, to be with their friends, and to keep learning new things. Founded back in 2013, the Santa Cruz Lady Lurkers frequent parks together and have built a buzz around their escapades. They use social media to connect with other skaters, sharing their progress, and showing off just how much fun skateboarding can be.

Catching air at the skate park is something Melissa loves to do, but it's not all she does. Most of her time is taken up by being a mom and a registered nurse, happily taking care of other people. An adventurous spirit, when she gets a chance to relax, she always tries to fit in some skateboarding, surfing, snowboarding, or rock climbing. To Melissa, skateboarding will always represent her ticket to freedom and a place where she can just be herself and have fun.

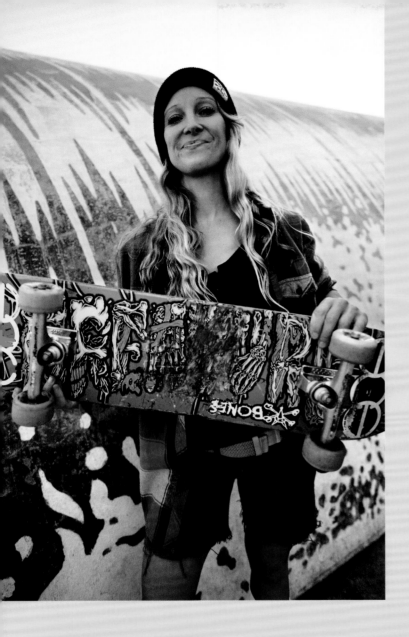

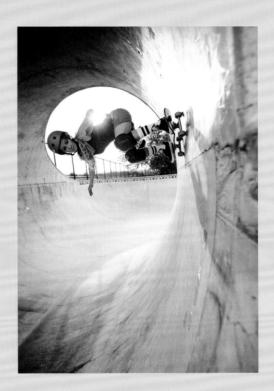

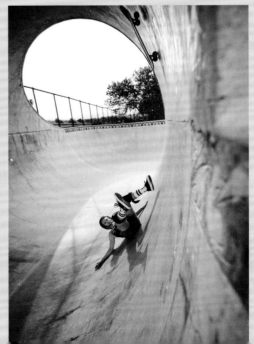

"There is no way to happiness; happiness is the way."

LENA SALMI
LENA SALMI
LENA SALMI

LENA SALMI

SOUL

BORN
Helsinki, Finland

CURRENT HOME
Helsinki, Finland

STARTED SKATING
61 years old

FIRST BOARD
Kadja-Nilla by Tikari Skateboards

BOARD PREFERENCES
Loose trucks, hard wheels

STANCE
Regular

FAVORITE TRICK
Nose Stall

TRICK IN THE WORKS
Dropping in on higher and higher ramps

SKATE DAY FOOD OF CHOICE
Ice cream

FAVORITE TIME TO SKATE
Morning

FUN FACT
She eats ice cream with berries
every morning

Retired sports journalist and media researcher Lena spends most of her time in action, whether she's swimming, playing ice hockey, making graffiti art, or skateboarding. She was first introduced to longboarding at the age of sixty-one and was instantly hooked. But when she began frequenting skate parks, she noticed that there weren't many other skaters her age. Feeling motivated to create a safe place for people like herself, she assembled a private skate group called the Early Skate Birds (ESB).

The ESB members offer support and advice to each other, have skate meetups, and go to skateboarding-related events together. The group inspired Lena to take it one step further, leading her to found Very Old Skateboarders (VOS), an online resource for new skaters picking up the sport later in life. The group quickly gained recognition and became an online phenomenon, inspiring people of all ages to pick up a skateboard. VOS has since grown to include longboarders and changed its name to Very Old Skateboarders and Longboarders (VOSL), but it still continues to be a place where older novice skaters share experiences, ask questions, and host an occasional meetup. Although Lena doesn't run the organization anymore, her initial efforts have brought out the "shredder" in people all over the world as the group continues to grow.

continued →

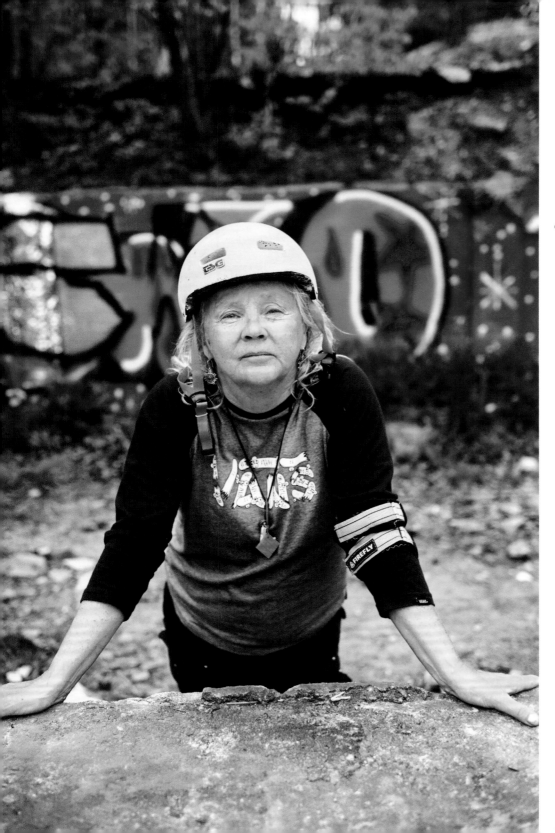

"Never
leave the
playground."

In 2019, Lena became the first Finnish woman to have her own signature model skateboard; it's with local skate company Tikari and features a graphic that Lena designed and drew herself. To offer a glimpse into her many facets, her design is full of details and icons from her life: spray paint, skateboards, ice cream, a stopwatch, a scooter, herself in a handstand—all positioned in the setting of a city by the beach. When I met Lena, I was surprised and stoked when she gave me one of her colorful decks, repeatedly telling me, "You better skate this."

Lena lives her life in the most organic way possible, following whatever idea pops into her head. If she's not skating, swimming, tumbling, standing on her head, or making friends with the scooter kids, she's likely procrastinating cleaning her home by doodling "Sk8chs" in her notepad. She took up making graffiti art just for fun, but has since become well-connected within Helsinki's art scene and has been commissioned to create graffiti murals all over the city.

When she's out skateboarding, she's regularly approached by skaters of all ages who recognize her and want to hear her story. Lena is pictured on page 112 skating with her friend Christina, who picked up skating in her forties despite living with osteoporosis. Christina practices with Lena regularly and says that it is Lena's infectious enthusiasm that encourages her to skate harder. Lena's impact as an ambassador for skateboarding in her hometown is great and she has noticed a rise in skate culture and the number of female skateboarders all over Finland.

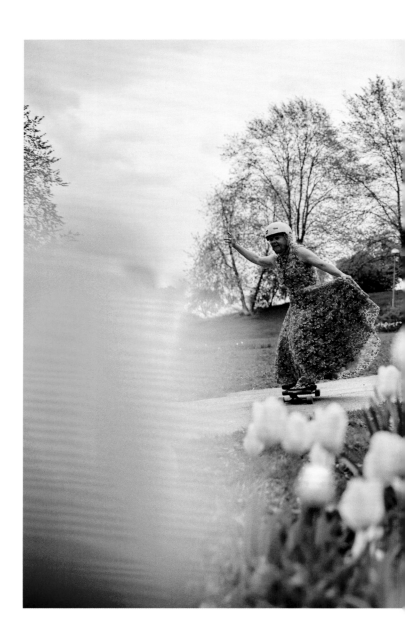

"Skateboarding makes me who I am. I am surprised how it feeds imagination."

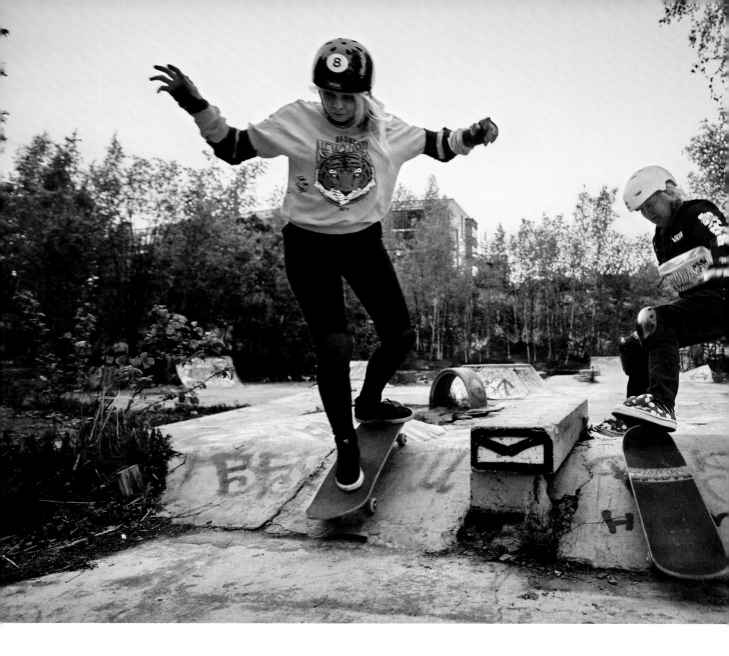

ARIEL CAI

ARIEL CAI

ARIEL CAI

ARIEL CAI

SOUL

BORN
Shanghai, China

CURRENT HOME
Shanghai, China

STARTED SKATING
2½ years old

FIRST BOARD
A scooter

BOARD PREFERENCES
Loose trucks, soft wheels

STANCE
Goofy

FAVORITE TRICK
Boneless

TRICK IN THE WORKS
Switch 50-50

SKATE DAY FOOD OF CHOICE
Her mom's homemade fried rice

FAVORITE TIME TO SKATE
Anytime

FUN FACT
She's working on cornering a road racing motorcycle down to her elbows

In Shanghai, China, thousands of miles away from where skateboarding was born, there is a tiny skater who rips the largest outdoor concrete skate park in the world, SMP. Ariel started skating when she was just a toddler and became a legend before she was even seven years old. As skateboarding gains popularity around the globe, more and more Chinese skaters are hopping on boards. And when skateboarding was added to the 2020 Olympics, the country started ramping up to compete. To allow the skaters a safe place to practice, China is now home to some incredible skate parks, like the enormous SMP and its indoor equivalent, which takes the cake as the world's largest indoor skate park.

While skateboarding is growing in China, it's still a long way from being more than an anomaly. In general, skate parks are few and far between, and there aren't a ton of skaters visiting them. Skateboarding among girls and little kids is really uncommon, and it's largely not recognized as a sport, let alone a potential career path. For kids Ariel's age, school is their absolute priority, with classes usually taking up most of the daylight hours. It takes Ariel more than an hour on public transit to get to SMP to skate; on a normal school day, that leaves her with only twenty minutes or so to enjoy the place. Still, her dad, Hifie, makes the trek with her as often as they can, even if only for a few minutes, just to see his daughter smile doing

continued →

what she loves. Hifie grew up with little opportunity to skate in Shanghai, so he is fervent about providing Ariel with a safe place to practice their shared passion.

Ariel's other passion is competitive diving, and her accomplishment in diving has actually allowed her to practice skateboarding more regularly, thanks to a creative idea of her dad's. Since diving is acknowledged as a legitimate sport in China, Hifie managed to get Ariel a pass to leave school slightly early to practice, which also allows her the chance to sneak in a little extra time on her skateboard.

I first saw Ariel in a video on Instagram—a little grom all padded up over her colorful retro outfit. In the video, Ariel begins off her board, doing a little dance at the top of a snake run, smiling, shaking her behind, making kissy faces, and just being a total goofball. Then a switch flips, she grabs her board and sends herself flying down the run. She didn't need any prep time and had no hesitation before shredding the run, and she came out of it still smiling and laughing. She radiates pure joy. Seeing her skate in person was even more impressive. She's tiny but fearless, super athletic, and seems to just *fly* on her board. She wasn't skating anything less than *huge* and the only speed she understands is *fast*. Her small size makes it tough to launch out of vert ramps, but she's dropping in and ready for it, tapping the coping each time.

In addition to skateboarding and diving, Ariel also competes in BMX (bicycle motocross), cruising around on her bike between skate runs to clear her mind. In 2019, she casually took three first place titles at SMP for bowl skating and BMX racing. And if all of that wasn't impressive enough, she also rides a motorcycle!

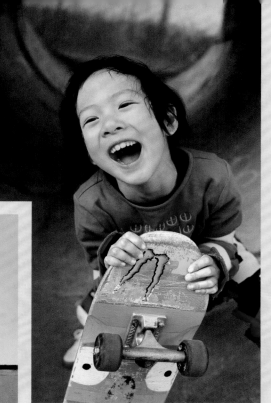

"Little by little,
step by step."

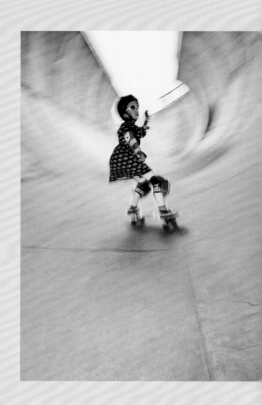

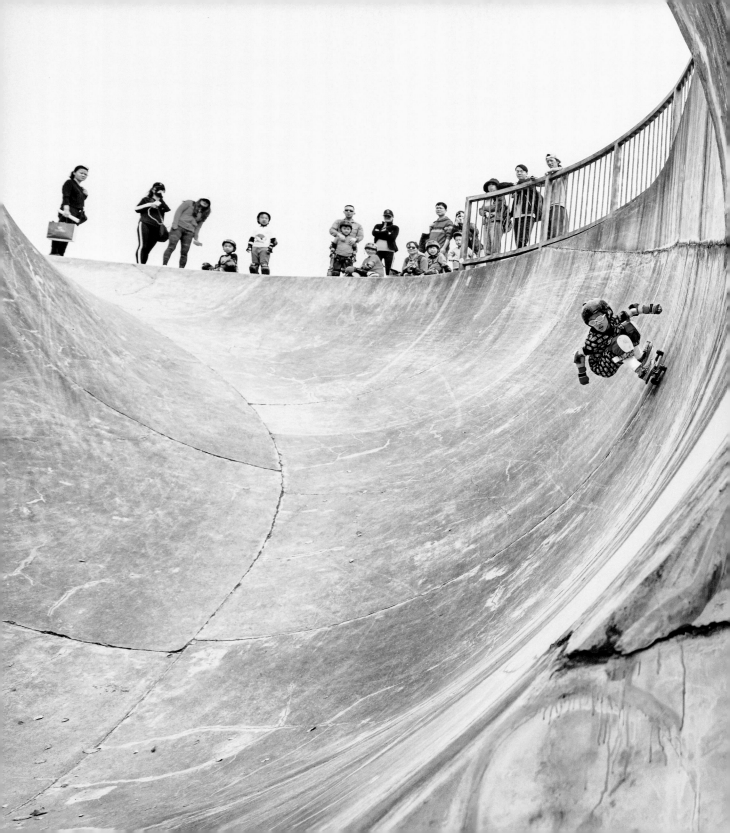

VIANEZ MORALES
VIANEZ MORALES
VIANEZ MORALES

VIANEZ MORALES

PRO

BORN
Luquillo, Puerto Rico

CURRENT HOME
Torrance, California

STARTED SKATING
5 years old

FIRST BOARD
Plan B

BOARD PREFERENCES
Wide board (8.0"), small wheels

STANCE
Goofy

FAVORITE TRICK
Kickflip

TRICK IN THE WORKS
Bigspin

SKATE DAY FOOD OF CHOICE
Bananas

FAVORITE TIME TO SKATE
Anytime

FUN FACT
She comes from a skateboarding family

SPONSORS
Saltrags, Adidas Skateboarding, Rastaclat, Rock Star Bearings

Vianez skates hard: she visualizes, homes in, and goes after it. She thrives under pressure but is very aware of her capabilities. Although skateboarding is mostly about fun and freedom for her, it is also a place to channel her larger life goals. She's on a mission to improve on the daily, inspired by pros like Jenn Soto, Candy Jacobs, Leticia Bufoni, Lacey Baker, Mariah Duran, and Pamela Rosa.

Vianez comes from a supportive family. Her dad, Daniel, skates with her, and her mom, Sely, is more often than not there to cheer her on. Together they are a powerhouse team, giving Vianez an incredible platform for growth. Already an accomplished skater, she is happy to further show her stuff by representing Puerto Rico in professional competitions such as Street League Skateboarding and the Dew Tour. Being a girl in a male-dominated sport has only ever motivated her. She has consistently impressed and drawn praise from guys at parks and competitions.

When she's not skateboarding, Vianez is likely constructing storytelling animations on her iPad.

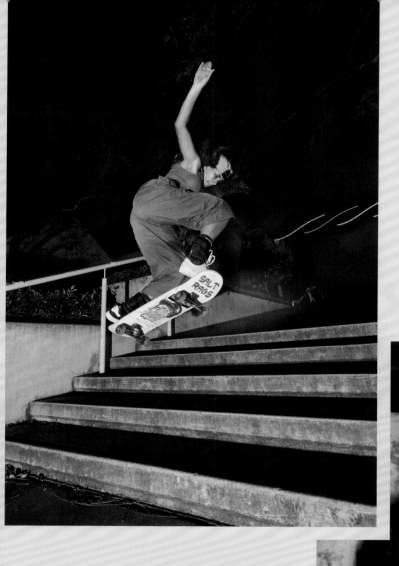

"Never give up, no matter how many times you fail."

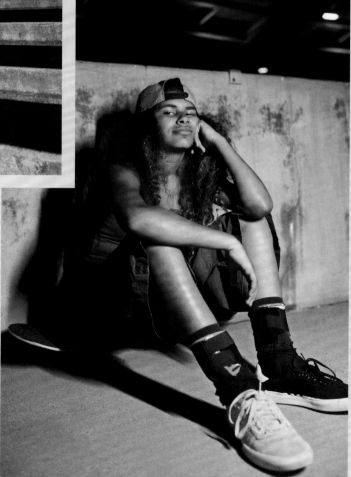

One of the awesome things about skateboarding is that it has such a strong culture and language of its own. Over the decades, skateboarding slang has circulated widely, and there are a ton of new words you might come across at skate parks or in conversation with friends. Here are some of the most common slang terms that are good to know.

Ate it: To have fallen hard. This typically refers to face-first falls.

Barney: *See* Poser.

Bogart: To hog a skate spot or obstacle and not let others use it. For example, if you stay on a mini ramp for an excessive amount of time when other skaters are waiting to use it, you're being a bogart.

Bolts: To land with each foot positioned above each truck, not on the tail, nose, or middle. This is considered a flawless landing.

Bomb a hill: To skate down a large hill, typically aiming straight down while executing necessary carves and speed checks to avoid loss of control as you gain speed.

Brain bucket: Another word for a helmet.

Burly: Referring to either a trick or the way a skater skates. Burly is a high-risk trick or something that could be more dangerous or difficult than normal, like roof gaps or long kinked rails.

Bust: This can be used two ways. A skate spot that you're likely to get kicked out of is described as a bust. Bust is also used to mean executing a trick well, as in, "Go bust a Kickflip."

Credit carded: When a skater falls with her legs on either side of something narrow, like her skateboard or a rail, and lands on her crotch or backside. This term is typically only used when this happens to a woman.

Curb cut: The two hips of transition created at the bottom of a traditional driveway, where the curb slants down to the street.

Deathbox: A feature of in-ground pools, a deathbox is the small rectangular section cut out in the top of the pool wall, below the coping. These are modeled after backyard pool "swimouts" and used in skateboarding as a place to air out or trick over.

Dial (or Dialed or On lock): To have a trick essentially perfected, so that you can land it consistently and repeatedly, as in, "She has Crooked Grinds on lock (dialed)!"

Flow rider: A skater who is paid in product (not cash) to promote a brand.

Gnarly (or Gnar or Gnar gnar): Same as super cool, sick, or rad; something semi-burly.

Grom (or Grommet): A name for little kid skaters and surfers.

Hang up: While skating transition, your back truck gets caught on the coping on your way back in.

Hipper: An injury that results in a large strawberry gash around the top of the leg or hip, typically resulting in a hematoma (blood pooling under the skin).

Jetty ledge: A ledge adjacent to a set of stairs that juts out straight and parallel to the ground rather than sloping down alongside the stairs.

Kook: *See* Poser.

Lazer Flip: 360 Heelflip

Lid: *See* Brain bucket.

Mobbing: To go somewhere via skateboard with two or more people, typically at a faster than normal pace.

Nightmare Flip: Combination of a Double Kickflip with a Varial.

Part: When a skater earns their own segment in a skate film, this is know as their "part."

Poser: Someone who doesn't actually skate, but acts as if they do by following the trends and buying the right stuff, essentially "posing" as a skateboarder.

Rad: Short for radical. This also means super cool, awesome, sick, out of this world, amazing, or incredible.

Razor tail: When the tail of a deck is so worn down that it has a squarer, sharper edge, which makes the board have little to no pop.

Ripper: A skater whose style is strong and consistent with a decent array of tricks.

Sack it (or Nut it): When a skater falls with his legs on either side of something narrow, like a rail, and lands on his crotch. This is typically referred to as a male term.

Shred: To skate hard and fast.

Shredder: Anyone who puts their heart into skateboarding. A shredder is a skateboarder regardless of his or her style or skill level.

Sick: Same as awesome, gnarly, rad, or super cool.

Skate Rock: Coined by *Thrasher* magazine in the 1980s, skate rock is its own musical genre, consisting of the punk rock and rock bands who are skaters themselves. These bands are known for skating to and performing aggressive, fast-paced songs that are typically under two minutes in length. Early pioneers of the genre were Black Flag, Circle Jerks, and X in Southern California; Fear and Dead Kennedys in Northern California; The Ramones in New York; and The Sex Pistols and The Clash in England.

Sketch (or Sketchy): Term used to describe a trick, obstacle, or skate spot with an apparent roughness or added difficulty to skate.

Skid lid: A helmet.

Slam: To fall extra hard.

Slob: To grab mute while airing frontside.

Snake: The act of stealing a run or line from someone or having a line or run taken from you (usually by being cut off).

Steeze: Used to describe ultimate style and flair and comes from a combination of "style" and "ease."

Stick: To land a trick cleanly.

Stoked: To be extremely happy about something.

Swellbow: The term given to a moderate to severe skate-related injury of the elbow ("skateboard elbow"). Today it can be used to describe any elbow injury, but it originated from an injury common in the 1960s: a fracture of the tip of the olecranon.

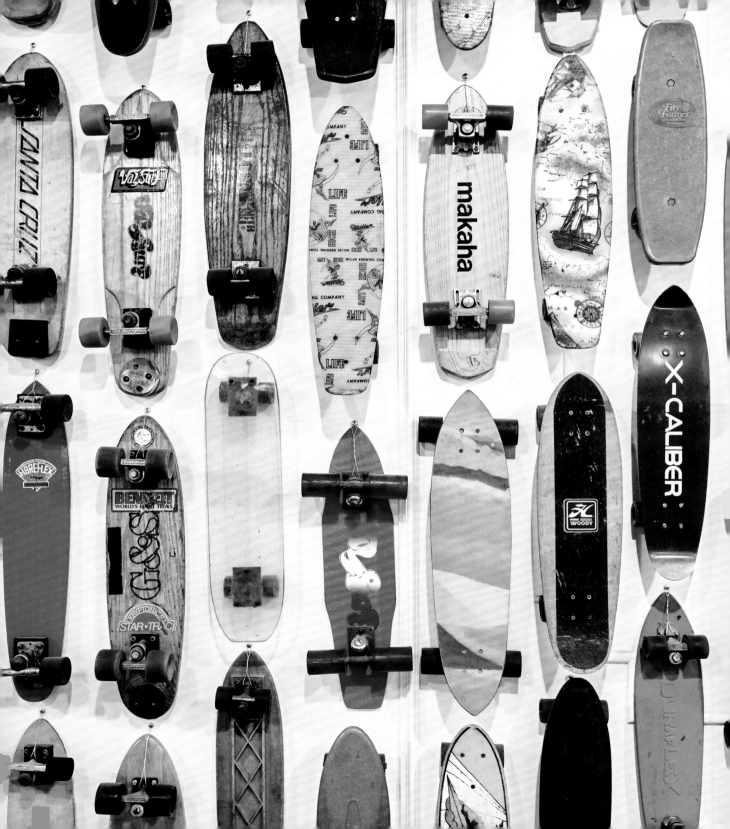

LILLY STOEPHASIUS
LILLY STOEPHASIUS
LILLY STOEPHASIUS

LILLY STOEPHASIUS

PRO

BORN
Berlin, Germany

CURRENT HOME
Berlin, Germany

STARTED SKATING
2½ years old

FIRST BOARD
Pink Flip 7.0"

BOARD PREFERENCES
Tight trucks, hard wheels

STANCE
Regular

FAVORITE TRICK
Backside Varial on vert

TRICK IN THE WORKS
Backside 540 Air

SKATE DAY FOOD OF CHOICE
Orange chicken

FAVORITE TIME TO SKATE
Night

FUN FACT
She loves listening to Guns N' Roses and hanging out with her cat, Filou

SPONSORS
Moonshine Skateboards, Protec, 187 Killer Pads, 90 The Original, Vans

Lilly started skateboarding shortly after she could walk. In fact, she probably skated better than she walked for the first few years of her life. Her skills on the board developed like crazy, and she was competing by the age of eight. She has since traveled the world to compete and has multiple podiums under her belt. Placing second in both the Vans Park Series Europa Continental Women's Final 2019 and Vans Womens Combi 2019 (fourteen and under division), as well as third in the women's World Skate Vert World Championship 2019, she is already one of the best, most consistent skaters out there. She looks up to contemporary ground breakers like Lizzie Armanto (see page 166) and Arianna Carmona and hopes to follow in their footsteps.

Her dad, Oliver, is her biggest support. A fan of skateboarding and surfing himself, he accompanies Lilly along with her skate coach, Jürgen Horrwarth, to all of her practices and competitions, helping her work through tricks and giving her the confidence to execute them. Lilly knows that skateboarding is 99 percent mental, and she carefully calculates the details of each new trick before committing it to memory. She's quick to ask for tips, and "giving up" is not in her vocabulary. She lives by the motto: "Get up and try again." When I asked her how she managed to learn tricks so quickly, she gave a confident smile, clenched

continued →

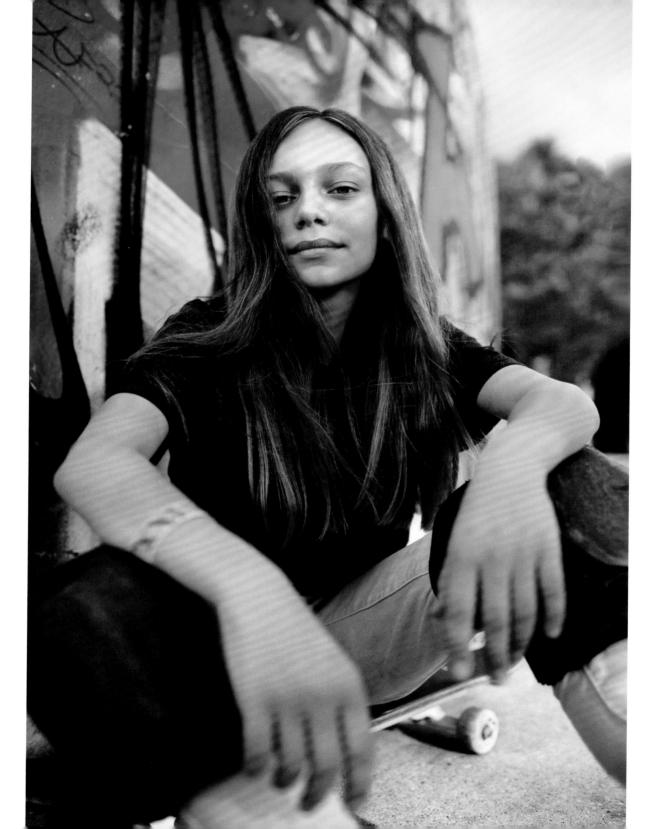

her fists, and said, "Because I want it . . . I want it *so* bad." Lilly is committed to the shot, committed to the vision, committed to improvement, and committed to execution. She practices for hours at least four times a week, and it shows. Always smiling, skateboarding is her happy place.

Germany doesn't have much of a girls' skate community, so Lilly often competes against the men; but to her, skating against them just gives her all the more motivation to push herself. The guys in her local skate community have welcomed her and encourage her to skate even harder, "But it is more fun to ride with girls," she admitted.

When she isn't slashing around on urethane, you can find her ballet dancing; participating in other board sports, such as surfing and snowboarding; and making memories with her friends.

"Don't be afraid. Skateboarders are very supportive, if you are really into it."

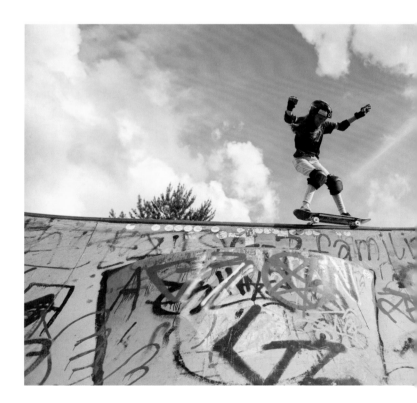

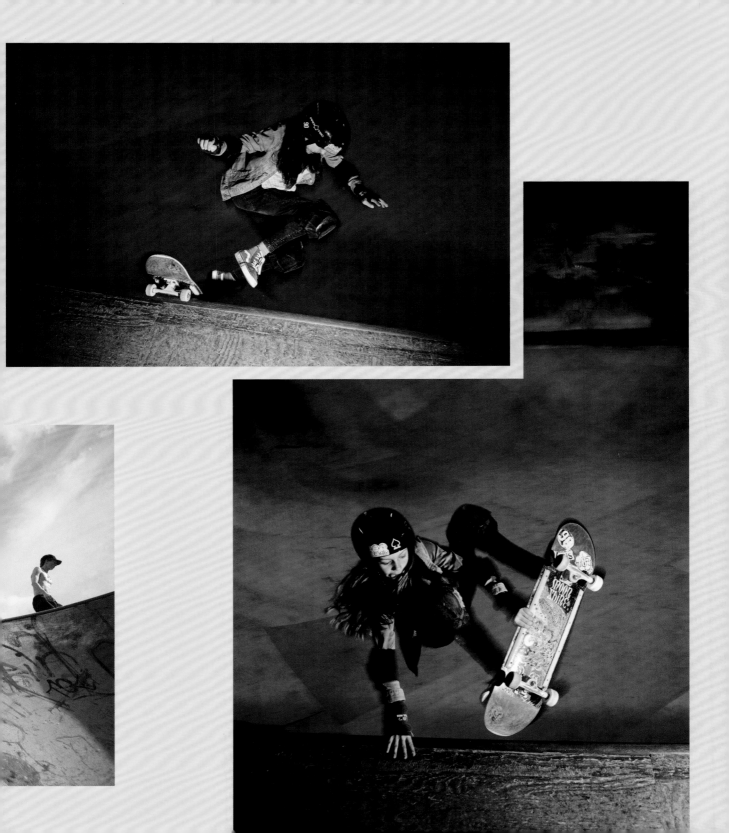

EUNICE CHANG

EUNICE CHANG

EUNICE CHANG

EUNICE CHANG

SOUL

BORN
Rancho Palos Verdes, California

CURRENT HOME
Los Angeles, California

STARTED SKATING
13 years old

FIRST BOARD
Enjoi

BOARD PREFERENCES
Loose trucks with plenty of concave

STANCE
Goofy

FAVORITE TRICK
Kickflip

TRICK IN THE WORKS
360 Flip

SKATE DAY FOOD OF CHOICE
Dirt

FAVORITE TIME TO SKATE
Night

FUN FACT
She loves to snack and is a self-described "legit snack monster"

"Anything worth doing is worth doing your best."

Eunice lives a simple life: she works to make ends meet and spends the rest of her time enjoying herself. To her, skateboarding isn't serious, it's a "good time" that allows her to break free from the mundane and spend time with friends. If Eunice had her way, she'd want to own and operate a parking lot, collecting money with each entry and skating the empty lot after hours. But until then, she's got a different nightly routine. Every evening, Eunice kicks back with a bag of Flamin' Hot Cheetos and a La Croix while laughing until she cries watching *The Office*. Maybe it's the Cheetos that give her all that pop?

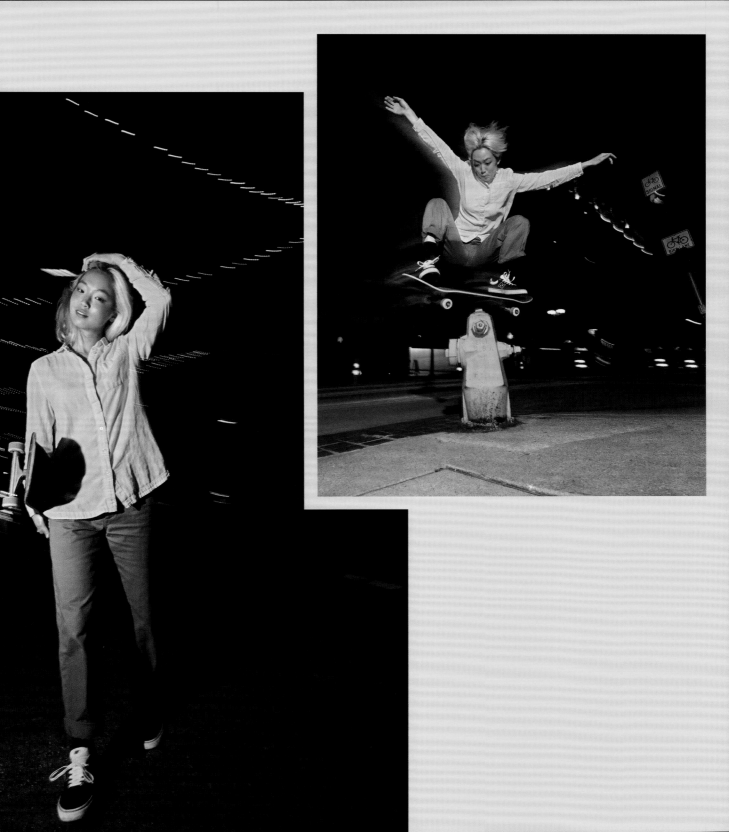

YARROW TORRES

YARROW TORRES

YARROW TORRES

YARROW TORRES

SOUL

BORN
Truckee, California

CURRENT HOME
Santa Cruz, California

STARTED SKATING
2 years old

FIRST BOARD
Creature Mini with Independent trucks

BOARD PREFERENCES
Loose trucks, hard wheels

STANCE
Regular

FAVORITE TRICK
Early Grab

TRICK IN THE WORKS
Rock n' Roll

SKATE DAY FOOD OF CHOICE
Burritos

FAVORITE TIME TO SKATE
Night

FUN FACT
She's super strong and loves to do pull-ups

Yarrow is hard to miss. She charges through the park with her long curly hair flying behind her, focused as ever. Skateboarding is in Yarrow's blood, and it shows. She learned to skate from her dad, Jonah, and routinely hits the park with him along with her brother, Rusty, while her mom offers encouragement on the sidelines. To the Torreses, skateboarding is truly a family affair.

When skating, Yarrow takes progression one step at a time, often fixating on something clearly in her mind before she sets out to complete it. Both her dad and her brother absolutely rip, so Yarrow studies them closely in between runs when she's not busy working on her new moves. When the family skates together, you can clearly see how they feed off of each other's energy. When I met Yarrow, I was fortunate enough to witness her dropping into a gnarly slanted bank that led her into a mini bowl for the first time. It was something she'd been eyeing but was a little hesitant to dive down. At first she was scared, but her family and I reassured her that she could do it—and sure enough, she nailed it. Then she proceeded to do it again, and again. Seeing Yarrow skate, it's clear that she puts in the work, consistently skating until her legs turn to Jell-o and she couldn't be more thrilled about it.

While she's a hard worker at the park, Yarrow doesn't take skateboarding too seriously. To her, it's all about having fun and being herself, and her family reinforces that. When she isn't skateboarding, Yarrow likes to surf, swim, and make art.

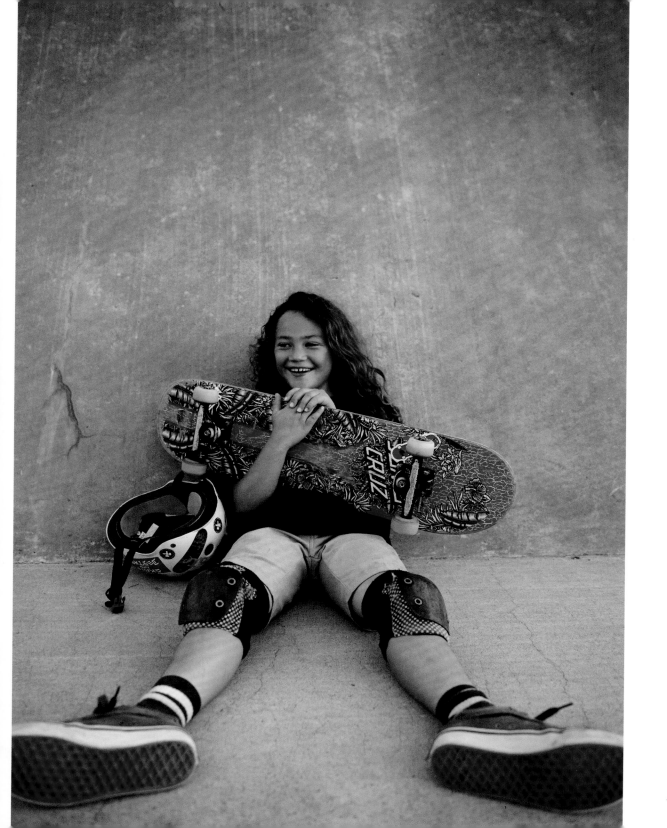

"I couldn't imagine life without skateboarding."

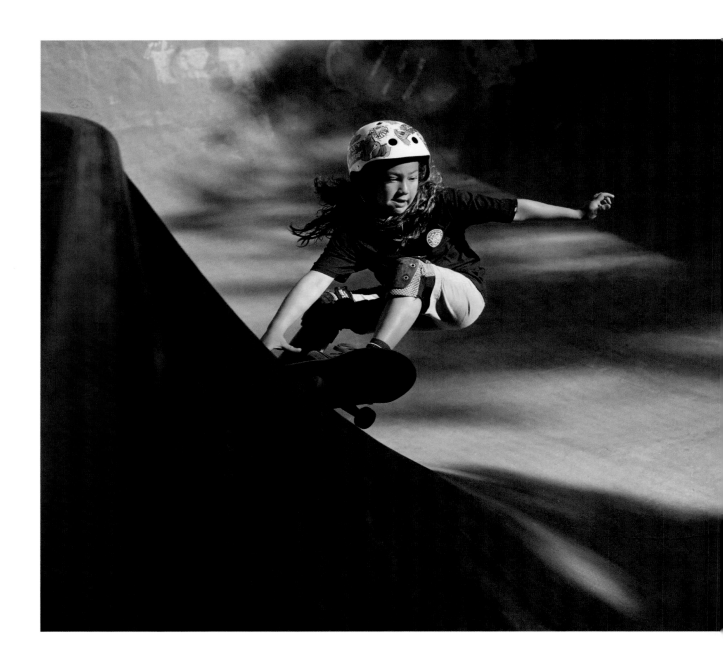

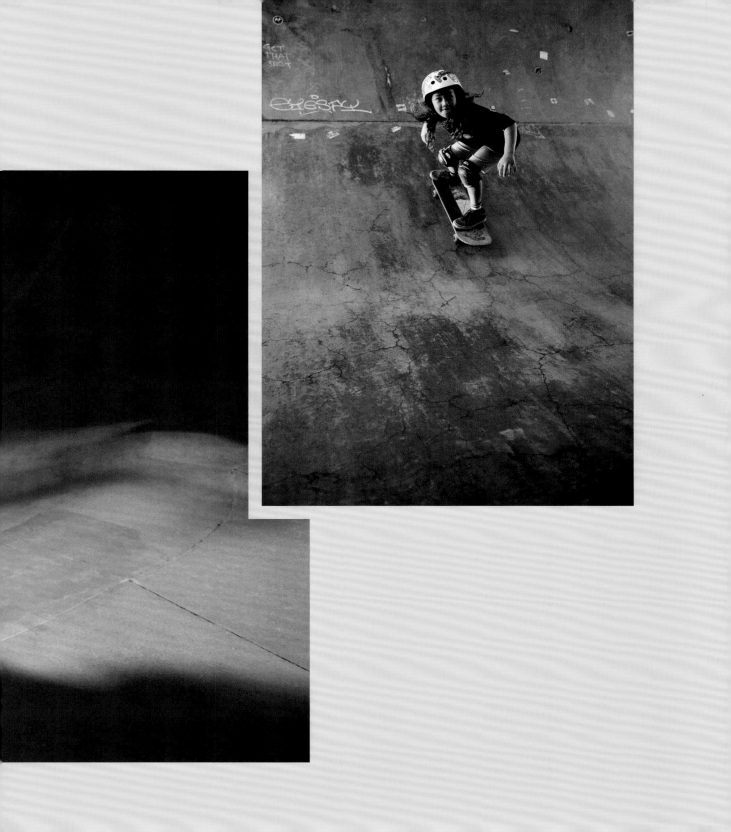

LAURA THORNHILL CASWELL

LAURA THORNHILL CASWELL

LAURA THORNHILL CASWELL

LAURA THORNHILL CASWELL

OG

BORN
Dallas, Texas

CURRENT HOME
Valencia, California

STARTED SKATING
13 years old

FIRST BOARD
A small wooden Black Knight with clay wheels

BOARD PREFERENCES
Loose trucks, hard wheels

STANCE
Regular

FAVORITE TRICKS
360s, Nose and Tail Wheelies, Kickflips, and Spacewalks

TRICK IN THE WORKS
Aging in reverse

SKATE DAY FOOD OF CHOICE
Anything Mexican with avocado

FAVORITE TIME TO SKATE
Anytime

FUN FACT
Laura's famous one-footed Nose Wheelie image is a poster on skater girl Max's wall in season three of *Stranger Things*.

Pioneer, trendsetter, record-breaker: meet Laura Thornhill Caswell. You might recognize her by her iconic long blonde hair, her effortless twirls, her narrow stance, or her one-footed Nose Wheelies.

Laura's a genuine tomboy and grew up playing hard. Her love of skateboarding started with the six rowdy boys next door who often left a skateboard on their front porch. Laura would swoop the board and teach herself how to Kickturn up and down the driveway. There was no such thing as a girl skateboarder then (as far as she knew, at least), but that meant nothing to her. She was one and the same with the boys: "I always rode more like a guy and was a tomboy, but I was fluid and graceful in ways that guys weren't."

In 1974, she and her family moved to Redondo Beach, California, where she heard about a few girl skateboarders. She made a wish, and on her thirteenth birthday it came true: Laura got her very own skateboard. It was a classic of the time, the Black Knight, and from that moment on, she was determined to do everything with it and be the best she could be on it.

SkateBoarder magazine had just come out with their first issue, with Gregg Weaver on the cover, and to her surprise, there were actually a few women inside. She knew that someday, she wanted to be in that magazine, "And that was my mission," she said. "I just ate and breathed skateboarding every day from then on."

continued →

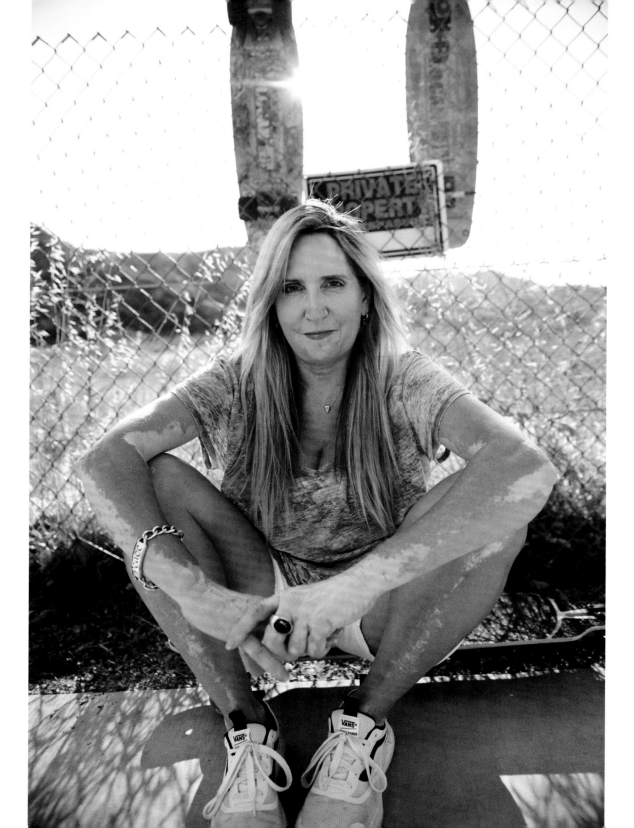

The first contest Laura skated was Steve's South Bay Skateboard in July 1975, where she placed first in both freestyle and slalom, gaining her a coveted spot on the Logan Earth Ski team. At the time, this was basically top of the charts as far as sponsorships go. Two weeks later, she met up with Warren Bolster, a photographer and the editor for *SkateBoarder* magazine, who made her the first girl featured in a "Who's Hot" layout in the magazine, additionally landing her multiple contents pages thereafter. By summer of 1977, she became the first with an interview in *SkateBoarder*; a month later, she was the first girl to score a centerfold. One of her most notable features was shot at the California Aqueduct pipeline project in Arizona and included a hand-picked group of thirteen skaters—Laura and twelve guys. The Arizona pipes were a dreamland for these skaters, and they went back three weekends in a row, until security began patrolling it and they were never skated again. Those pipes were arguably the best, most exclusive skate spot of the time—and for many decades to come, for that matter. Skating them was a once-in-a-lifetime experience.

After her "Who's Hot" feature, Laura gained instant fame and became busy with contests, photo shoots, and demos, as well as stunt, TV, and film work. She was practicing everything from freestyle to slalom, from pools to pipes and skate parks. In late 1976, Logan Earth Ski presented Laura with a signature model board, making her the first female ever to receive a signature model skateboard with any brand. Her rise to fame was again made apparent in the first "who's your favorite" skater poll in *SkateBoarder* magazine, where Laura got over three thousand more votes than her male counterpart, Tony Alva. It was an extremely exciting time for Laura.

continued →

"It just felt like I was connected to what I was meant to do at the time. [Skateboarding] was all I cared about, being on that board and learning something new. . . . It's just the best."

Logan Earth Ski Laura Thornhill model (original)

For a multitude of reasons, a lot girls fell out of the skateboard scene in the late 1970s, most of them continuing on to college and not really thinking about a future in skateboarding. Shortly after, cities became lawsuit-happy and many skate parks were closed in the name of safety. With no skateparks, skateboarding largely fell off of the mainstream media's radar. It became more underground, more reckless, which doesn't mean that girls weren't doing it, but the struggle for opportunity and the spotlight was substantially more difficult for women than men.

For Laura, the end of her pro career was caused by a severe left elbow dislocation in 1978. Injured and with skateboarding on the decline, Laura went on to pursue her other passion of music. She and her husband, Johnny, started a record label and later went on to run one of the premier rehearsal studio facilities in the world, Center Staging Musical Production in Burbank. With that business now sold, she keeps busy and active in the skateboarding community. After being inducted into the Skateboarding Hall of Fame on May 9, 2013, she joined the SHOF team as the event coordinator and co-producer for the SHOF awards, which continues to this day. What's more? One of her skateboards is on display at the Smithsonian as a piece of skateboarding history.

A tomboy to this day, you'll never find her *not* doing something active, like cycling, mountain biking, snowboarding, or surfing—when she's not tinkering around on a cruiser board. Her active lifestyle even has a philanthropic component. She has cycled from San Francisco to Los Angeles twice, each time raising money for people in her life who suffer from debilitating arthritis, including her late grandmother, Olive, who lived to be over one hundred years old, and her old photographer pal, Warren Bolster. "I wake daily full of gratitude, knowing that I had an extremely blessed life and am forever thankful to still be an athlete," she says. Once a skater, always a skater.

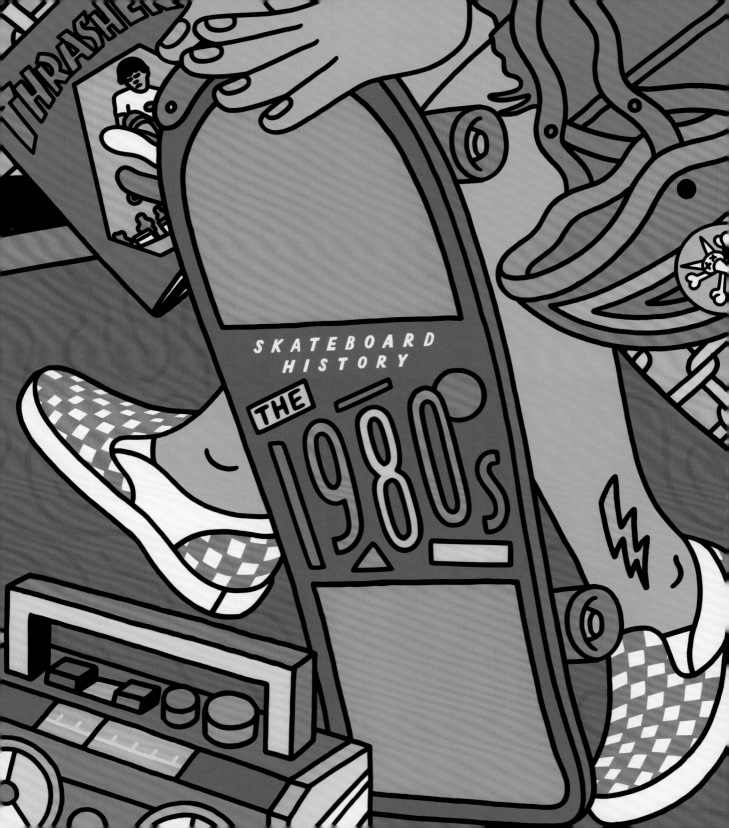

After the heyday and subsequent backlash of the 1970s, skateboarding was at a low point at the start of the 1980s. The end of the 1970s saw skate parks closed and pools filled as cities faced lawsuits and insurance rates soared. By 1980, the number of pro skateboarders had dropped from 175 to just fifteen people. In the 1980s, skate culture started moving further away from surf culture to create more of its own style—aggressive, fast, angry, and hard-core. Boards became bigger and flatter, with widths reaching around 10 inches (up from 6 inches in the early 1970s), and featured more accessories like rails and tail skid plates.

With few skate parks open, skaters increasingly took on the more aggressive and hectic life of street skateboarding searching for new empty backyard pools and building DIY wooden ramps. In a way, these creative solutions made skateboarding more accessible because it could be done anywhere out in the world, in a friend's driveway or your own backyard. But on the flip side, the closure of skate parks meant that many girls and women fell out of the sport since they no longer had fun, friendly, and safe places to skate. Street skating was usually illegal, so it was often done at night, and skaters had to evade or run from the police all the time. This tough-as-nails style of skating meant that the number of injuries soared, again giving skateboarding a bad name.

The 1980s saw the introduction of *Thrasher* magazine, which brought the punk vibes and music of the era to the skateboard scene. The pro circle became smaller, and skateboarding got more technical with flips, spins, stair sets, and rails becoming the new normal. With the help of Hollywood, skateboarding was boosted back into mainstream media with the films *Fast Times at Ridgemont High* and *Back to the Future*. By the end of the decade, though women skaters were still an anomaly, Cara-Beth Burnside landed the cover of *Thrasher*, helping to open minds and inspire would-be girl skaters everywhere.

1980

Feeling the pressure of skating's cultural decline, *SkateBoarder* magazine relaunched itself as *Action Now* and began covering other extreme sports on the rise, including BMX, snowboarding, and roller-skating. This paved the way for extreme sports magazines of the future and inspired the idea for the X Games (though they didn't start until 1995).

The movie *Skateboard Madness* directed by Julian Pena debuted in theaters. The movie, which stared Tony Alva, Stacy Peralta, and Alan "Ollie" Gelfand, helped boost the flagging interest in skateboarding by showing that it was an inspiring and fun culture full of exploration and camaraderie.

1981

The first issue of *Thrasher* magazine was released. Founded in San Francisco, California, by Eric Swenson and Fausto Vitello (the makers of Independent Trucks), the magazine covered a combination of skating, lifestyle, and music. Skateboard companies didn't want to pay for advertising in *Action Now* since it covered other sports, so they took it upon themselves to create a hard-core, skateboarding-only magazine. The magazine sealed the bond between punk culture and skateboarding culture by including music-forward content like band interviews, album reviews, and playlists of the bands in the Skate Rock scene. As skate parks declined, *Thrasher* contributed to the boom of street skating by choosing to feature street spots rather than parks.

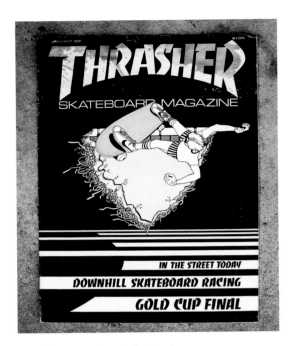

Thrasher *magazine, Vol. 1 No. 1*

1982

Sean Penn played Jeff Spicoli, a stereotypical "skater dude" in the hit film *Fast Times at Ridgemont High*. The character not only inspired a slew of new skaters to hit the scene, he also made the checkered Vans slip-on—which Penn selected for the film himself—the company's best-selling shoe of all time.

Skateboarding became a hit worldwide with the first of the Münster Monster Mastership contests in Western Germany. The first American to skate the contest was Adrian Demain in 1984. By 1987, Lance Mountain, Tony Hawk, and Steve Caballero were a part of the contest.

Action Now ran its last issue, which featured Neil Blender on the cover. The company used their last issue to go all out with hard-core skateboarding, including a story on the influential punk band Black Flag, as well as some epic snowboarding.

1983

The first issue of *TransWorld Skateboarding* magazine was released and featured Steve Caballero on the cover. Started in Southern California by Larry Balma along with Peggy Cozens (owner of Tracker Trucks), the ultimate goal of the magazine was to bring athleticism and clean creativity back into skateboarding. Their motto was "Skate and Create" to contrast with *Thrasher*'s more punk motto of "Skate and Destroy." The bright and polished look of *TransWorld* was well received, and it remained a leading skate publication through its last printed issue in March 2019. The magazine continues on today as an online resource with a digital subscription.

TransWorld Skateboarding *magazine, Vol. 1 No. 1*

Brought to life by *Thrasher*, Skate Rock released the first of its series of cassette tapes featuring a mix of skater-run and skater-inspired bands. The first cassette featured the likes of The Faction, Minus One, The Big Boys, Riot, and Jodie Foster's Army (JFA). As the series progressed, it included a large number of punk bands, and the music featured on these tapes went on to be the background tracks for many skate videos of the time.

Sevie Bates started an all-female, punk-rock, tough-as-nails skateboard gang, called The Hags in West Los Angeles, California. These women embodied the punk-rock mentality of skateboarding in the 1980s with their bleached blond hair, ripped shirts, patch-covered denim vests, men's boxers, and Mohawks. They were a true skate gang, showing up to clubs, partying, and repping their custom Hags patches as a group. The Hags showed that skateboarding was a place for girls, too, and hoped to inspire more girls to hop on a board.

1984

Makaha Skateboards debuted a plastic board with their own patented trucks, patented kicktail, and wheels with semi-precision bearings. The plastic design stuck and went on to become the most popular deck material used in skateboard design after maple wood.

1985

Back to the Future hit theatres all across North America in the summer of 1985, grossing close to $4 million in the box office. Michael J. Fox as Marty McFly thrust skateboarding back into popular culture through the power of fantasy.

1986

The movie *THRASHIN'* made its debut. Though quietly inspired by The Hags, the film focused on male skaters and only included women as background extras.

1988

Boards began to take on new shapes. Kicktails were added to the front ends of boards giving them a nose and a new lever with which to steer. Additionally, the plywood of the skateboard deck was pressed to create concave, making the board stronger and providing more traction and new ways to maneuver it by gently angling up the toeside and heel-side edges of the deck.

1989

Pro skater Cara-Beth Burnside made the cover of *Thrasher* magazine, giving her the honor of being the first female to do so during a time when women were scarce in skateboarding.

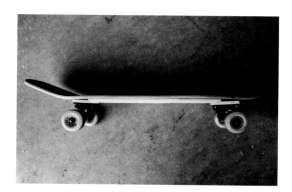

Kicktail on front end and concave with plastic rails

DOMINIQUE DAY PAKINGAN

DOMINIQUE DAY PAKINGAN

DOMINIQUE DAY PAKINGAN

DOMINIQUE DAY PAKINGAN

SOUL

BORN
Los Angeles, California

CURRENT HOME
Los Angeles, California

STARTED SKATING
10 years old

FIRST BOARD
Purple Fisher-Price scooter converted into
a skateboard

BOARD PREFERENCES
Tight trucks, hard wheels

STANCE
Goofy

FAVORITE TRICK
Pogo

TRICK IN THE WORKS
Old-school Kickflips

SKATE DAY FOOD OF CHOICE
Bubble Tea

FAVORITE TIME TO SKATE
Night

FUN FACT
She loves to make mini lounge chairs out of
bottle caps to hold spare change

One of the earliest styles of skateboarding (and arguably the most fun to watch), freestyle is the art of finding unique ways to flow from one trick to another using footwork and grabs. All you need is a skateboard and some creativity. Unfortunately, there aren't that many girls who freestyle in the United States, which makes riders like Dominique really special. For Dominique, a typical freestyle routine might resemble something like this:

Walk the Dog → Tail Stop → Rail Flip → land → Tic-Tac → End-Overs (x2) → 360 Spin → Tail Slide Shove-it → Tail Stop → Pogo → land → 360 Spin → Tail Slide Shove-it → Calf Wrap → Grab Board → 180 Board Grab Flip → land → ride away

Freestyle requires a ton of skill, strength, and precise movements—it is clearly not for the faint of heart. Luckily, Dominique is tough as nails, though I, unfortunately, learned that the hard way. As I was headed to photograph her at Signal Hill in Long Beach, California, on a beautiful sunny day, my phone rang. It was Dominique, and she sounded a bit garbled. "I . . . um . . . I was practicing Rail Flips and . . . um . . . I fell." I could hear in her voice that something was wrong. My heart started to race. "Are you okay?" I asked. "I don't think so . . ." she said. I told her I was almost there and braced for whatever was coming next. When I pulled up, she was holding her chin, blood seeping through her fingers. She looked worried but calm. I grabbed

continued →

146

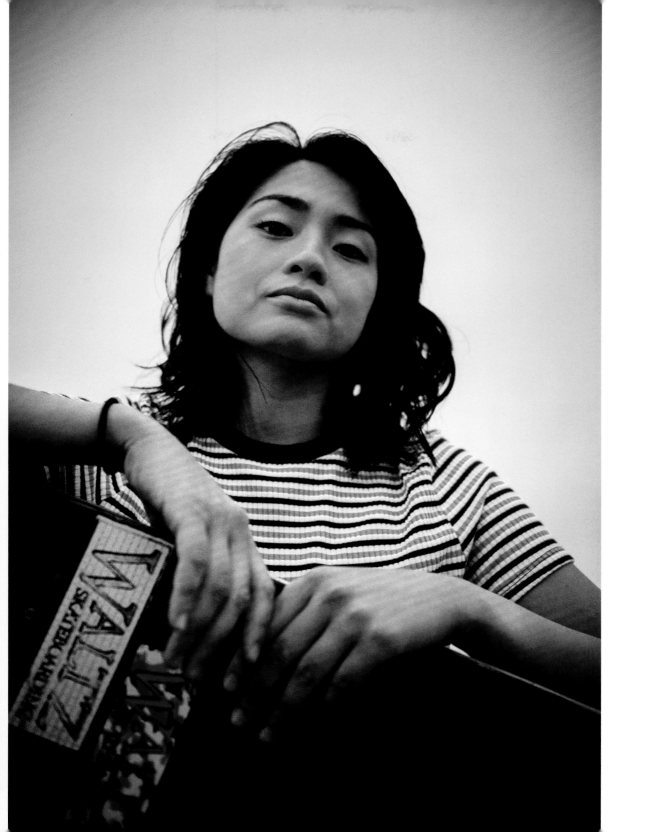

my first aid kit and did what I could to gently but quickly clean her up. "I remember hearing a crack, a ringing in my left ear, and blood running down my chin," she recalled. I put her in my passenger seat and hastily headed to the emergency room.

Dominique fractured the ramus of her mandible doing something she's done hundreds of times before. She didn't need surgery; however, she had her jaw wired shut for a month. No eating and no talking, though she got pretty darn good at ventriloquism. When I saw her four months later, she was slowly progressing toward normal food.

"[After the accident,] everyone told me to quit skateboarding. They told me I am getting too old. It is too dangerous," she said. But even after a jaw fracture, Dominique's love for skateboarding and positivity reigned supreme: "Skateboarding was the hug I needed that whispered everything will be okay." Since she started skateboarding, it has been her departure from the ordinary. It makes her feel strong even though most other times she's seen as quiet and shy. Being injured was just a blip in her relationship with skateboarding and she's eagerly looking forward to getting her flow back. "I learned the valuable lessons in life of acceptance and failure. Sometimes bad things happen, but as long as we push through, it can only make us stronger."

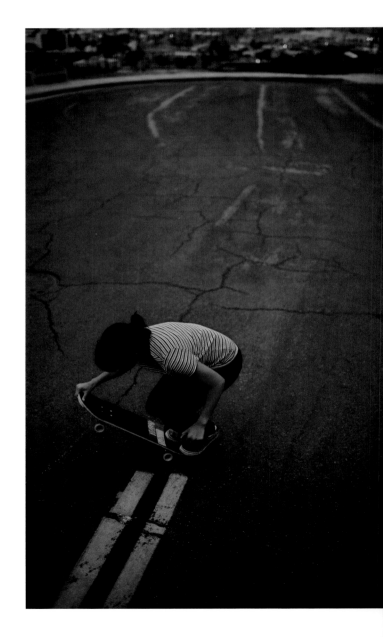

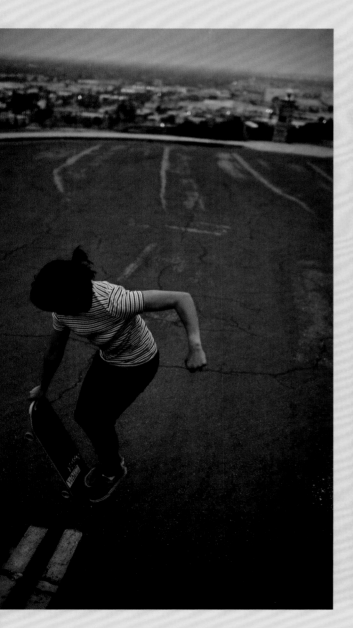
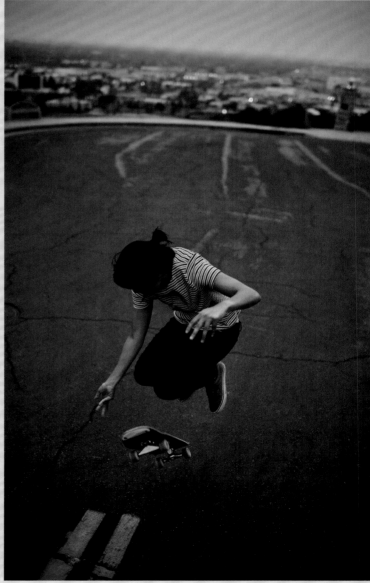

SEYLAH CHILDRESS

SEYLAH CHILDRESS

SEYLAH CHILDRESS

SOUL

BORN
Orange County, California

CURRENT HOME
Orange County, California

STARTED SKATING
6 years old

FIRST BOARD
A too-big hand-me-down from her dad

BOARD PREFERENCE
Tight Independent trucks

STANCE
Regular

TRICK IN THE WORKS
Disaster on bigger ramps and bowls

SKATE DAY FOOD OF CHOICE
In-N-Out Burger combo #2 (ketchup only)
with a 7 Up

FAVORITE TIME TO SKATE
Morning

FAVORITE TRICK
Backside Air

FUN FACT
She sings (in a rock band) and can play
ukulele or piano simultaneously

To Seylah, skateboarding means friends and fun. It means the community she's built of kids who lift each other up, who cheer each other on. "All of my friends on Pink Helmet Posse push me to go harder and inspire me to try new things," she says proudly. The Pink Helmet Posse is a brand of gear designed specifically for girls, and Seylah is a part of their team of skaters who all ride with the eponymous pink helmets, frequenting parks and events as a group. Belonging to such a supportive organization makes Seylah feel confident in her abilities and free to be herself—the total goofball that she is—in every situation.

Skateboarding genuinely makes her smile, and since she's an avid surfer, it's another way for her to spend her time when the swell is subpar. If she isn't skateboarding or surfing, you may find her snowboarding. Otherwise she's playing music, making art, or being a rad big sister to her two brothers, Strider and Stone.

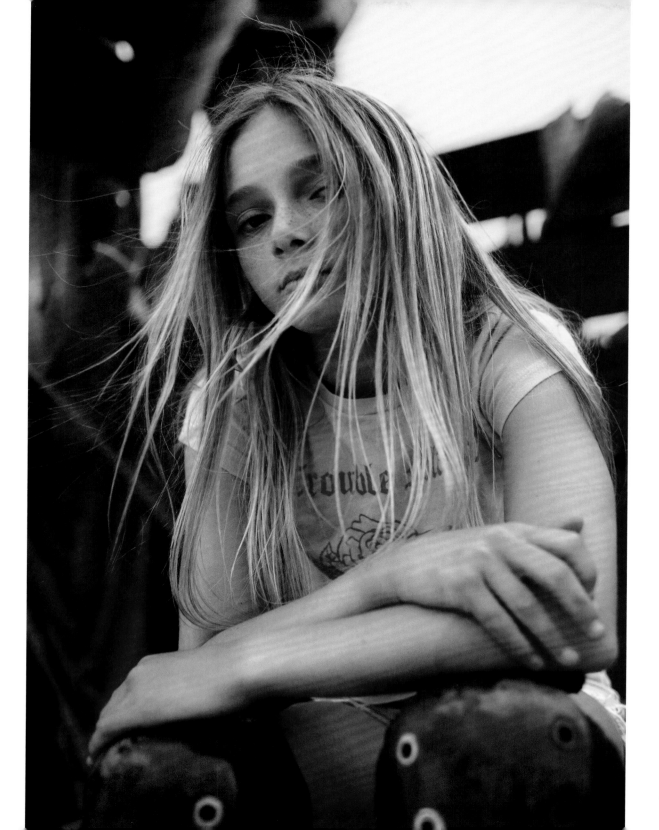

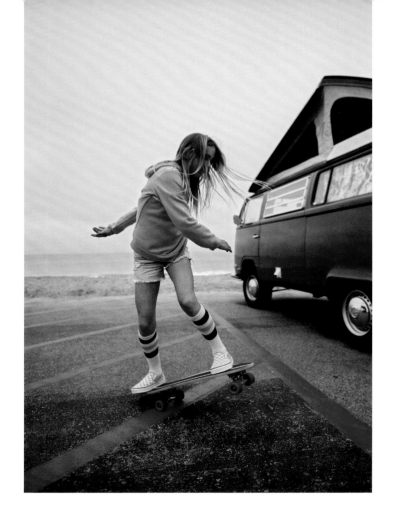

"Skateboarding
 means pushing me
 past my comfort
 zone and giving me
 confidence outside
 the skate park."

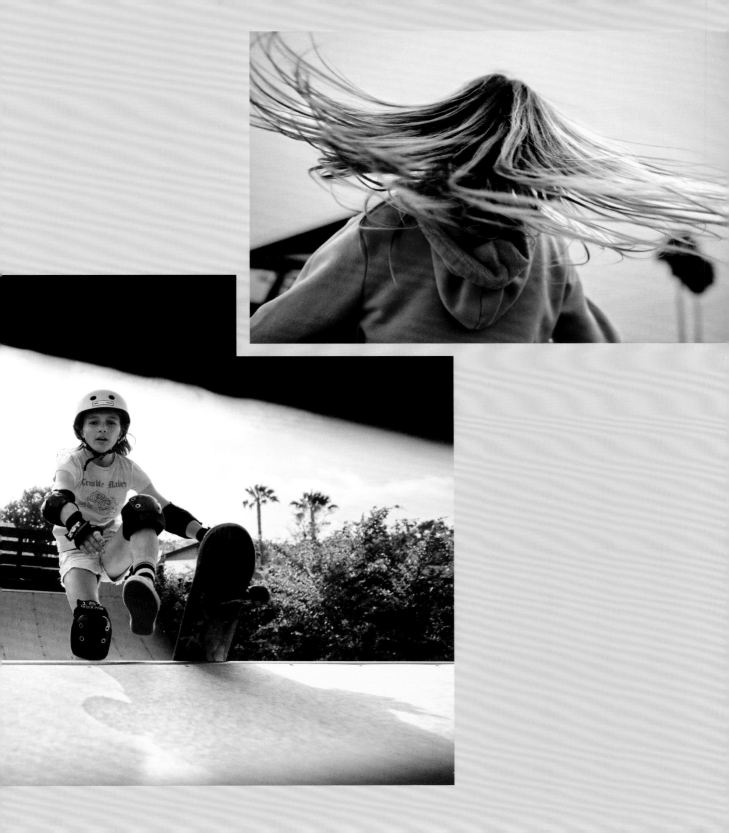

PEETA KENWORTHY
PEETA KENWORTHY

PEETA KENWORTHY

SOUL

BORN
Southern California

CURRENT HOME
Dana Point, California

STARTED SKATING
1 year old

FIRST BOARD
Pink Helmet Posse board

BOARD PREFERENCES
Loose trucks, hard wheels

STANCE
Goofy

FAVORITE TRICK
Frontside Air

TRICK IN THE WORKS
Frontside Smith Grind

SKATE DAY FOOD OF CHOICE
Strawberry ice cream

FAVORITE TIME TO SKATE
Night

FUN FACT
She frequently walks face-first into lone pillars and car side-windows—by accident, of course

Peeta is a powerhouse. She started skateboarding at just a year old, despite the fact that just seven months before that, she was fighting for her life in the Newborn Intensive Care Unit with a rare case of infant botulism (IB). This extremely uncommon disease shuts down muscle function across the body, including the ability to eat and breathe, and only occurs in children under six months of age. When Peeta was admitted to the hospital, and to the family's saving grace, a doctor in the vicinity was completing a study on IB and was able to diagnose Peeta right away, allowing her to be medicated on the spot. After a shorter-than-expected two weeks in the hospital, Peeta was able to go home, returning to her family like a superhero.

Six months later, Peeta was a healthy baby living and loving life with no fear. With three older siblings who were already skateboarding and surfing, as well as her father, Jason, to learn from, Peeta was immediately hooked on board sports. Fear and hesitation are not in her vocabulary; she is spunky, sneaky, skilled, and just a wee bit klutzy. Minor injuries are the norm for Peeta, and she bounces back stronger after every incident. Nothing can stop her from going ham with everything she does.

continued →

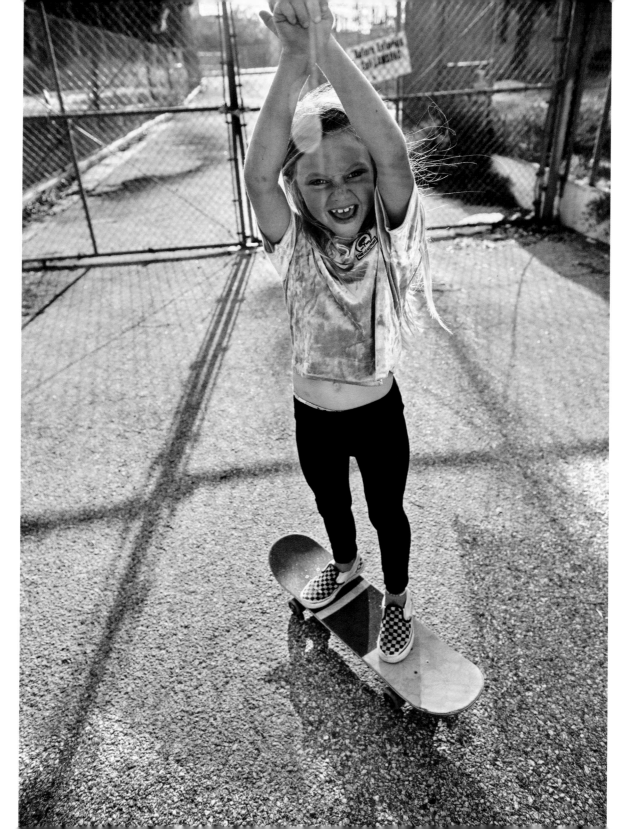

Peeta is gutsy, but she doesn't always listen. For example, after landing her first Frontside Disaster on the 3-foot mini ramp in her backyard, she promptly graduated herself to the 4-foot ramp, executing it with tenacity. After landing it on the 4-foot, she set her eyes on the 5-foot. When her father saw the determined look in her eyes, he advised her to wait to try it on the 5-footer, thinking she'd get hung up on the coping. He then went inside for a moment and came back out to catch Peeta mid-run and heading straight toward the 5-footer. Sure enough, she got hung up and fell flat. This all happened in just a 15-minute time span.

With an array of ramps to practice on in her backyard, and an outstanding lust for life, Peeta is driven to experience all the world has to offer. At just five years of age, she participated in the annual Nine Mile Skate with Paul "the Professor" Schmitt. Within minutes of leaving the starting line, Peeta caught speed wobbles and scored herself a gnarly strawberry. Did she stop? Of course not. She powered through the next two hours of the race and finished with a scab that had just about formed. She's true to the end.

Although not often, she does sit still. Peeta is a jewelry-making queen, creating a wide variety of pieces, packing them in personalized envelopes and hand-delivering them to her friends and classmates. Future pro athlete? Future entrepreneur? I think both.

"Be a bad ACE."

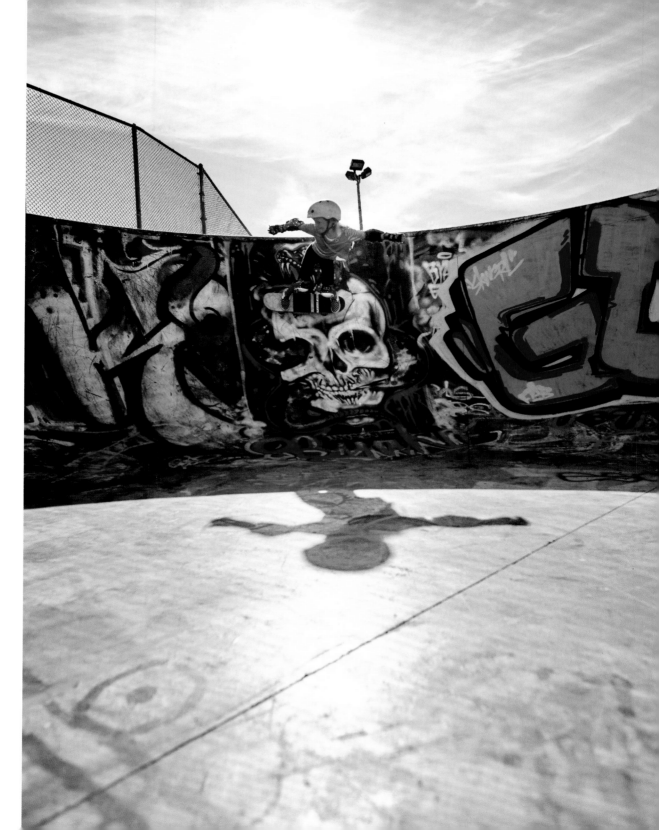

BELLATREAS KENWORTHY
BELLATREAS KENWORTHY
BELLATREAS KENWORTHY

BELLATREAS KENWORTHY

PRO

BORN
Southern California

CURRENT HOME
Dana Point, California

STARTED SKATING
5 years old

FIRST BOARD
Hand-me-down from her dad

BOARD PREFERENCES
Loose trucks, hard wheels

STANCE
Regular

FAVORITE TRICK
Frontside Feeble Grind

TRICK IN THE WORKS
Frontside Blunt Stall

SKATE DAY FOOD OF CHOICE
Sandwiches and ice cream

FAVORITE TIME TO SKATE
Night (mornings are for surfing)

FUN FACT
She joined the U16 Junior USA National Surf Team in 2019

SPONSORS
Welcome Skateboards, Vans, Orbs, S1 Helmets, Krux Trucks, Jacks Surf Shop, Pink Helmet Posse

When Bella was five years old, her little brother Loyal (who was just three) started taking skateboarding lessons. Bella's dad, Jason, who had grown up skateboarding, put a mini ramp in the family's backyard so Loyal could practice. Bella was already a surfer, and at first, she wasn't interested in skateboarding, telling her parents it was for boys. But one day, something clicked in Bella, and she asked for a skating lesson. She fell in love and has skated every day of her life since then. As the years have gone on, the Kenworthy family ramp has expanded, with every birthday and celebration resulting in an additional piece—an extension, a roll in, a spine, pool coping, and more—being added.

Two years after she started skating, Bella won her first contest. She was seven years old, competing against boys and girls twice her age, but she took home the gold. That was only the beginning for this shredder, as Bella has gone on to podium in just about every contest she has entered. In one year alone, she placed first in her age group at the Vans Girls Combi Pool Classic, Exposure Skate, and Dew Tour.

But when Bella was falling in love with skating, she initially had a hard time finding gear suitable for her small frame, let alone gear that didn't look like it was for a boy. She and her family searched skate shops high and low, driving hours with no luck.

continued →

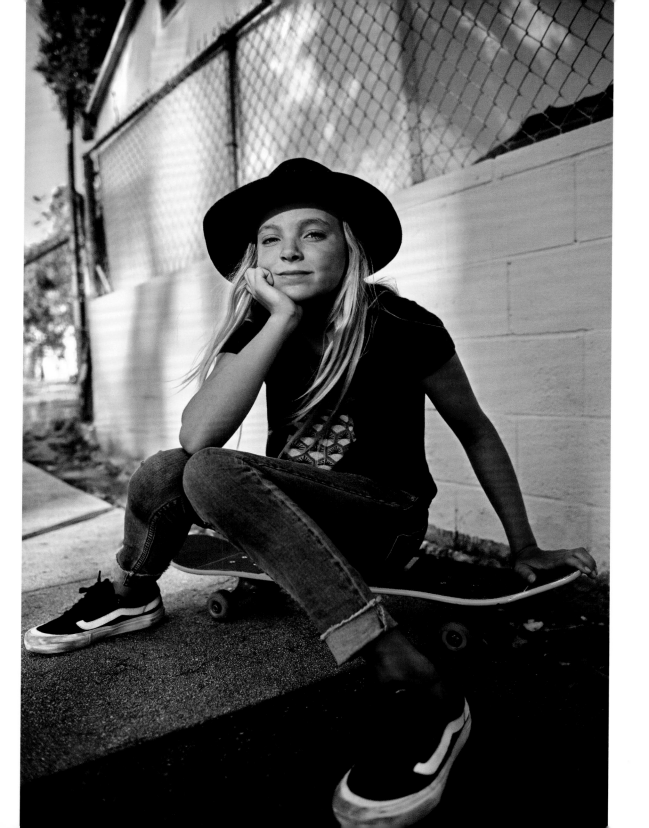

Anxious for a solution, they thought that maybe they could go straight to a manufacturer to make the right gear for Bella and other girls in similar situations.

Jason went in to see Paul "the Professor" Schmitt, the most well-known skateboard shaper there is, but at first, he wasn't interested in helping out. Paul didn't think that many kids were really skating, especially not girls, and small orders are not the most efficient. After a year of persistence, the Kenworthy family got a yes and placed an order for one hundred (the minimum quantity) pink and purple skate decks. Seeing the opportunity to get more young girls on a skateboard, Jason went into all the shops again, this time to try and sell what he originally came to buy. Yet again, he was unable to get any traction. Nobody was interested in the decks.

So the Kenworthy family decided to take matters into their own hands. They launched a little online store to sell the decks and also offered customization help, frequently taking buyers into the local skate shops to help get their boards set up. After a while, they saw another opportunity, and teamed up with the brand Krux—who saw the value in their mission—to create a line of hardware to go with their decks. On special order, Krux produced smaller trucks in colors that would appeal to girls like Bella. The stuff was pro quality, but kid size, and so the The Pink Helmet Posse was born: a one-stop, girl-centric skateboard shop. Bella was the OG of the Pink Helmet Posse, rocking her custom ride, sporting a pink helmet, and handing out PHP stickers at every practice and competition to create buzz around her family's new endeavor. "Throw a sticker on your helmet, and you're part of us," she says.

The PHP has grown into a thriving business, shipping rad girl-centric gear worldwide. It's also grown to sponsor a ten-rider, no-pressure, no-rules team with both soul and core skaters on the roster. All you need to do is love skateboarding, be cool, stay positive, and encourage other people.

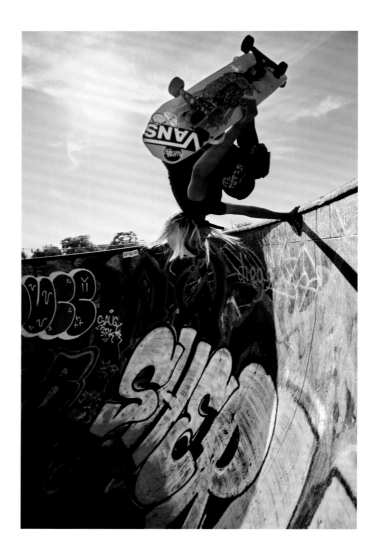

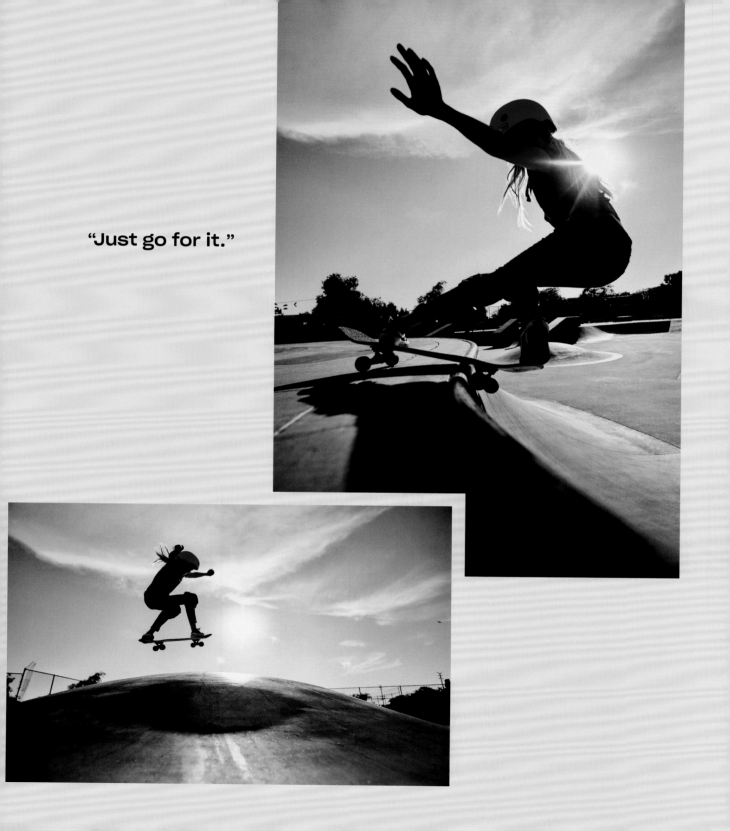

"Just go for it."

The 1980s were a tough time to be a skateboarder, but the 1990s also presented its own set of challenges before skateboarding boomed by the close of the decade.

Skate parks were still not really a thing in the early 1990s, so skaters flocked to schools, parking lots, washes, and curbs. Skateboarding got even more technical across the styles and went worldwide with the Münster Monster Mastership, and living rooms around the world were flooded with the inauguration of the X Games on television.

The "popsicle stick" skateboard design was introduced. Its big nose, slightly shorter tail, and thin and curvy body are still the standard today. Other board innovations of the 1990s included wheels becoming smaller and harder to maximize Ollie height and the standardization of the 2⅛-inch hole pattern.

Early skaters who had aged out of competition began creating skate brands that sold everything from boards to hardware, and clothing to stickers—it was a major era for small brands. The skate "uniform" of baggy clothes, chunky shoes, and plain t-shirts emerged in the 1990s as a result. And although skateboarders were proving themselves in competition, the community's increased reliance on shock factor—through hardcore attitudes and racy advertising—didn't help its reputation in the public eye. With the release and success of the movie *Kids*, skaters were painted as hoodlums and skateboarding was made to look like a bad thing.

However, by the end of the decade, skateboarding had made a sharp turn back into mainstream cultural acceptance with more skate parks opened, greater visibility of the sport through the X Games, and video games like *Tony Hawk's Pro Skater*.

1992

The modern skateboard as we know it was normalized, with the "popsicle" shape made thinner, more concave, and curvy all around.

Big Brother magazine debuted. With *Thrasher* and *Transworld Skateboarding* doing their own things, *Big Brother* wanted to represent the super-edgy, badass attitude that skateboarding media was missing. It was put together by Jeff Tremaine, Steve Rocco, and Dave Carnie, and there were *no* rules, no filter, and no censorship. Although not profitable, it was a revolutionary publication that brought the "screw-the-system" attitude of skateboarding to the cultural forefront.

1993

411 Video Magazine hit the scene. Founded by Josh Friedberg, Steve Douglas, Chris Ortiz, Paul "the Professor" Schmitt, and Andy Howell, *411* began as a quarterly (and eventually became a bi-monthly) videotape zine. *411* included pro and amateur segments, contest highlights, location reviews, branded content, and personality pieces, and it essentially set the tone for internet skate videos as we know them today.

Juice magazine was born. Founded by female skater Terri Craft, *Juice* was free for the first fifty issues and covered skateboarding, music, art, and surfing—a combination of culture that no one else was doing at the time. The first issue had Mr. Bill from *Saturday Night Live* on the cover and featured bands like the Ramones and Bad Brains. *Juice* was a witty, smart community resource, with a calendar of events in every issue and continued coverage of vert and backyard pool skateboarding (even though they were essentially dead in the 1980s). Terri still runs the magazine to this day and helped fight for the Venice Beach Skatepark—one of the most well-known skate parks in the world—to be built.

The "popsicle stick" shape, the universal skateboard as we know it

1995

Hosted by ESPN, the X Games (initially called the Extreme Games) ran its first annual extreme sports event, featuring a wide range of sports including skateboarding, bungee jumping, roller blading, mountain biking, sky surfing, and street luging. The exhibitions were held in the Rhode Island cities of Newport, Providence, and Middleton, as well as Mount Snow, Vermont. They brought some two hundred thousand spectators to the event and into millions of living rooms on television, making it a huge success. Though originally planned as a onetime event, the X Games went on to become an annual event.

Looking to create a reliable ranking system for skateboarding around the world, the World Cup of Skateboarding (WCS) was formed, later called the World Cup of Skateboarding Tour. The WCS aimed to be a trusted liaison within the skateboarding community for skaters all around the world to stay informed and check their rankings.

1996

American skateboarders boycotted the Münster Monster Mastership due to concerns about the security guards, skate structures, and layout. Within a year, the contest was revamped, renamed Dortmund, and was able to again attract full American participation. Interestingly, the year Americans boycotted, many up-and-coming international skateboarders, such as the high-profile riders coming from Brazil, were now in the spotlight.

The Vans Triple Crown of Skateboarding launched its first skateboarding-only event, which, as a contrast to the new and commercialized X Games, presented a more real and raw approach to competition. The event quickly went on to be absorbed by the World Cup of Skateboarding. Vans Triple Crown lives on today as a surfing tour.

1999

Pro rider Cara-Beth Burnside became the first woman to have a signature skate shoe with Vans: the "CB" pro model, a thick-soled suede sneaker, customized with her sunburst tattoo on the heel. The CB sneaker sold more than 150,000 units a year and went on to release numerous additional models: CB2, CB3, CB4, and so on.

Tony Hawk's Pro Skater video game was released and included one female skater, Elissa Steamer, in the character lineup. She was the only playable female character in the game until Tony Hawk's Project 8 game (released in 2006) included Lyn-Z Adams Hawkins.

The World Cup of Skateboarding sent out its WCS Competition Guide and Rule Book all over the USA and several countries around the world to aid local organization in setting up and running fair competitions. The book contained confirmed rules and formats from skaters' inputs over the years and was a reference point for the WCS pool of judges, rider representatives, event promoters, and ramp builders.

LIZZIE ARMANTO
LIZZIE ARMANTO
LIZZIE ARMANTO

LIZZIE ARMANTO

PRO

BORN
Simi Valley, California

CURRENT HOME
Oceanside, California

STARTED SKATING
14 years old

FIRST BOARD
Teenage Mutant Ninja Turtles toy board

BOARD PREFERENCES
Tight trucks, hard wheels

STANCE
Regular

FAVORITE TRICK
Frontside Grind on pool coping

TRICK IN THE WORKS
Catching up on sleep

SKATE DAY FOOD OF CHOICE
Oatmeal

FAVORITE TIME TO SKATE
Night

FUN FACT
She finds vacuuming super satisfying

SPONSORS
Birdhouse Skateboards, Vans, Monster Energy, Independent Trucks, Baby-G, Bro Style, 187 Killer Pads, Bones Wheels, Bones Bearings

Lizzie Armanto is setting the bar, not just for women, but for the collective future of skateboarding. She exists in a class of her own.

Lizzie's young life seemed pretty mundane until her dad, Eero, handed Lizzie and her brother Max a couple of toy skateboards. Then one unforgettable weekend Eva, their mom, took them to the skate park and gave the two her blessing to skate whenever they wanted. Lizzie immediately took to it; it was better than school, better than chores, better than being at home. Luckily they lived right near The Cove Skatepark in Santa Monica, California, so it was easy to put in time on the board. Lizzie's motivation to progress set off like a rocket, "I wasn't going to have my brother be better than me," she says. When he gave up skating after a chipped front tooth, Lizzie proceeded to make it her everything.

Growing up in the hub of skateboarding, Lizzie's local parks were full of bold, daring, older dudes with skate styles she really looked up to. She spent countless hours watching, then doing, quickly getting better and better; in the skate scene in Santa Monica, she stood out like a sore thumb. She's naturally shy, but put her on a board, and you'll see her confidence break through. When she participated in her first local contest and watched the pros there doing their thing—their ease on the board and crazy bags of tricks—Lizzie's pursuit to become a pro skater was *on*.

continued →

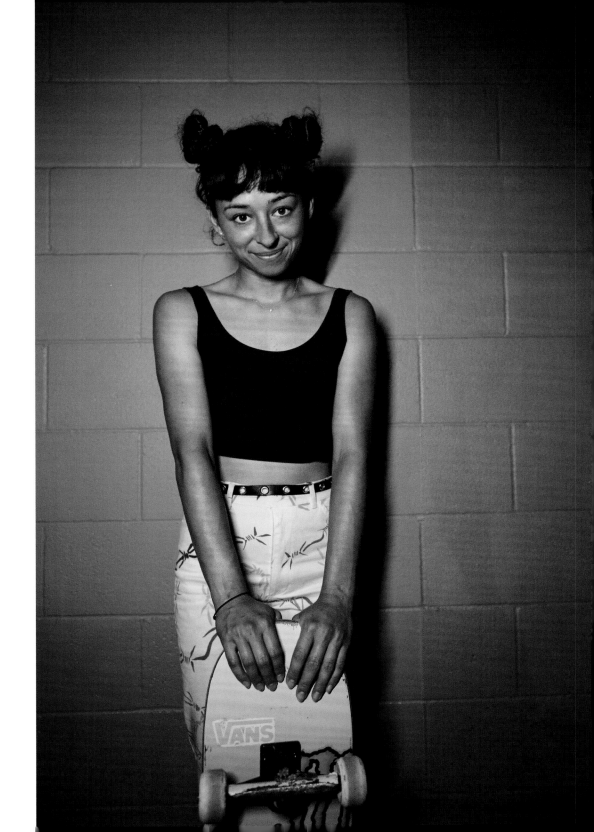

Since then, Lizzie has earned a lot of firsts. She was the first woman to grace the cover of *Trans-World Skateboarding*, the first woman in more than two decades to be on the cover of *Thrasher* magazine, and the first woman to successfully complete Tony's Hawks infamous 360-Degree Loop, along with earning more than thirty exhibition titles and an X Games gold medal. She got her first signature skateboard with Birdhouse in 2017, and in 2018 a pro wheel with Bones followed. She is globally ranked in the top ten in multiple categories. Lizzie is truly phenomenal, and her style is explosive. Her Boneless is extended, her hand plants tweaked, her slashes raw and lengthy: Lizzie does all the hard stuff and makes it look easy and flawless, yet meticulously perfected.

In addition to inspiring people all over the world with her skating, Lizzie makes sure to give back to the community. She regularly travels to developing countries with Step Up and Skate, offering her expertise in skateboard clinics, teaching workshops, and of course, the fan favorite, giving demos.

In the rare moment when Lizzie is not contributing to skateboarding, you can find her relaxing in the garden, drinking bubble tea, thrifting with friends, reading, drawing, or cooking. Something you *won't* find her doing? Watching scary movies. All in all, Lizzie is repeatedly breaking down barriers in skateboarding and zeroing in on becoming the best version of herself, while we all watch in awe.

"Skateboarding doesn't discriminate. We all pay our dues."

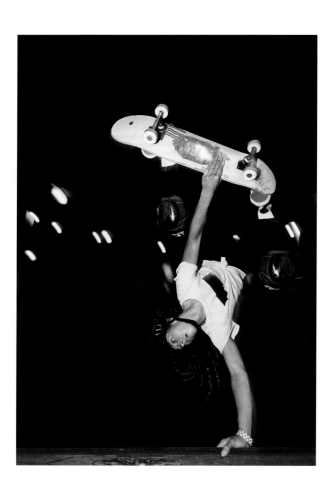

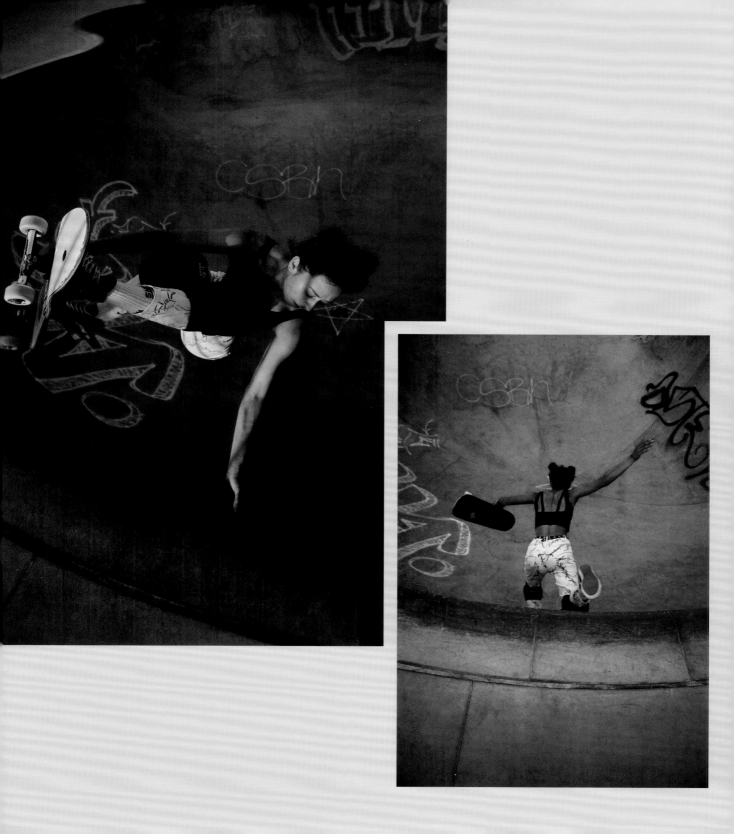

JULI HERNANDEZ

JULI HERNANDEZ

JULI HERNANDEZ

JULI HERNANDEZ

PRO

BORN
Newport Beach, California

CURRENT HOME
Costa Mesa, California

STARTED SKATING
13 years old

FIRST BOARD
Enjoi

BOARD PREFERENCES
Loose trucks, medium to soft wheels

STANCE
Regular

FAVORITE TRICK
Frontside Tuck Knee

TRICK IN THE WORKS
Backside Smith Grind

SKATE DAY FOOD OF CHOICE
Burritos

FAVORITE TIME TO SKATE
Night

FUN FACT
She loves to create and then edit video content for the internet

SPONSORS
Nike, Hurley, From Beyond, RXBAR, GoPro, Kindhumans, Garmin

Growing up by the beach, Juli has always been enamored of board sports. She was already skating, surfing, and snowboarding as just a grom. Watching the way she skates, it's clear that she brings the heart of surfing the waves back onto her skateboard. Whenever possible, Juli can be found skateboarding and surfing on the same day. Her favorite place is Mammoth Lakes, California, where she can mix in snowboarding, going from snow to concrete with epic views to enjoy. To further mix it up, she likes to skate various shapes of boards for specific kinds of rides, from cruisers to "popsicle sticks" to double kingpin setups that let her get into that surfy flow, turn on a dime, and hold lengthy, buttery Tuck Knees. When I met up with Juli to take her photo, she brought four different rides with her, ready to indulge her every mood.

Even when she's not in the water, slashing through powder, or screeching along the concrete, Juli still loves to be outside. She currently works for the police department and is on track to join the search-and-rescue team or the harbor patrol. For the record, she's going to be a "cool" law enforcement officer, the kind that lets the skater get that trick in before asking them to leave, she assures. Her other pick-me-up, besides her love for skateboarding and the great outdoors? Sweet treats. Juli's got a colossal sweet tooth. Hand her a dark chocolate peanut butter cup and you're her new favorite person.

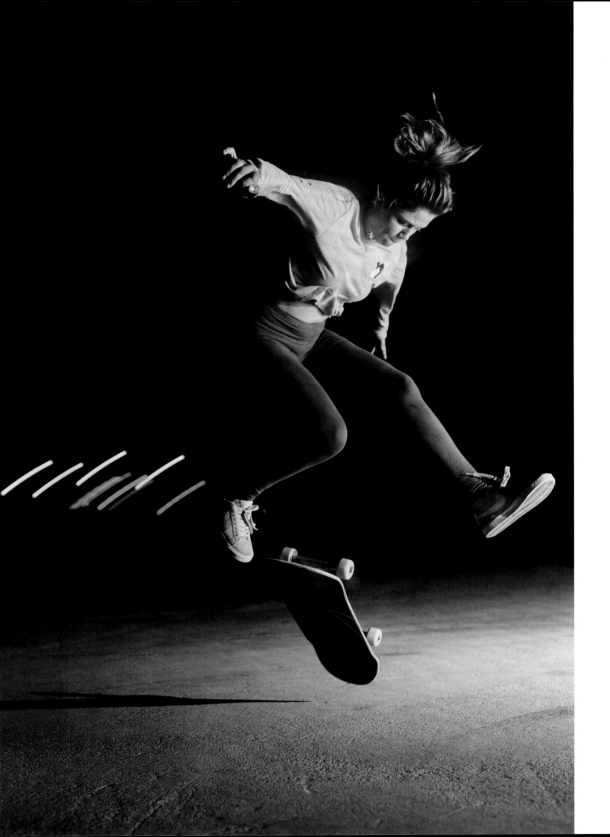

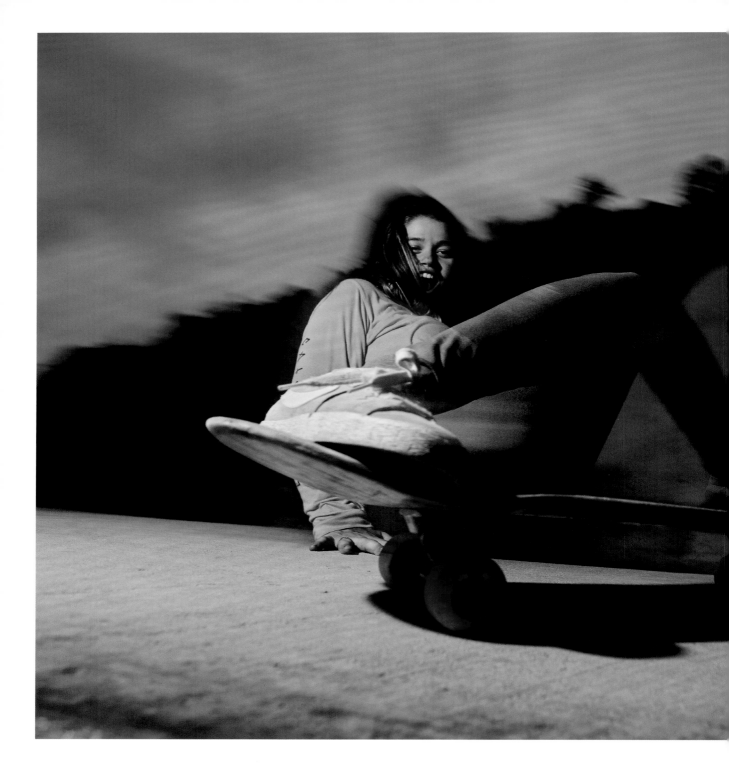

"Skateboarding is one of the most technical sports in the world. It teaches you perseverance and how to quite literally pick yourself up when life pushes you down."

KAT FOLSOM

PRO

BORN
San Jose, California

CURRENT HOME
Sacramento, California

STARTED SKATING
19 years old

FIRST BOARD
Folslam Skatz

BOARD PREFERENCES
Tight trucks, hard wheels

STANCE
Regular

FAVORITE TRICKS
Frontside Air, 5-0 Grind, Rock n' Roll

TRICK IN THE WORKS
Boneless Disaster

SKATE DAY FOOD OF CHOICE
Nachos with loads of jalapeños

FAVORITE TIME TO SKATE
Anytime

FUN FACT
Kat has a pet tarantula named Mr. Spider who is more than ten years old

SPONSORS
BadAss SkateMom, Girl is NOT a 4 Letter Word, Embassy Skateboards, Speedlab Wheels, Ace Trucks Mfg., Kung Fu Griptape, XT Outfitters

If you try to find Kat's house in her unassuming neighborhood in Sacramento, California, you won't have to look too hard. If you see a wooden vert ramp standing tall behind a gate, you're there. And that's not the only exciting thing in Kat's home setup. Walking through her yard, I didn't know where to look first. Multiple ramps jigsaw throughout the yard, making it a skateboarder's paradise. Kat and her husband, Roger, are always getting creative in their yard, regularly changing the layout of ramps, switching up the style of coping, adding extensions, and more. Even more rad than that? The whole setup is secondhand, made up of pieces pulled out of dumpsters, found on Craigslist, upcycled from friends, and recycled from playgrounds. There's even an Ikea bed!

Kat's relationship with skateboarding started when she was nineteen, at a time when skate parks were nowhere to be found, and girl skateboarders were similarly uncommon. She didn't have anyone in Northern California to look up to, or many places to go, so getting started and staying consistent with skateboarding was tough. It wasn't until she made it down to Southern California to the Vans Combi and witnessed girls like Lizzie Armanto and Allysha Bergado shredding up a bowl that it clicked—she wanted to feel what they were feeling. Being surrounded by awesome lady skateboarders was unlike anything she'd

continued →

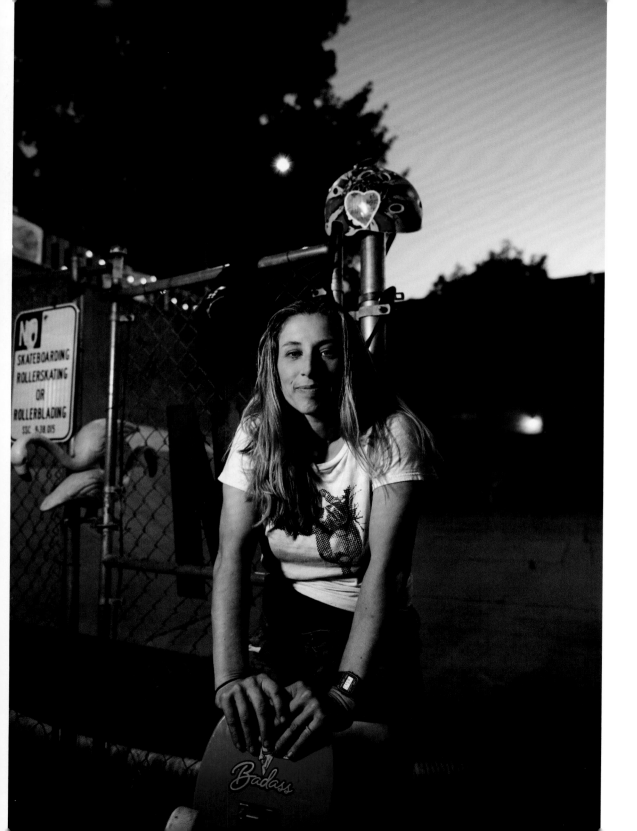

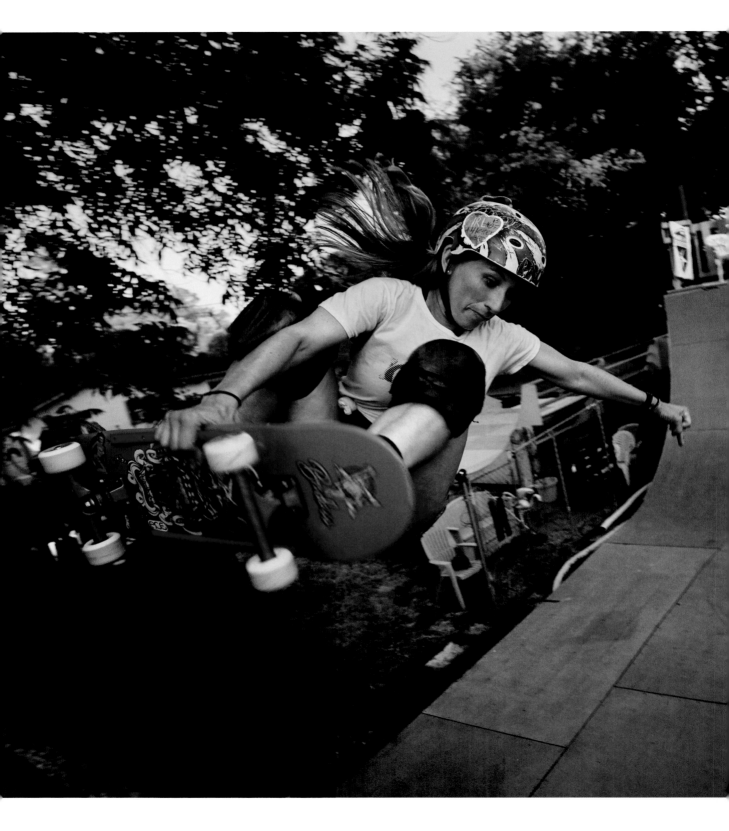

"Follow your heart. If it makes you happy, do it. Don't worry about anyone else but you. Don't worry about being cool . . . just keep skating."

experienced before, and that sense of community really motivated and inspired her to want to skate harder. Energized by that epiphany, little time passed before she was learning Frontside Grinds in the bowl at the Venice Beach Skatepark. Her skills grew, and she went on to compete against the same girls who inspired her when she started. She funneled all of her prize money back into her passion, using the proceeds to patchwork together and maintain her backyard skate ramps. Fast forward to present day, and her backyard paradise has been visited by countless pros.

In addition to her love for skating, Kat is also a full-time dance teacher and has performed in many plays, her favorites of which are by Shakespeare.

ELISE CRIGAR

SOUL

BORN
St. Pete Beach, Florida

CURRENT HOME
Dana Point, California

STARTED SKATING
20 years old

FIRST BOARD
Powell Peralta Pro Jordan Hoffart

BOARD PREFERENCES
Loose trucks, medium wheels

STANCE
Goofy

FAVORITE TRICK
Backside Grind

TRICKS IN THE WORKS
Disasters

SKATE DAY FOOD OF CHOICE
Tacos

FAVORITE TIME TO SKATE
Morning

FUN FACT
She loves to spend hours in the garden

"You'll never know unless you try."

Elise is a photographer passionate about skateboarding, and a skateboarder proficient with a camera. Both of her passions have grown and flourished because of each other, and together they have set her on the path she is on today. One primary focus of her photography is girls skateboarding, seamlessly and organically blending her two biggest passions—and she's quite good at it, too. Her images exude a unique, sun-drenched vibrancy, with a perfect combination of composition and color. Both on film and in life, Elise makes all moments feel dreamy.

When Elise is on her skateboard, she feels free and alive. She's also a surfer, so it's unsurprising that she likes to skate barefoot; carving on land is her way of surfing even out of the water. When she's not surfing or skating, you'll probably find her lounging in the sand and soaking up the sun or gardening—with a camera in her hand, of course.

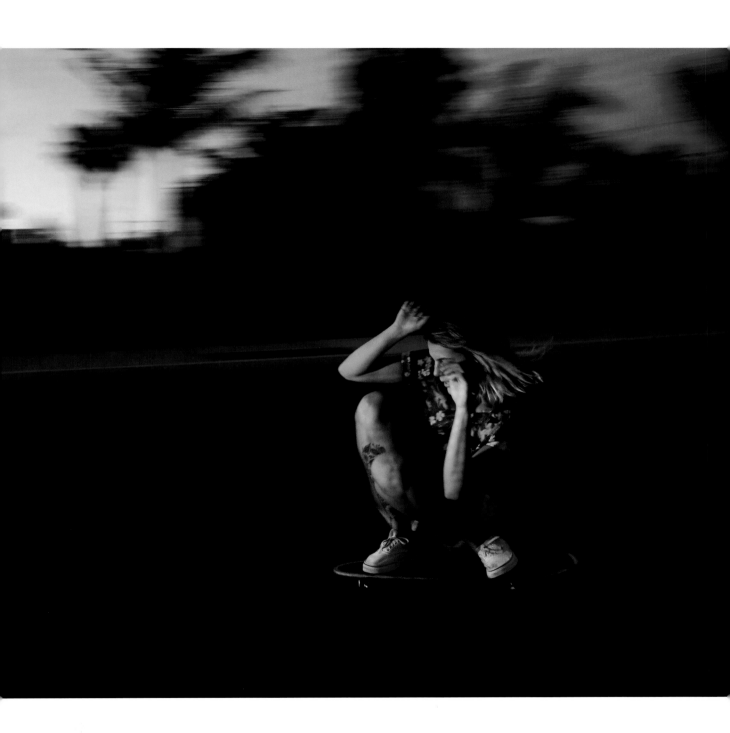

By the time the year 2000 rolled around, skateboarding was officially back on the map and more popular and commercial than ever. Skateboarding clothing went from being un-cool utilitarian garb to influencing high fashion. Skate shoe sales exploded to become the largest skate-focused consumer product. Women gained more and more recognition in the new millennium, with the X Games awarding the same prize money to women as men, thanks to the efforts of Cara-Beth Burnside and Mimi Knoop. Street League Skateboarding went from a boys-only tour to one that included women's competitions. *TransWorld Skateboarding* broke new ground by releasing a girls-only issue in 2016 with Lizzie Armanto on the cover.

This era is unique in that skateboarding has finally become something passed down through generations, with the pioneers of the 1970s and 1980s, and the pros of the 1990s having families and allowing their kids to turn pro in elementary school. This in turn has raised the bar within the pro and competition circuit. Today, skateboarding is fully flourishing, with major wins like its inclusion in the 2020 Tokyo Olympic Games, and new state-of-the-art equipment now available—from titanium trucks to Swiss-made bearings to electric skateboards and one-wheeled contraptions. Although many find the commercialization of skateboarding an annoyance, one beautiful fact still remains: however you choose to connect with skateboarding is entirely up to you.

2000

The Vans Triple Crown Series now included surfing, BMX, wakeboarding, snowboarding, freestyle motocross, and supercross. By 2001, the series of events were broadcast on national television with NBC and Fox Sports.

2003

The X Games hosted its first-ever all-female contests, Ladies Vert and Park. The Vert competition was led by Cara-Beth Burnside, who took home gold (followed by Jen O'Brien, Lyn-Z Adams Hawkins, Mimi Knoop, and Holly Lyons). Vanessa Torres took home the gold for Ladies Park (followed by Lyn-Z Adams Hawkins, Amy Caron, Karen Feitosa, Lauren Perkins, Jessie Van Roechoudt, Elissa Steamer, and Jaime Reyes).

2004

The inaugural Go Skateboarding Day (GSD) was held on June 21, the longest day of the year. The event was started by the International Association of Skateboard Companies and was initially intended as an informal skate outing within the industry. GSD has since turned into an international holiday, encouraging skaters wherever they are to pick up their boards and hit the streets and parks. GSD encourages brands and organizations around the world to hold events, meetups, and contests to get more skaters on their boards.

2005

Thanks to the efforts of Cara-Beth Burnside and Mimi Knoop, the X Games began awarding women the same amount of prize money as men.

2009

The Skateboarding Hall of Fame (SHOF) was created to honor the passion, dedication, and contributions to skateboarding history and culture by skateboarders and cultural icons throughout the decades.

2010

Street League Skateboarding, a new international competitive series, was founded by pro skater Rob Dyrdek. This street-only competition is recognized as the official street skateboarding world championship by the International Skateboarding Federation. It was initially open only to men and didn't allow women to compete until 2015.

The Skateboarding Hall of Fame inducted its first woman, skate pioneer Patti McGee.

2012

The Skateboarding Hall of Fame inducted female skater Peggy Oki.

Skateboarding had a growing collection at the Smithsonian, including Tony Hawk's first skateboard, a Bahne skateboard, Laura Thornhill Caswell's signature Logan Earth Ski complete, Cindy Whitehead's pro helmet, and a Hobie Super Surfer from Patti McGee, among loads of other collectibles.

Go Skateboarding Day T-Shirt, 2018

2013

Laura Thornhill Caswell—the first woman with a signature model skateboard—was inducted into the Skateboarding Hall of Fame.

Wendy Bearer Bull was inducted into the Skateboarding Hall of Fame.

The inaugural Innoskate Festival took place in Washington, DC, and included skateboarding pioneers Tony Hawk, Rodney Mullen, Patti McGee, Laura Thornhill Caswell, Cindy Whitehead, and Paul "the Professor" Schmitt. The event received over thirty thousand visitors and explored innovations in skateboarding and equipment tech through films, demos, hands-on activities, and more. Innoskate also worked in coordination with the Smithsonian for the national collection of skateboarding.

2014

Laurie Turner Demott and Ellen O'Neal were inducted into the Skateboarding Hall of Fame.

2015

Robin Logan, Cara-Beth Burnside, and Elissa Steamer were inducted into the Skateboarding Hall of Fame.

For the first time in Street League Skateboarding (SLS) history, a women's assemblage of eight riders was invited to compete in the SLS Super Crown World Championship in Chicago, the top level of competition within SLS. The prize purse for the winner was $30,000, which was $5,000 higher than the max prize at the X Games. The group of world-class riders included Lacey Baker, Samarria Brevard, Leticia Bufoni, Marisa Dal Santo, Pamela Rosa, Alexis Sablone, Alana Smith, and Vanessa Torres.

Leticia Bufoni became the first women's Street League Skateboarding Super Crown champion, earning herself a $30,000 prize and $11,000 Nixon watch. She was followed by Vanessa Torres with a close second place, and Alana Smith taking third.

2016

Vans organized the first-ever men's and women's Park Terrain World Championship Series, putting the Vans Park Series on a global stage.

Jen O'Brien, Ellen Berryman, and Cindy Whitehead were inducted into the Skateboarding Hall of Fame.

Quit Your Day Job premiered as the first all-women full-length skate film in more than ten years. Created by Erik Sandoval and Monique O'Toole, the film displayed progressive street skating from some of the top female skaters in the world, as well as appearances by up-and-coming riders.

Lizzie Armanto was the first woman to be on the cover of *TransWorld Skateboarding* magazine. The November issue was called a "girls' issue" and also featured the likes of Lacey Baker, Vanessa Torres, Leticia Bufoni, Alexis Sablone, and Nora Vasconcellos, among others.

2017

Lizzie Armanto turned pro and became the first woman in more than two decades to land the cover story of *Thrasher* magazine.

Kim Cespedes and Vicki Vickers were inducted into the Skateboarding Hall of Fame, and the ICON Award was presented to Sonja Catalano.

2018

Judi Oyama and Pattie Hoffman were inducted into the Skateboarding Hall of Fame.

2019

Nike Skateboarding released its first all-female skate video, entitled *Gizmo*. Directed by Jason Hernandez, the film featured all-stars Lacey Baker, Leticia Bufoni, Sarah Meurle, Josie Millard, and Elissa Steamer.

Edie Robertson and Desiree Von Essen Harrington were inducted into the Skateboarding Hall of Fame, and the ICON Award was presented to Gale Webb.

TransWorld Skateboarding magazine published its last in-print issue, ending a run of thirty-six years.

2020

Skateboarding became an Olympic sport in the Tokyo summer games, open to the top female and male skaters in two disciplines: Park and Street. Skateboarding was one of five new sports to be added to the Olympic agenda for Tokyo 2020. This addition to the Olympic program was partially meant to attract young people and was part of the most comprehensive evolution of the Olympic program in modern history, including the use of temporary venues in urban settings.

GLOSSARY

ABEC (Annular Bearing Engineers Committee): A rating given to bearings based on their dimensions, tolerances, geometry, and noise standards, predominantly used for industrial purposes. The rating grades range from 1 to 9 with the larger numbers functioning best at a very high RPM. Although informative in other fields, the ABEC rating system is not the best way to choose a bearing for skateboarding, because skateboarding is not a precision application.

Acid Drop: Skating directly off the end or edge of an obstacle without lifting up the nose, popping, or grabbing the board with the hands.

Air: Being launched out of a ramp, bowl, transition, or street obstacle into the air and catching air time.

Airwalk: A trick performed in the air by kicking the front foot forward and the back foot backward, and grabbing the nose (or not) while the board is vertical.

Alley-oop: An air trick performed in transition where the skater airs in one direction and spins in the opposite direction (for example, spinning to the right while airing to the left).

Amateur (AM): A skateboarder competing, representing, or taking part (in whatever capacity) in skateboarding events with no expectation of financial reward for their participation.

Andrecht Invert: A trick performed by executing a Backside Invert with a Backside Grab.

Backside: When spinning on a board (on flat or in air), the skater performs a Backside when the rotation of the spin puts the back or heel-side immediately forward.

Backside Flip: A maneuver where the skater rotates 180 degrees heel-side while performing a Kickflip.

Bail: Purposefully dismounting or strategically falling off a skateboard while in the middle of a trick to avoid an injury.

Bank: Any noncurved incline that can be used to ride up, perform a trick, and ride back down.

Benihana: A grab maneuver where after an Ollie, the skater's front foot extends forward with the board while her back foot is left to hang. Mid-air, the skater's back hand grabs the tail, pulling the board back under the feet to land.

Bertlemann (Bert Slide): Invented by surfer Larry Bertlemann in the 1970s, a Bert Slide is performed by bending the knees and placing your front hand on the ground while simultaneously turning to pivot around the hand, essentially sliding horizontally before pulling the legs back underneath the body to stand up.

Bigflip: While performing a Bigspin, the skater throws a Kickflip into the mix.

Bigspin: A trick where the board rotates a full 360 degrees underneath the skater's feet while her body rotates 180 degrees (that is, a 360 Shove-it with a Body Varial).

Bluntslide: A slide in which the bottom of the nose or tail of the board is pressed against an obstacle with the trucks or wheels sliding on top of the obstacle.

Bluntstall: When a skater approaches an obstacle straight on and lifts the back trucks over the lip to stall with the trucks and tail pressed against the lip with the nose pointing up and out, performing an Ollie to get out of the stall and roll away.

Boardslide: A slide in which the nose of the board is brought up and over the obstacle and the board slides along the obstacle anywhere between the two trucks.

Body Varial: When the skater rotates her body and switches foot position in the air while her board does not spin or follow.

Bowl: A type of vert or mini-ramp transition that wraps around 360 degrees and creates a closed, bowl shape.

Boned: A stylistic move added to any trick performed in the air, where the skater sends her legs out in front while pointing the nose down (for example, a Boned Ollie).

Boneless: To perform this trick, the skater bends down and grabs the board toe-side with the back hand, then quickly slides the front foot off and uses it to jump up and forward with the back foot and hand still in contact with the board. While airborne, the skater will bend and pull her leg back over the board, let go with her hand, and brace for landing.

Bullnose: A traditional and commonly used style of pool coping, bullnose coping refers to a bowl's lip having a smooth, rounded edge reminiscent of backyard pools.

Calf Wrap: This is a freestyle trick that is done by stepping off the board with the front foot and having the back foot maneuver the board to wrap the board around the calf of the front foot, holding it against the calf with the back foot, then maneuvering it back to land.

Carve: The act of making smooth, fast turns (either wide or tight) while in motion, essentially "surfing" the concrete.

Casper Slide: A slide in which the board is Kickflipped halfway and then caught with the back foot on its tail, while the front foot simultaneously catches and holds the front of the board up, then she slides on the tip of the tail along a flat obstacle. Once the board slows to almost a stop, the skater jumps and uses the front foot to flip the board back into position to land.

Casper Flip: A maneuver in which the board is Kickflipped halfway and then caught with the back foot on its tail while the front foot simultaneously catches and holds the front of the board up. Once ready, the board is flipped back over with the front foot while the skater uses both feet to pivot the board 180 degrees, all while in mid-air.

Catch: Using either foot to stop the board from rotating mid-air, then placing the feet back into position to land.

Cess Slide: A skater performs this by sliding horizontally on all four wheels while on a transition.

Coffin: An old-school trick where the skater starts from a standing position while moving, then lies down flat (as in a coffin), feet-forward still in motion and gets back up to standing position.

Coleman Slide: Made up by Cliff Coleman in the 1970s, this is a 180-degree heel slide, typically performed while longboarding downhill as a way to slow down.

Complete (Skateboard): A preassembled and pre-chosen skateboard package, typically sold in non-skate shops or online.

Concave: Explains the curvature of the short side (width) of the board, arced inward. More concavity gives the rider easier flipping and spinning capability.

Coping: An attachment affixed to the edge of an obstacle to allow easier slides and grinds.

Crooked Grind: Also called a K Grind or Crooks, this is a type of grind where the front truck and nose are pressed against the obstacle, leaning weight on the wheel closest to the obstacle, (essentially "crooked") with the tail pointing up, back, and away.

Cross Step: A basic longboard dancing maneuver, a cross step involves sliding your front foot back, then stepping across with your back foot, then swinging your front foot back behind your back foot to land both feet near the nose of the board.

Cruiser: A short style of board typically used for carving and commuting that has big, soft wheels.

Darkslide: A slide in which the board is Kickflipped halfway, then caught with both feet placed on the outside of the trucks before landing into a slide, grip tape down. The board is then flipped over and off the obstacle to roll away.

Delamination: When the plies of a skateboard deck separate due to extensive use, weather, or manufacturing defects.

Demo: A presentation of skateboarding typically held by pro or amateur skateboarders at skate parks or skate shops.

Disaster: After the skater catches air, the center of the board slams onto the edge of the obstacle just before re-entry into transition or rolling away.

Double Kingpin Trucks: A special type of longboard truck that allows for an ultra-smooth turn and consistent response. These are loved by surfers and skateboarders who like to carve or "surf" concrete.

Double Set: A stairway that consists of two groupings of stairs separated by a flat section.

Drop-in: This is the term given to entering a ramp by placing and stepping on the tail of the board with the back foot on the edge of the coping, then swinging the front foot to join then lean and roll into the transition.

Dual Durometer: A style of skateboard wheels in which there is a different level of hardness between the outer and inner core. The inner core reflects the strength of the hold on the bearing (typically a firmer durometer) and the outer core reflects the ride (typically a softer durometer for smoother ride). Although still in production, Dual Durometer wheels aren't very popular.

Durometer: The description given to the hardness of a wheel. In the larger world, there are about nine different scales that a chemist would use to measure durometer, but the ones applied to skateboarding are A, B, and D. Because urethane falls into the A category, most wheels are measured along the A scale.

Early Grab: When the skater grabs the board before leaving transition or catching air.

Eggplant: A trick performed by executing an Indy Handplant. Done correctly, the back hand grabs the board in between the legs, not Tuck Knee style.

Elbow Pad: A form of protective gear that uses foam and/or hard plastic to safeguard the elbows against impact injury.

End Overs: This footwork-style trick is performed in freestyle. It is a pivot done by lifting the back wheels and pivoting 180 degrees toward the other set of wheels.

Extension: An extension is a piece of the ramp that stretches out further than the rest of the ramp or transition.

Fakie: The skater is riding or executing a trick fakie if she is in a dominant stance and moving backward; her back foot will be on the nose.

Fast Plant: A maneuver performed by popping an Ollie, then taking the back foot off the board and planting it on the ground or obstacle, then pushing off with the back foot and, using some variation of a grab to control the board with front foot still on, then landing back on with both feet.

Feeble Grind: A grind in which the front truck first goes up and over the obstacle, bringing the back truck to grind the edge with the nose pointed away from the obstacle.

Finger Flip: This is a freestyle trick done by grabbing the nose of the board, jumping, and, while air-borne, flipping the board under the feet a full rotation to land back on top.

Flatbar: A level rail or bar that does not incline, decline, or slope inward or outward.

Flatbottom: The flat surfaces at the bottom of any transition.

Flatground: A skate style that describes skateboarding without utilizing any obstacles.

Flatspots: Clean-looking spots on skateboard wheels caused by their urethane surface being gradually worn down from sliding. As they get worse, they cause a bumpy, inconsistent ride.

Flick: A motion of the feet and ankles to flip the board. For example, a Kickflip is made possible by the flick of the front foot off the nose of the board.

Flip Trick: Any maneuver in which the skater uses her feet to pop, flick, and rotate the board around to do a full 360 rotation.

Focus: To break a board in half.

Footage (or Footie): Video captured while skateboarding.

Footstop: Used in slalom, a footstop is a piece of hard plastic attached to the top of the board near the front truck to rest the side of your front foot against for stability maneuvering the board at high speeds.

Footwork: Used in freestyle, footwork refers to moving from one trick to another. Footwork is typically done to a beat, similar to a choreographed dance.

Freeride: To freeride is a type of downhill longboarding that is characterized as much slower than downhill racing, with the incorporation of stylish maneuvers including powerslides and spins, which inherently also control the skater's speed.

Freestyle Skateboarding: One of the first forms of skateboarding, freestyle consists of finding unique ways to flip or stall one's board on a flat surface. Freestyle tricks are often linked together in routines through hand and footwork.

Frontside: When a skater's toes face the direction of travel, or enter a carve or air facing the coping or ramp. Additionally, if the skater's toes are facing the obstacle while approaching, the trick will be Frontside.

Frontside Flip: A maneuver where the skater rotates 180 degrees toe-side while performing a Kickflip.

Frontside Invert: A trick performed by a skater executing a Frontside Handplant with the front hand on the lip of the board.

Full Caballerial ("Cab"): The term for the trick also known as a Fakie Ollie 360.

Fun Box: Any style of box with grindable and slidable surfaces, typically movable and made of wood and/or steel.

Gap: Any space between two riding surfaces that can be used to Ollie or perform other tricks over.

Goofy: Skaters who ride with their left foot on the tail of the board.

Grab: Using either hand to grasp anywhere on the deck while in mid-air.

Grind: Any kind of trick where the hanger of the truck makes contact with an obstacle.

Halfcab: A Fakie Ollie 180 that can be performed Frontside or Backside.

Half-Pipe: *See Vert Ramp.*

Handplant: An invert maneuver where a skater grabs the board with one hand and gets into a one-handed handstand with the other, holding herself inverted.

Handrail: A rail positioned along an embankment, a staircase, on a flat, and so on; traditionally used in skateboarding as a double-sided obstacle to grind or slide.

Hardflip: The combination of a Kickflip with a Frontside 180 Pop Shove-it.

Heelflip: A maneuver where the skater kicks her front foot off heelside to rotate the board away from the toes a full rotation.

Heelside Rail Stand: This freestyle trick is done by standing on the rail (side of the board) with the trucks facing in front of the skater.

Helmet: The piece of protective gear that covers the head. It can come in a variety of styles including full face and flyaway.

Hip: Any two inclined planes that meet to create an edge (a pyramid is made up of multiple hips).

Hippie (or Hippy) Jump: An old-school trick where a skater jumps straight up and off the board while the board stays rolling on the ground, jumping over an obstacle (or not) and landing back on the board to roll away.

Ho-Ho Plant: An invert performed by initiating a Handplant, then releasing the board to stand on both hands and somersaulting back into the ramp.

Hubba: The flat ledge next to a set of stairs.

Hurricane: A stall that starts with a more direct approach to the obstacle, the skater begins with 180 Ollie, landing with the back truck (now in the front) on the obstacle with the nose aimed back, down, and toward the obstacle, with a brief hold before rolling out and away.

Hurricane Grind: A grind that begins with a 180 Ollie, then places the back truck (now in the front) on the obstacle with the nose aimed back, down, and toward the obstacle.

Impossible: A maneuver that can be performed with either the front or back foot, an impossible involves wrapping the nose or tail around its corresponding foot 360 degrees.

Indy Grab: When a skater grabs the toe edge in between her feet in mid-air.

Invert: A trick that is essentially a Handplant in transition. The skater performs an Invert by thrusting all of her weight up and out from a ramp while holding the coping or peak of the obstacle with one hand, holding herself upside-down, and using her other hand to hold the board to her feet.

Japan: A trick that's a combination of a Mute Grab and a tweaked Frontside 9090 (*see also* Shifty).

Jolly Jambo: Performed by executing a stalled Miller Flip; basically it is a stalled-out Frontside Invert where the tail is swung around and set back and then rolled back in Fakie.

Judo: A trick performed in mid-air by the skater grabbing the heel edge near the front wheel with the front hand and kicking the front foot off in front.

Kickflip: A maneuver where the skater kicks the foot off the heel edge of the nose to rotate the board toward the toes for a full rotation.

Kickflip Underflip: A skater performs this by first executing a full rotation of a Kickflip and then, while in midair, using the toe to tap the board on the underside to send it flipping back the way it came.

Kickturn: Commonly used as a way to turn around on a wall of transition, a kickturn is lifting the front trucks up and rotating on the back trucks, either direction. On flat, this is also known as a Tic-Tac.

Kinked Rail: A rail that is bent or misshapen, making it an obstacle difficult to navigate.

Knee Pad: A form of protective gear that uses foam and/or hard plastic to safeguard the knees against impact injury.

Knee Slide: A proper bail done while wearing knee pads with hard caps. Within transition, skaters will bail by bending their knees and sliding on the plastic of the knee pads to the flat bottom of transition.

Land: To successfully perform a trick.

Late Trick: Any maneuver that is executed after the board has either completed another trick or reached its peak height.

Launch Ramp: Coming in a variety of different degrees of inclines and sizes, a launch ramp is used to propel a skater into the air.

Layback Air: Performed by executing a Frontside Handplant using the rear hand on the lip.

Ledge: An obstacle, usually higher than a curb, that is used to grind, to slide, or (if wide enough) as a manual pad.

Lien Air: A maneuver performed by the skater grabbing the heel edge while airing Frontside. First accomplished by Neil Blender, the trick is now named after him. ("Lien" is his first name spelled backwards, and he was known for saying, "You have to *lean* into it.")

Line: 1) When a number of tricks are performed consecutively without a bail or fall; 2) When a skater maps out a run through a skate park or spot, this is considered their line.

Lip: The edge or corner of an obstacle that a skater grinds or slides on. Within transition, the lip is the coping; in street skating, the lip is the corner of a ledge, curb, or other obstacle.

Lipslide: A slide that the skater enters by snapping the board's tail and trucks up and over an obstacle to slide in between the two trucks.

Local: Skaters are considered local to a spot if they live nearby and frequent the spot.

Lock In: While in a grind or a slide, skaters are locked in when they are steady and anchored to the obstacle, making it possible to carry out a long maneuver.

Long Distance Pushing (LDP): A style of endurance longboarding, LDP is focused on stance, posture, and pushing with key differences in the board design to allow for high efficiency to skate long distances. Riders will race against each other and the clock for furthest distance traveled.

Madonna Air: While mid-air, a skater performs this by grabbing the heel edge near the front wheel with the front hand and kicking the back foot behind; this is commonly done as an entry back into the ramp with a tail smack.

Manual (Wheelie): Similar to a cyclist performing a wheelie on a bicycle, a skater performs a Manual by balancing on the back truck and keeping the front truck off the ground. Manuals can be performed while in motion or in place.

Manual Pad: Any raised, semi-smooth surface that a skater can use to Ollie up onto one side, and drop off on another. Manual pads can be used for a variety of combinations, including tricks onto and while on the pad, tricks connected by manuals, and tricks off or out of a manual/grind/slide.

Mega Ramp: Used mainly in large scale exhibition, a mega ramp consists of a roll in ramp roughly 180 feet tall leading to a launch ramp (or two), which sends a skater over a 70 foot gap to land and then approach a 30-foot-tall quarter pipe to air out of.

Melon Grab (Melancholy): Using the front hand to grab the heel edge while airing.

Method Grab: Performed by grabbing the board heelside with the front hand and pulling the edge out and up toward the skater's back. The Method Grab was developed by Neil Blender as a way to achieve higher airs.

Miller Flip: Performed by executing a Frontside Invert flipped around to then roll away Fakie.

Mini Ramp: A mellow form of transition made with two sets of quarter-pipes, which are joined by a flat bottom.

Mongo Pushing: A skater is "pushing mongo" when she pushes with her leading foot, with the other foot on the back of the skateboard. This is the "incorrect" way to push for mechanical reasons.

Mute Grab: Grabbing the toe edge with the front hand while Airing Backside. The name came from Chris Weddle, a deaf skater who was the first person to perform this trick.

No Comply: Any number of tricks performed by stepping the front foot off the board, quickly placing it on the ground and using the back foot to start any number of tricks, such as an Ollie No Comply, a 180 No Comply, a No Comply Pop Shove-it, and so on.

Nollie: Invented by Natas Kaupas, a Nollie is an Ollie off the nose of the board.

Nose Bonk: A very short grind on the front truck.

Nose Grind: To make contact with (grind) an obstacle on the front truck, tail pointing up and back.

Nose Manual (Nose Wheelie): A maneuver performed by balancing on the front truck while in motion or still and hovering the back truck in the air.

Nose Pick: When the front truck gets in position for a nose grind and stalls; this is typically accompanied with a Tuck Knee Indy Grab to help pop out of the stall.

Nose Slide: When the nose of the deck makes contact with an obstacle and slides.

Nose Stall: When a skater approaches an obstacle straight on and presses the nose against the lip and uses the front foot to remains static with the tail pointing up and back.

Obstacle: Any object or structure that can be incorporated into a skateboard trick.

Old School: Used to describe a number of tricks or maneuvers that come from skateboarding's origins; it can also mean outdated.

Ollie: Invented by Alan "Ollie" Gelfand in 1978, the Ollie is the fundamental groundwork for modern skateboarding. Simply put, it's the act of popping the tail and using the front foot to slide the board up into the air, sucking the back foot up, catching some air, and leveling out to land. It was first accomplished on vert, using the coping to snap the board and executing calculated movements to launch the board into the air. Although many called his success an accident, Gelfand had fine-tuned the engineering of the Ollie to make it consistent; from then on, skateboarding was forever changed. Rodney Mullen completed the first Ollie on flat ground.

Ollie North (Ollie One Foot): A maneuver performed by popping an Ollie, and, while at peak and level height, immediately using the front foot to tap down on the board and then kick out, causing the board to angle downward while the back foot holds the Ollie position. The front foot then returns to land.

180: Pronounced "one eighty," this is half of a rotation.

O-Vert: Short for over-vertical, this is when transition goes past vertical and begins to arc inward.

Phillips 66: Accomplished by very few, this is essentially a Fakie Frontside Invert 360.

Pivot Grind: Any trick or part of a trick where the skater's back truck grinds atop an obstacle briefly before the completion of another trick.

Play Skate: Also called S.K.A.T.E., this is skateboarding's version of the basketball game H.O.R.S.E. In the game, a skater performs a trick and if she lands it, the next skater has to land that same trick on the first try—and if she doesn't, she collects a letter. If the second skater does land the trick on the first try, it is then her turn to challenge back with another trick. The skater who collects all five letters in "S.K.A.T.E." loses.

Pogo: This freestyle trick is done by standing on the bottom trucks with one foot and bouncing up and down on the tail while holding the upper trucks or nose of the board with both hands.

Pole Jam: A trick performed by riding up to and launching off a pole that has been bent diagonally to the ground. These poles are found mostly in and around parking lots, where poles are bent after being hit by cars.

Pop: To smack the tail against the ground to begin a trick. Also used to describe the amount of snap or firmness of the nose or tail. For example, over time boards may lose their "pop" because of wear and tear.

Pop Shove-it: A maneuver in which the skater pops the board and rotates it 180 degrees, grip tape remaining up.

Popsicle Board: Adopted as the standard skateboard shape since the 1990s, popsicle boards have a shape that is most functional for street and technical skating. Essentially a larger and more curvy freestyle board, popsicle boards tend to run around 8.0 inches wide, have plenty concave and pronounced, rounded noses and tails—similar to the shape of a popsicle stick.

Power Slide: Used in downhill, freeriding, or simply when a skater needs to lower speed quickly, a power slide is when a skater shifts the board 90 degrees while in a forward motion to slide horizontally with her wheels absorbing friction and slowing the board down before shifting it 90 degrees back into position to keep riding.

Primo: To land or be in Primo, the board is on its side, axles standing vertically.

Primo Slide: This freestyle trick is done by sliding the board on its side along a surface while balancing in Primo (on the side of the board).

Pro (Professional): A skater who makes money by skateboarding, usually by riding for or commercially representing a company or brand.

Pump: Within transition or on any decline, bending and then extending the legs during the decline to gain speed.

Push: The common way to pick up speed is to have one foot on the board and use the other foot to push off the ground to propel forward.

Pyramid: A pyramid-shaped obstacle made up of a bunch of banks and hips; instead of coming to a point at the top, most skate pyramids have a flat, square top.

Quarter-Pipe (Quarter): A ramp with only one side of transition, leading from flat ground to a coping. Think of a quarter as half of a mini ramp, plus a connecting flat bottom.

Rail: A bar or set of bars, typically fixed by upright supports, which act as a barrier or as something to hold onto for stability. These, in turn, are skateable obstacles, and they can be round, flat, square, kinked, and so on. In freestyle, rail refers to the side of the board.

Rails: Hard plastic accessories affixed to the bottom of a skateboard within the wheel base, toward the outside edges of the deck. They allow for a better grab and/or for a smoother, longer slide. In freestyle, the rail refers to the side of the board.

Rail Flip: This is a freestyle trick that is done by flipping the board from a rail stand and landing on the board to ride away.

Railslide: A slide performed with the help of a rail or set of rails affixed to the board.

Regular: A skater who rides with her right foot on the tail of the board.

Revert: When a skater completes an additional 180 after already completing an initial trick, essentially ending the trick.

Roastbeef: Invented by Jeff Grosso, a grab performed mid-air using the back hand to grab the heel edge through the legs.

Rocket Air: While airing, a skater slides both feet to the tail while holding the nose with both hands; the skater should be as straight as possible, resembling a rocket.

Rock n' Roll: A maneuver done in transition when the front truck is lifted up and over the lip of the obstacle, stalls, and then turns 180 to go back down the ramp.

Roll In: On a ramp, the roll in is the smooth part, sans coping, where a skater can enter a bowl, vert, or mini ramp without having to drop-in.

Sad Plant: Essentially a tweaked invert, a sad plant is performed by straightening the front leg while inverted.

Scorpion: A scorpion is an aggressive wipeout when a skater falls on her stomach or face so abruptly that her legs and hips curve up and backward over her head, similar to a scorpion about to strike.

Session: Any time a group of skaters or friends get together for a skate.

Sex Change: Another name for a Body Varial.

Shifty (9090): With her feet always in contact with the board, a skater rotates the board 90 degrees midair, then shifts it back into position in the opposite direction.

Shuffle (into Transition): To go back into transition sideways, sliding into Fakie Stance upon entry.

Shuvit: Without popping the tail, the skater uses a back foot to scoop or shove the tail backward, rotates the board 180 degrees with a slight hop, and uses the front foot to guide and catch the board.

S.K.A.T.E.: See Play Skate.

Skate Park: An area, public or private, that is designed with obstacles made for skateboarders.

Skate Plaza: Referring to a specific kind of skate park, a skate plaza is designed for street skaters and features little to no transition; typically it will lack a full mini ramp, bowl, and so on.

Slalom: Beginning in the 1960s, slalom is one of the earliest forms of skateboarding. Slalom is essentially downhill racing while skaters weave in and out of deliberately placed cones.

Slam: To fall extra hard.

Slappie (Slappy): Any grind or slide that is entered without Ollieing into it.

Slide: Any type of trick where the deck makes contact with an obstacle while in motion.

Slob: To Grab Mute while Airing Frontside.

Smith Grind: A grind in which the back truck makes contact to grind the edge with the nose pointed down and away from the obstacle.

Smith Vert (Smith Plant): A maneuver performed by executing a regular Handplant with a leg twist.

Snake Run: Curved, smooth, and typically made of solid concrete, this skate park feature mimics the flow of waves of transition with no coping.

Space Walk: A footwork-style trick created by Torger Johnson in the 1970s, which is essentially a repeating Kickturn with the wheels accelerating forward, side to side; the front trucks never touch the ground.

Speed Wobble: When traveling at high speeds, uneven weight distribution will cause the board to oscillate back and forth, typically resulting in a loss of control.

Spin: Rotating the board along its vertical axis (the perpendicular rotation of a Flip). The simplest form of a Spin is the Shuvit.

Spine: When two quarter-pipes are back-to-back, they make a spine. The spine is typically narrow and made up of one or two pipes of coping.

Sponsored: Describes someone who is supported by a brand, company, or person by receiving free product (also known as flow), money, and/or funding entry into contests and travel.

Spot: The term for any place that is a frequented or desired place to skate.

Stalefish: While airing, this grab is performed by using the front hand to grab the back of the board, in between the legs.

Stall: What happens when a skater gets into position to perform a slide or grind, but remains static instead of being in motion.

Stance: Describes the way skaters stand on their boards (regular or goofy).

Stink Bug: When performing an Indy or Mute Grab, the skater grabs the board in between the legs, not tuck knee.

Street Course: Referring to part of a skate park, the street course section is designed to include obstacles typically found while street skating such as stairs, ledges, handrails, and so on.

Street Skating: The style of skateboarding that originated in the 1980s after the decline of skate parks. Street skating makes the world, but more often an urban environment, into a makeshift skate park.

Switch Stance: If a skater is not riding in his or her dominant stance, it is considered switch.

Tail: The raised back end of a skateboard deck, which is typically shorter and has a less steep slope than the front end (nose).

Tail Grab: While in mid-air, a skater performs a tail grab by bending the knees and grabbing the tail with the back hand.

Tail Slide: When the tail of the deck makes contact with an obstacle and slides. In freestyle, a tail slide is skidding and dragging the tail on the ground.

Tail Slide Shove-it: A freestyle trick done by skidding the tail and gliding it into a 90-degree turn, then using the back foot to push the last 90 degrees and jumping into a Shove-it.

Tail Stop: Performed in freestyle, this is done by slowing down to a stop, and having the back foot on the tail in position, ready to progress to another trick, such as Pogo or Finger Flip.

360: Pronounced "three sixty," this is one full rotation.

Tic Tac: To Tic Tac means to pivot on the back truck left and right, tapping the ground each time with the front truck and twisting the hips to swing the nose back and forth; commonly used as a means of acceleration or to maintain balance.

Toe-Side Rail Stand: A freestyle trick done by standing on the rail (side of the board) with the trucks facing behind the skater.

Tools: Typically in the form of all-in-ones, the tools used by a skater are a Phillips head screwdriver, a hex key or Allen wrench, and socket wrenches in ⅜-inch, ½-inch, and 9/16-inch sizes.

Topsheet: The top ply of a skateboard deck.

Transfer: This is when a skater goes from one obstacle to another, for example entering on one ramp and rolling away on a different ramp, or starting on one side of an obstacle and ending up on another side.

Transition: Typically found in skate parks, transition refers to a skating surface with a gradual buildup of height, often from horizontal to vertical. Transition ramps consist of obstacles such as quarter-pipes, mini ramps, half-pipes, spines, verts, bowls, and so on.

Trick: Any maneuver that can be performed on a skateboard.

Triple Set: Three groupings of stairs separated by a two different flat sections.

Tuck Knee: A maneuver that can be done in the air or while carving, where the skater grabs Indy around the legs (if in between, that would be considered a Stink Bug) and pulls the board back while pushing the knees forward.

Tweak: To over extend or exaggerate a trick, often as a choice of style.

Varial: *See* Shuvit.

Vert Ramp: A form of half-pipe, a vert ramp describes transition where the ramp goes from horizontal at the bottom and transitions to vertical on both sides, resembling a U. Vert ramps are typically at least 10 feet high and have at least 1 foot of vertical wall.

Wallie: When a skater gets all four wheels onto a wall and Ollies off.

Wallride: To get all four wheels of the board onto a vertical or almost vertical surface.

Walk the Dog: This footwork-style freestyle trick is performed when the back foot is placed on the nose and pivots the board back 180 degrees while moving forward.

Wax: Traditionally made of paraffin, wax is applied to ledges, rails, and even onto a skater's own deck and trucks to ease the friction from sliding or grinding an obstacle.

Wedge Ramp: Similar to a launch ramp but typically less steep and featuring a flat, not curved, transition. A wedge ramp can be by itself or positioned corner to corner with another to make a proper wedge ramp fun box.

Wheel Bite: When the trucks come into contact with the bottom of the board, causing the wheels to stop their rotation. This happens when a skater turns too hard or gets off balance on loose trucks.

Whirlybirds: A longboard dancing trick invented by Amanda Powell Webber: "A whirlybird is a trick slathered in melted butter in which the rider grabs the nose, slides the tail, and propels into space."

Wipe Out: To fall.

Wrist Guard: A form of protective gear that uses foam and/or hard plastic to safeguard the wrists against impact injury.

VISITING, & VIEWING
RECOMMENDED READING,
VISITING, & VIEWING
RECOMMENDED READING,
VISITING, & VIEWING

RECOMMENDED READING, VISITING & VIEWING

BOOKS

Blümlein, Jürgen; Dirk Vigel, and Cap10. *Skateboarding Is Not a Fashion: The Illustrated History of Skateboard Apparel.* Berkeley, California: Gingko Press, 2018.

Borden, Iain. *Skateboarding and the City: A Complete History.* New York: Bloomsbury Publishing, 2019.

Cliver, Sean. *Disposable: A History of Skateboard Art.* Berkeley, California: Gingko Press, 2004.

Cliver, Sean. *The Disposable Skateboard Bible.* Berkeley, California: Gingko Press, 2009.

Holland, Hugh and Steve Crist. *Locals Only: California Skateboarding 1975–1978.* Pasadena, California: Ammo Books, 2012.

Schiot, Molly. *Game Changers: The Unsung Heroines of Sports History.* New York: Simon & Schuster, 2018.

Snyder, Craig B. *A Secret History of the Ollie; Vol 1: The 1970s.* Cambridge, Massachusetts: Black Salt Press, 2015.

MUSEUMS

Skateboarding Hall of Fame (SHOF)

1555 Simi Town Center Way #230
Simi Valley, California 93065

NHS Skate Museum

104 Bronson Street
Santa Cruz, California 95062

National Museum of American History

14th St and Constitution Avenue NW
Washington, DC 20001

FILMS

Freewheelin', 1976

Skateboard, 1978

Skateboard Madness, 1980

Fast Times at Ridgemont High, 1982

Back to the Future, 1985

Thrashin', 1986

The Search for Animal Chin, 1987

Public Domain, 1988

Gleaming the Cube, 1989

Video Days, 1991

The End, 1998

Dogtown and Z-Boys, 2001

Opinion, 2001

TransWorld Skateboarding in Bloom, 2002

Sorry, 2002

Yeah Right!, 2003

Mosaic, 2003

Lords of Dogtown, 2005

Fully Flared, 2007

Street Dreams, 2009

Cherry, 2014

Mid90s, 2018

Skate Kitchen, 2018

Rodney vs. Daewon, Round 1, 1997

Rodney vs. Daewon, Round 2, 1999

Rodney vs. Daewon, Round 3, 2004

ACKNOWLEDGMENTS

ACKNOWLEDGMENTS
ACKNOWLEDGMENTS
ACKNOWLEDGMENTS
ACKNOWLEDGMENTS
ACKNOWLEDGMENTS

Making this book would not have been possible without a ton of physical and emotional support. The time frame to make this book was ambitious, but we did it.

First and foremost, I want to thank all the skateboarders who responded to my out-of-the-blue DMs and opened their busy schedules and inspiring lives up to me. I am beyond moved by each and every one of you. Skateboarding truly is a captivating form of communication and growth, and I feel ridiculously fortunate to have met all of you incredible ladies.

Thank you to everyone who held a flash or bounce, brought me coffee, held me stable in precarious positions, accompanied me on road trips, and took my phone calls when I needed to ramble—namely Kory Archuleta, with an additional thanks to Ignacio Bello and Danny Bezinovich.

Thank you to Professor Schmitt for presenting me with so much history and so much confidence.

Thank you to the families who took me under their wings: the Serafins, the Frames, and the Cais.

Thanks to my cat, Cheesecake, for putting up with me either not being home for weeks on end, or at home never leaving my computer.

Thanks to my dad and mom for always believing in me, and to my late Grandma Carol, Grandpa Bob, Uncle Chris, and Aunt Lisa for eternally watching over me.

Thanks to the multitude of friends and family I didn't see for months on end while I disappeared to make this book. Thank you for understanding. I am so grateful.

Thank you to the awesome team at Ten Speed Press and Penguin Random House for giving me such an electrifying opportunity and always meeting me with so much faith, support, and excitement. Special thanks to my editor, Kaitlin Ketchum, and designer, Annie Marino, as well as Kimmy Tejasindhu, Serena Sigona, Windy Dorresteyn, and Kristin Casemore for helping me make this book what it is today.

Lastly, I want to give a massive thank you to Anne Goldberg, who first reached out to me about a book and helped shape my book proposal. Anne is the reason this book was made possible, starting from a friendly note through the contact page of my website.

I couldn't be happier. Life is RAD. Let's Live.

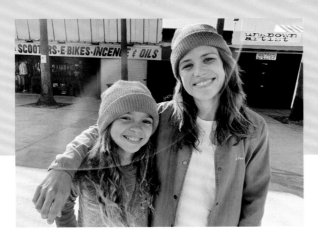

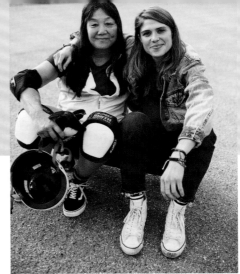

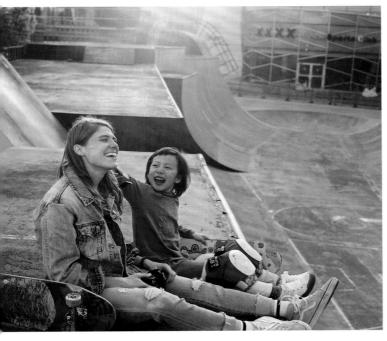

ABOUT THE PHOTOGRAPHER
ABOUT THE PHOTOGRAPHER
ABOUT THE PHOTOGRAPHER
ABOUT THE PHOTOGRAPHER
ABOUT THE PHOTOGRAPHER
ABOUT THE PHOTOGRAPHER

ABOUT THE PHOTOGRAPHER

Born and bred in Los Angeles, California, Sierra Prescott is a commercial photographer specializing in lifestyle, portraits, food, drink, and, of course, action. She's been at it since she shoplifted her first (and last) Kodak disposable camera at the ripe age of four. Knowing that they had either a photographer or a potential felon on their hands, Sierra's folks rolled the dice and gave her a camera instead of a time out.

Sierra has always loved skateboarding. She kicked-and-pushed around with the boys all through elementary and junior high, skating to, from, at, and after school. Her love of photography and skateboarding had their first meet-cute when Sierra's dad gifted her a hand-me-down point and shoot. From there, she lived for rolls of black and white film that she would later develop, print, dodge, and burn herself.

By high school, Sierra was photographing a wide range of team and action sports. At eighteen, she framed up alongside esteemed photographers Dave Black and Heinz Kluetmeier at the Kentucky Derby. She was accepted early to the Brooks Institute, worked for the prolific Peggy Sirota while she was a student, and graduated in 2010 with a BA in Professional Photography.

Since 2014, Sierra's work has appeared worldwide, both in print and online, as well as on billboards and on television. A creative through and through, her commitment to capturing candid moments is bar-none. Each piece breathes character and freshness; her own charming, ever-smiling disposition sings through each face, item, movement on the page. Sierra has shot campaigns for brands such as Fossil, G Star Raw, Joe's Jeans, Michelob Ultra, Hulu, Hansen's Soda, Hurley, as well as the Los Angeles restaurants Bestia, Republique, and Otium. In addition to her work behind the camera, she has been featured as talent in campaigns for Madewell, J. Crew, New Era, GQ, Apple, Under Armour, LG, Universal Studios, Credit Karma, and Victorias's Secret, among others.

While she may have two great loves in photography and skateboarding, Sierra's goal is singular: to pass on her "lust for life" attitude, ever blurring that line between work and play.

"LIFE IS RAD."

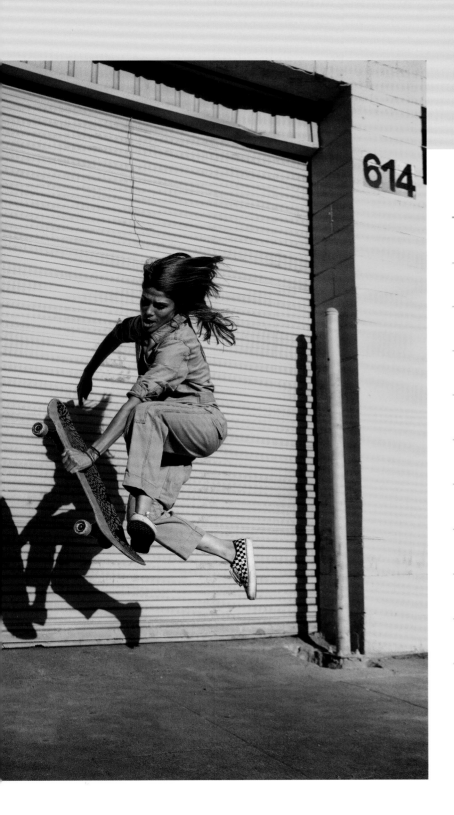

SIERRA PRESCOTT
SOUL

BORN
La Cañada, California

CURRENT HOME
Silver Lake, Los Angeles, California

STARTED SKATING
10 years old

FIRST BOARD
Element Featherlight with Independents

BOARD PREFERENCES
Loose with wheel wells and a small nose

STANCE
Goofy

FAVORITE TRICK
Bertslide

TRICK IN THE WORKS
Airwalk on flatground

SKATE DAY FOOD OF CHOICE
Açaí bowl

FAVORITE TIME TO SKATE
Morning

FUN FACT
Won a Tony Hawk Birdhouse complete by
Ollieing in front of a crowd at X Games 2003

INDEX

Copyright © 2020 by Sierra Prescott
Illustrations copyright © 2020 by Kate Prior

All rights reserved.
Published in the United States by Ten Speed Press, an imprint of Random House,
a division of Penguin Random House LLC, New York.
www.tenspeed.com

Ten Speed Press and the Ten Speed Press colophon are registered trademarks
of Penguin Random House LLC.

Some photos previously appeared on the author's personal Instagram accounts
(@shreddersbook and @sierraprescottphoto).

Names: Prescott, Sierra, 1989- author. | Ten Speed Press.
Title: Shredders : girls who skate / Sierra Prescott.
Other titles: Girls who skate
Description: First Edition. | California ; New York : Ten Speed Press, 2020. |
 Includes bibliographical references and index.
Identifiers: LCCN 2019054486 | ISBN 9781984857385 (Hardcover) |
 ISBN 9781984857392 (ePub)
Subjects: LCSH: Women skateboarders--Pictorial works. | Skateboarding. |
 Skateboarding--Equipment and supplies.
Classification: LCC GV859.8 .P73 2020 | DDC 796.22082—dc23
LC record available at https://lccn.loc.gov/2019054486

Hardcover ISBN: 978-1-9848-5738-5
eBook ISBN: 978-1-9848-5739-2

Printed in China

Design by Annie Marino

About the photographer text by Julia Rubano

10 9 8 7 6 5 4 3 2 1